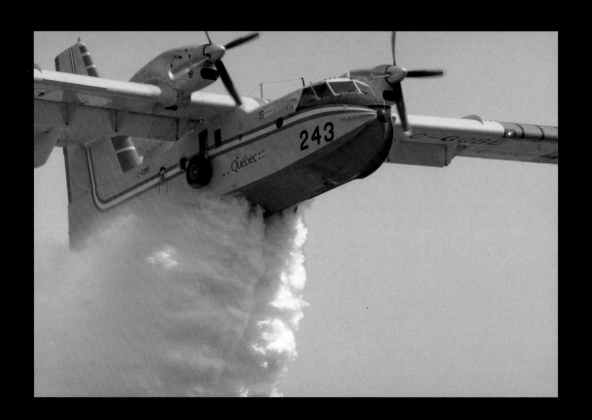

FIRESTORM

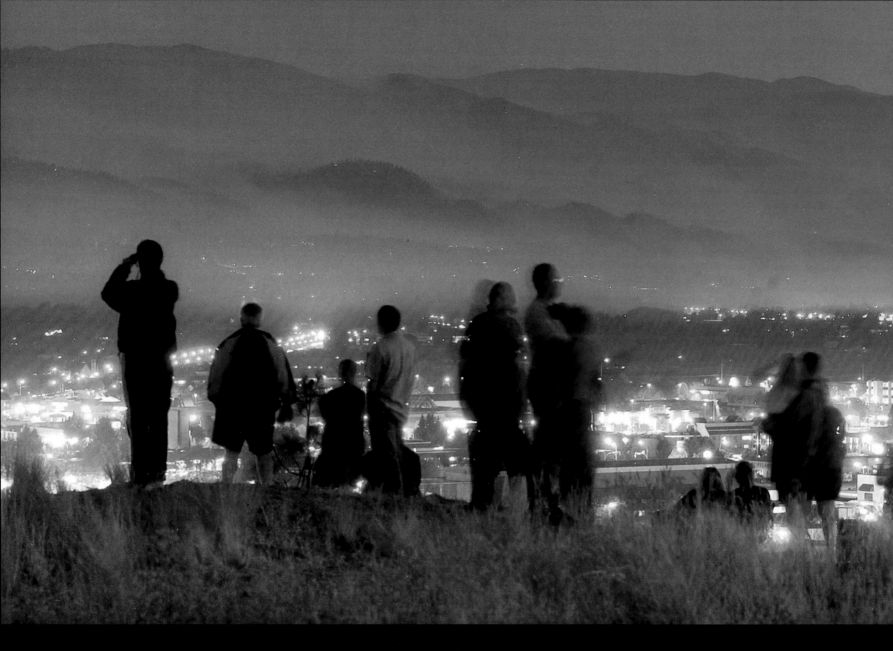

Spectators watch the Okanagan Mountain Park fire from Dilworth Drive in Kelowna.
(Gary Nylander/*The Daily Courier*)

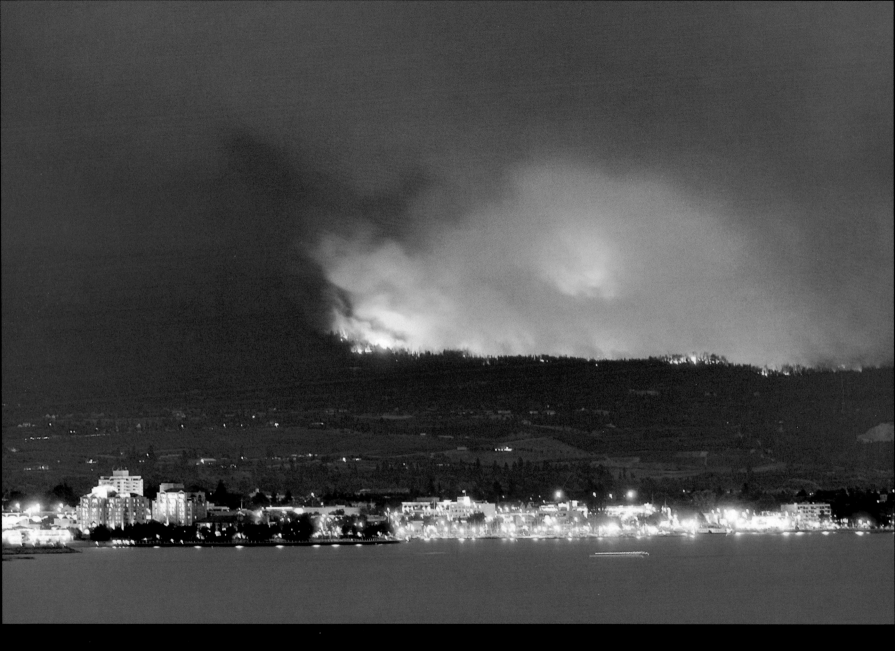

Flames creep closer to homes in the Mission area of Kelowna in this photo taken from Highway 97 near Glenrosa Road in Westbank on August 21. (Gary Nylander/*The Daily Courier*)

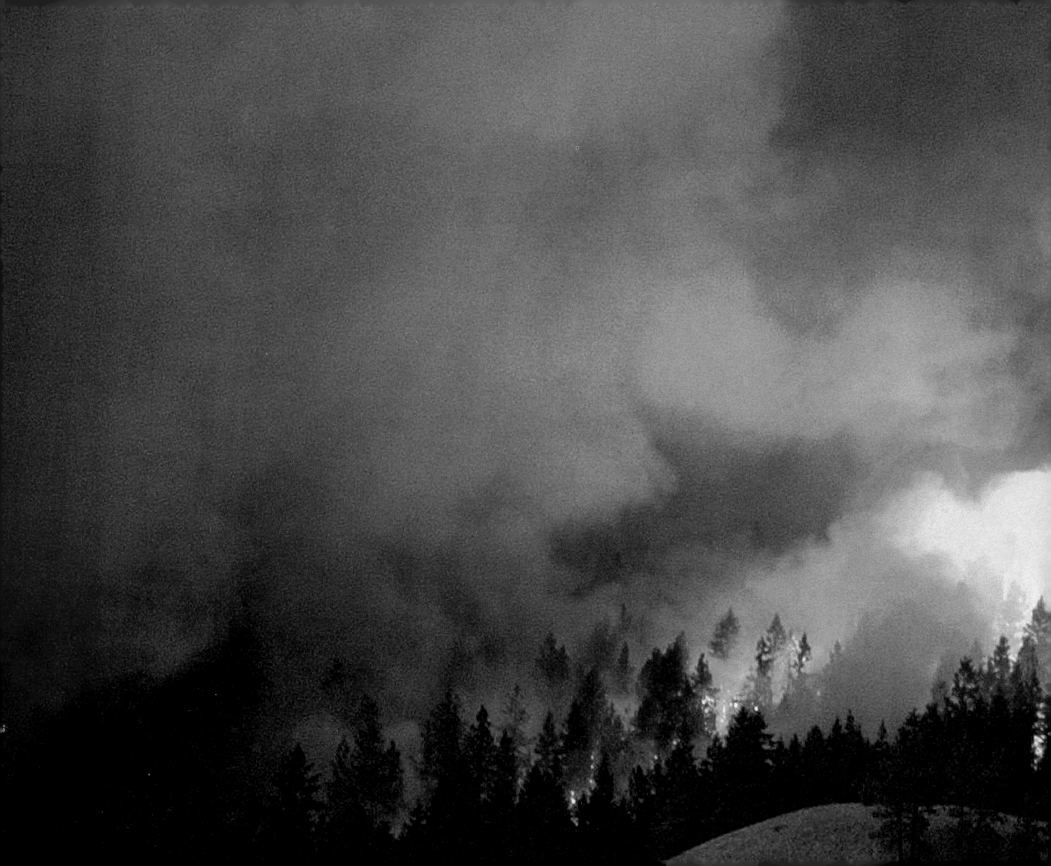

FIRESTORM

THE SUMMER B.C. BURNED

EDITED BY ROSS FREAKE AND DON PLANT

FOREWORD BY PREMIER GORDON CAMPBELL

M&S

Sponsored in part by:

National Library of Canada Cataloguing in Publication

Fire storm : the summer B.C. burned / edited by Ross Freake and Don Plant.

ISBN 0-7710-4772-X

1. Forest fires – British Columbia – Okanagan Valley. 2. Fires – British Columbia – Okanagan Valley.
3. Fire fighters – British Columbia – Okanagan Valley. I. Freake, Ross II. Plant, Don III. Title.

SD421.34.C3F57 2003 363.37'9 C2003-906269-4

We acknowledge the financial support of the Government of Canada through the Book Publishing Industry Development Program and that of the Government of Ontario through the Ontario Media Development Corporation's Ontario Book Initiative. We further acknowledge the support of the Canada Council for the Arts and the Ontario Arts Council for our publishing program.

Endpapers: *"Thank You" sign outside the Kelowna fire hall.* (Darren Handschuh/*The Daily Courier*)
Photograph on page 1: *Quebec-based air tankers helped fight fires in the Okanagan Valley and were part of the attack on the Vaseux Lake blaze near Penticton.* (S. Paul Varga/*Penticton Herald*)
Photograph on pages 4-5: *A forest fire rages out of control on the mountainside above Chase, B.C., on August 16 at Niskonlith Lake.* (Murray Mitchell/*Kamloops Daily News*)

Typeset in Minion by M&S, Toronto
Printed and bound in Canada

McClelland & Stewart Ltd.
The Canadian Publishers
481 University Avenue
Toronto, Ontario
M5G 2E9
www.mcclelland.com

1 2 3 4 5 6 07 06 05 04 03

CONTENTS

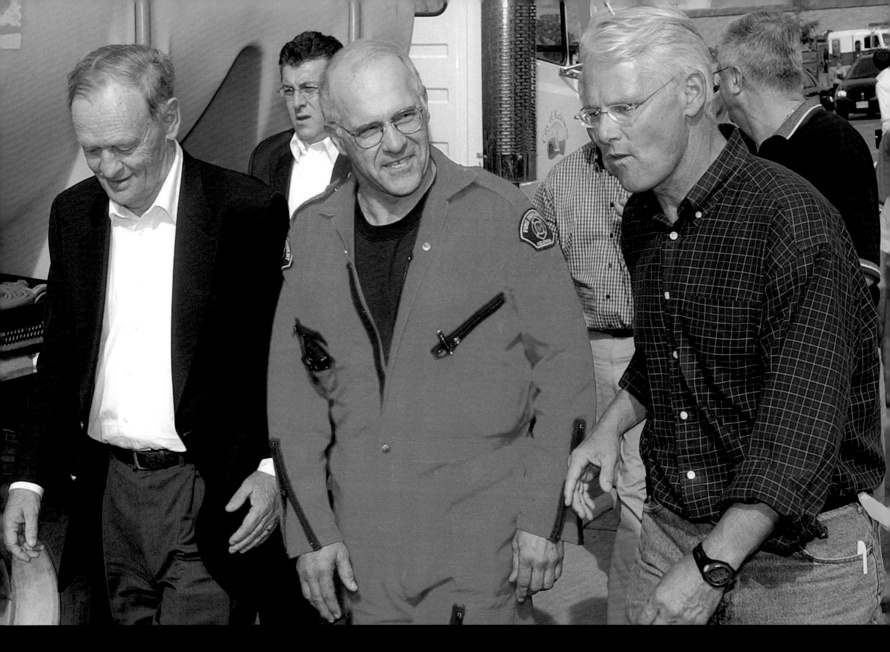

Prime Minister Jean Chrétien, left, Fire Chief Gerry Zimmermann, and B.C. Premier Gordon Campbell leave the Kelowna fire hall after meeting with firefighters. (Darren Handschub/*The Daily Courier*)

FOREWORD

The summer forest fire season of 2003 will long be remembered by all British Columbians. It was the worst in our province's history. It tested us all but it brought out the best of British Columbians' spirit of courage and compassion.

The awesome power of the fires threatened communities across the southern interior. We were all moved by the incredible resiliency of the 50,000 people evacuated from their homes. We were inspired by the exceptional courage of the men and women who put themselves in the path of danger to protect lives, homes, and communities.

More than 7,600 men and women from across B.C., across Canada, and south of the border came together to battle wildfires and protect the public. Forest service personnel, members of the military, First Nations firefighters, public safety personnel, volunteers, professional firefighters, and RCMP from dozens of communities stood shoulder-to-shoulder to protect British Columbians.

Three civilians lost their lives in airplane and helicopter crashes as they helped support firefighters. It is a testament to their efforts and the dedication of all those who fought the fires that not one single life was lost among those they worked to protect. In the end, 334 homes were lost, but ten times that many were saved thanks to their courage and determination.

Two thousand volunteers stepped forward to help their friends, neighbours and fellow British Columbians. When families were forced from their homes, they found supportive words and helping hands waiting for them in their time of need. The corporate community contributed goods and services, and people from Telus, BC Hydro, and BC Rail worked tirelessly to protect and connect thousands of people to families and friends.

And all across the province, individuals and communities came together to offer up whatever they could to help the families affected by the fires. When 50,000 British Columbians needed help, 4.2 million stepped forward to provide it.

As you look through this book, the power and the devastating fury of the fires are clear. But let us not forget that we witnessed something even more powerful this summer: the exceptional determination, humanity, and compassion of the people of British Columbia.

THE HONOURABLE GORDON CAMPBELL
PREMIER OF BRITISH COLUMBIA

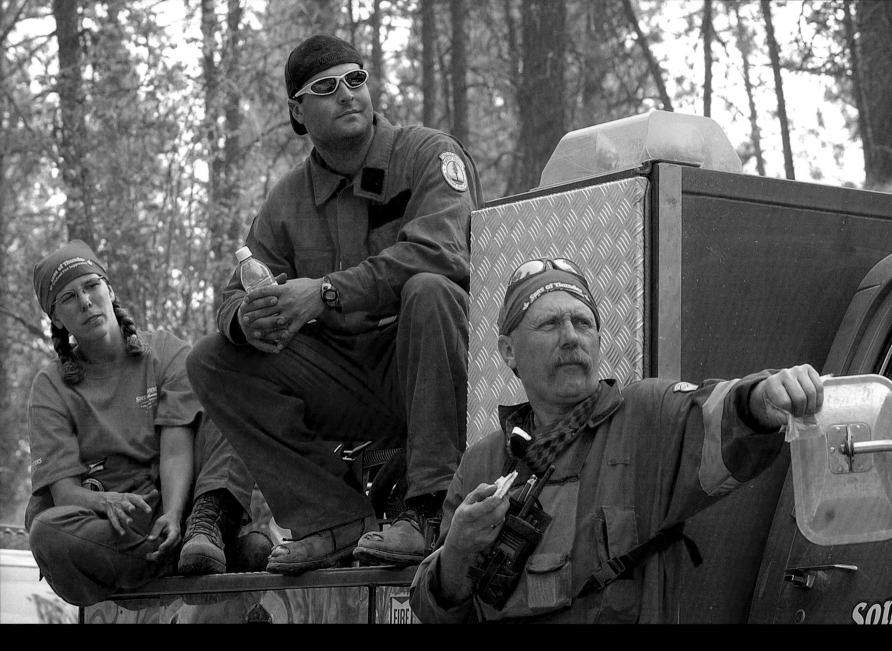

Firefighters Michelle Barker, Mike Walroth, and Ed Brouwer take a break from fighting the Okanagan Mountain Park fire at the Chute Lake staging area just outside the wilderness park. (Gary Nylander/*The Daily Courier*)

ACKNOWLEDGEMENTS

Like some slow-moving snake, the line of cars wound down the hills, filled with passengers fleeing the danger zones of south and east Kelowna. The fire raged behind them, creeping closer and closer to their homes. The vehicles were filled with family heirlooms, pets, and whatever mementos people deemed irreplaceable at a time when it was almost impossible to think clearly. For some, it was the last time they would see their homes.

The summer of 2003 won't soon be forgotten in British Columbia's interior. More than 330 homes were destroyed. A sawmill burned, putting hundreds out of work, and possibly consigning to ghost-town status the thriving little community of Louis Creek. Out of the ashes came some irrefutably positive stories. The disaster plans of many communities were put to the test and passed. At one time during the fire, 27,000 people in Kelowna were evacuated, almost a third of that city's population. Through the outstanding work of emergency personnel and volunteers, that mass of people was handled with compassion and precision. In short, the response to the fires by volunteers, community leaders, firefighters, pilots, heavy-machine operators, and military personnel was as impressive as the blazes were. Mother Nature took her best shot, bruised us badly, but we stand stronger than ever before.

This volume would not be in your hands today if it weren't for the determination of Alison Yesilcimen, the vice-president and publisher of the Kelowna *Daily Courier*. Ross Freake and Don Plant worked tirelessly under tight deadlines to write the text and select and edit photographs taken by some of the best newspaper photographers in the country, bolstered by images from some keen and talented freelancers. Among these photographers are Bill Atkinson, Eric Cullen, Corporal Bill Gomm, Darren Handschuh, Kip Frasz, Gary Nylander, Yukon Ellsworth, Stan Chung, Kyle Sanguin, and Jeremy Wageman from Kelowna; S. Paul Varga, Laurena Typusiak, Sean Ardis, Alan Heaven, John Moorhouse, and Warren Lee from Penticton; Joey Hoechsmann, Troy Hunter, and Chris Marchand from Cranbrook; Murray Mitchell, Keith Anderson, Robert Koopmans, and Brendan Halper from Kamloops; Bob Hall, Darren Davidson, Kathy Kiel, and Margaret Hughes from Nelson. All the managing editors, reporters, photographers, and editors at the Kelowna *Daily Courier*, *Penticton Herald*, *Kamloops Daily News*, *Nelson Daily News*, and *Cranbrook Daily Townsman* went beyond the call of duty to cover the fires and help produce this book.

JOHN HARDING
Managing editor, Kelowna *Daily Courier*

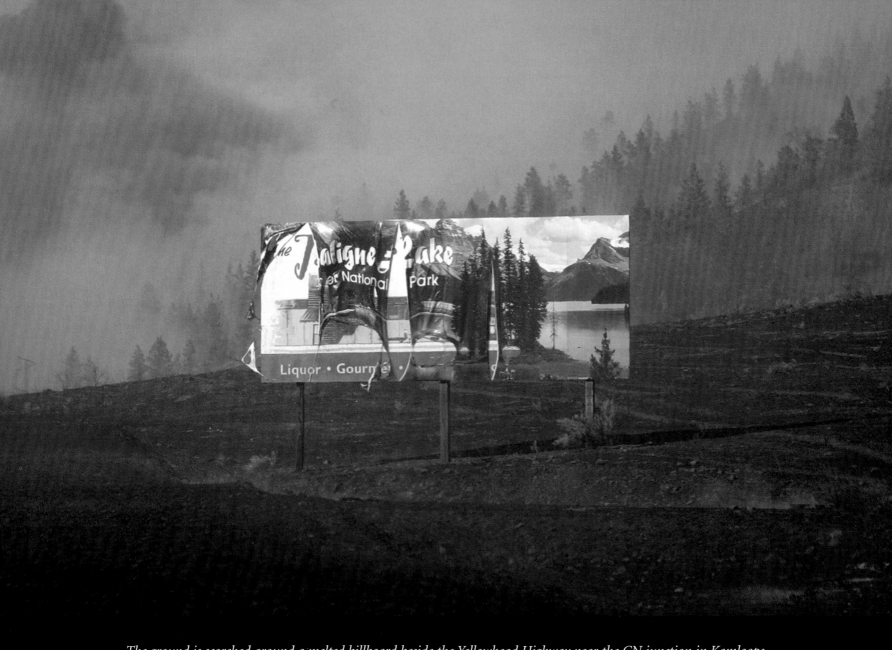

The ground is scorched around a melted billboard beside the Yellowhead Highway near the CN junction in Kamloops.
(Murray Mitchell/*Kamloops Daily News*)

INTRODUCTION

British Columbia was besieged. An implacable enemy had invaded. Men and women in red uniforms, their faces blackened by soot and etched with fatigue stood together. Sometimes they were forced to fall back. Sometimes they were forced to run. But they never gave up. They regrouped and marched back to the front. They formed a red line around cities and towns. Except for a few horrifying instances, they protected communities against an enemy stronger than they had ever seen.

The enemy was fire.

B.C. has the highest risk of interface fires – a wildfire that threatens structures – in Canada because of its climate and geography. The conflict continues to escalate as people move from urban areas to the edge of the forest. Usually, B.C. faces one interface fire a season. This year, there were 14: McLure-Barriere, Strawberry Hill, McGillivray, Venables Valley, Cedar Hills, Okanagan Mountain, Anarchist Mountain, Vaseux Lake, Bonaparte Lake, Chilko Lake, Tatla Lake, Lamb Creek, Plumbob Mountain, and Ingersoll.

B.C.'s southern interior is dry, mostly semi-desert, but in the summer of 2003 the Okanagan was drier than Death Valley. Interior communities started breaking high-temperature records in June. The region had already endured three dry summers in a row. In July, only trace amounts of rain fell and by the end of the month more than 240 fires were burning in the lower third of the province. One hundred and fifty-eight fires were sparked by lightning strikes in a single night. The little moisture in the grass, shrubs, and needles on the forest floor offered no protection from the flames that followed.

The first blaze hit near Kamloops on January 4, and by year's end more than 2,500 fires had destroyed at least 264,433 hectares of forest, one quarter of a billion trees, 334 homes, and 10 businesses. Altogether, 45,193 people were evacuated, and 6,035 were forced to evacuate a second time. Three pilots – part of a flying armada that bought invaluable time for firefighters on the ground – were killed while fighting the fires.

One community was destroyed. When the Tolko Industries sawmill burned in Louis Creek – along with 39 houses, 26 mobile homes, the general store, and several businesses – it sucked the life from the village of 250. Tolko announced that it would not rebuild the mill; many, perhaps most, residents of the community would have to relocate.

More property was destroyed by forest fires in B.C. than at any other period in Canadian history. Some days, it felt like the whole province was going up in smoke. Still, British Columbia survived. It emerged from the inferno stronger and more united than before nature turned its wrath on forests and homes. When 27,000 people were evacuated, Kelowna took them in with smiles; more people volunteered than were needed. When

horses and cattle had to be moved, especially near Kamloops, some people provided shelter and others donated food.

At times, when all the news was bad – when the fires doubled in size, houses were being abandoned and others were burning, when the great railway bridges were lost, and the night sky lit up with a hellish, orange glow – hope wavered. Many wondered whether anything would be left of the province's famous beauty except charred trees and ash-covered ground.

But the worse things became, the more people helped each other. When a small grass fire broke out along the side of a road, motorists jumped from their vehicles and snuffed out the flames with their shoes and rocks. When the Kelowna fire was at its most fearsome, three friends set up pumps and hoses to try to save a million-dollar lakefront house in an area backing onto Okanagan Mountain Park.

On the first night, they could hear propane tanks exploding and trees candling. They spent the following day soaking the ground near the house and removing flammables. In the afternoon, the wind picked up and the fire grew more intense. It jumped fireguards and pushed fire-fighters back. A little later, a helicopter circled the house twice, a warning that the fire was closing in. On his way out along the only road, an RCMP officer told them the fire was within a few hundred metres. They stayed but kept their boat motor running.

The ground fire came first. The men could hear the jet-like roar of the crown fire following. They resisted the urge to run and fought back the flames. They saved the house, but homes on either side and others in the area burned down. In all, 223 houses were razed that night, leaving some neighbourhoods all but wiped out.

The scale of the disaster was obvious. Prime Minister Jean Chrétien, prime minister-in-waiting Paul Martin, Opposition Leader Stephen Harper, B.C. Premier Gordon Campbell and a host of cabinet ministers flew over damaged areas and met with victims. After they left, the fire-fighters and soldiers resumed the combat despite the heat, dust, dehydration, and fatigue.

For their valour, they were almost deified. Kelowna Fire Chief Gerry Zimmermann became a symbol of a community's resolve. His struggle to control his emotions when talking about the loss of homes and how his men almost lost their lives touched the hearts of people struggling with their own pain and grief.

Politicians had their picture taken with him. Martin and Campbell held up the sign that a cab driver had given the chief: "Gerry Zimmermann for Prime Minister." If Kelowna people were the only voters, Zimmermann, not Martin, would replace Chrétien as prime minister. "Firefighters were raised one level by 9/11, which typified what firefighters are all about," Zimmermann said. "They're going in when everyone else is coming out. Basically, that's what they're like. What happened here wasn't on the magnitude of New York, but the principle is the same: we weren't going to back off."

There was no shortage of firefighters willing to suit up. San Diego firefighters visiting Vancouver offered their services, as did one from Alberta who was willing to spend his two weeks of vacation in the fiery forests of B.C. Standing shoulder to shoulder with the 5,700 firefighters were 2,000 soldiers. Like veterans of any battle, these warriors have a wordless understanding that comes from common experience and shared pain.

The war was not unexpected. Professional foresters had predicted that a catastrophic fire would engulf Okanagan Mountain Park. The 10,000 hectares of forest had been left in their natural state untouched by fire for almost 50 years. The forest floor was covered with tinder. Blocks

of standing dead trees grew bigger because falling them in B.C. parks is forbidden. Insects killed many of them, providing more fuel.

Fire is nature's way of managing the forest. Throughout the province, fuel on the ground, dead trees, withering heat, the driest weather in a century, lightning strikes, and high winds helped create "perfect-storm" conditions. Residents prayed for rain, knowing a weather change was the only quick solution. After a firestorm destroyed 15 houses on Rimrock-Timberline in Kelowna, one firefighter said Mother Nature started the fire and Mother Nature would put it out – all man could do was try to control it. He was right.

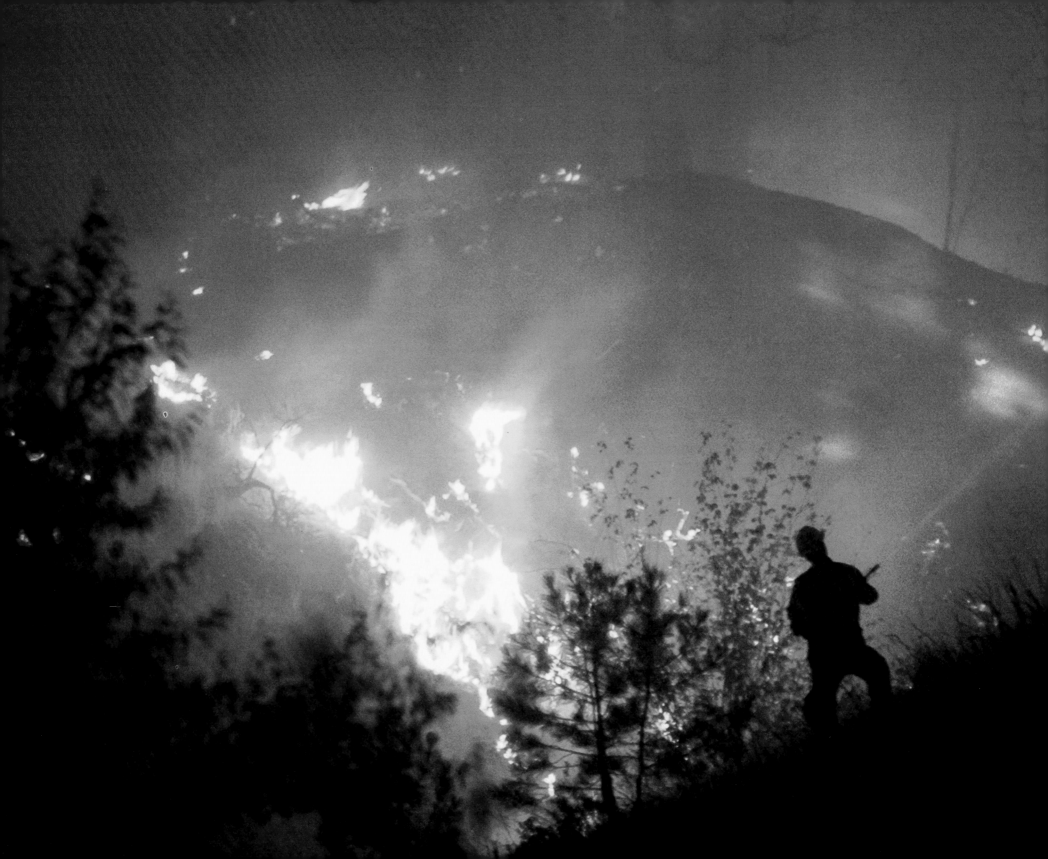

KAMLOOPS

A discarded cigarette ignited the McLure-Barriere fire on July 30, 2003. The conflagration that followed would haunt the smoker, a former prison guard who later confessed his guilt, for months. He said the fire started in a bed of cedar needles in his backyard under a forested mountain. His action, aggravated by the worst fire conditions in decades, would force thousands to flee, leave dozens homeless, and destroy hundreds of jobs in this blue-collar region.

The forest fire started near McLure, a community of 400 people about 50 kilometres north of Kamloops, and spread at a rate of 50 metres a minute. High winds and relentless heat made the blaze too treacherous to fight. Firefighters and air tankers failed to halt its advance. Six houses burned in nearby Exlou and three homes in McLure. The raging forest fire created its own draft as it stormed north up the North Thompson Valley towards Barriere, a town of 2,800.

Ashes and burned leaves flew into Barriere and the village of Louis Creek as residents packed their valuables. Electricity was out in more than 9,000 homes in the valley. Flames destroyed a key transmission line,

◀ *A firefighter is backlit against the orange glow of a fire in Kamloops's Westsyde on August 1. This fire was brought under control before noon.* (Murray Mitchell/*Kamloops Daily News*)

disrupting power from Heffley Creek to Valemount. Twenty kilometres of line and 100 poles were damaged. By 9:00 the next night, the fire had spread across 1,000 hectares. The roar of the advancing flames echoed through the valley. The fire rumbled down the road into Louis Creek, a community of 250 residents, destroying nearly every home and vehicle in its path. The flames levelled 39 houses, 26 trailer homes, the general store, several businesses, and a nearby sawmill owned by Tolko Industries, the community's largest employer.

The sawmill, one of three owned by Tolko in the southern interior, was worth more than $50 million. It employed directly 180 people and indirectly another 150. Two months later, the company delivered the bad news: the mill would not be rebuilt, due to a lack of natural gas, to poor rail access, and to the softwood-lumber dispute with the United States, which had disrupted the market. The community's economic lifeline was cut, forcing families to pull up stakes and find work elsewhere.

Barely a single structure in Louis Creek was left intact. Weeks after the firestorm, dozens of residents saw pictures of their burned homes when they met privately with provincial officials in Kamloops. Photographs of their blackened properties were flashed on computer screens. The North Star Trailer Park lost 11 mobile homes. Six of the eight homes on the First Nations reserve were razed. Half the residents of

Louis Creek, many of them on fixed incomes, were uninsured: rebuilding was going to be a challenge.

The wildfire moved fast, crossing the 24 kilometres between McLure and Barriere in less than a day. When flames reached Barriere's outskirts on August 1, everyone in town and a thousand others from smaller communities had been directed to the evacuation centre at Sport Mart Place in Kamloops.

A handful of volunteer firefighters and a couple of RCMP officers struggled to save the town from destruction by battling a rain of burning embers, flames, wind, and smoke. Fire encircled Barriere, but no home inside the town limits was lost. Four businesses in the industrial section were destroyed, including a log-home manufacturer and a towing company. Cathy and Dennis Bachmier lost their 20-year-old heavy-equipment-repair business. Their home a few blocks away was still standing. Officials estimated the residential cost of the fire's destruction in the area was $8.2 million.

The inferno expanded north to cover more than 4,000 hectares, moving another 12 kilometres in 24 hours. Crews were spread even thinner as fires erupted closer to the Rayleigh neighbourhood on the outskirts of Kamloops, and near Paul Lake. Two hundred and sixty new fires were reported to the Kamloops Fire Centre in just six days. Premier Gordon Campbell announced a provincial state of emergency. His authority gave emergency officials the power to take all actions necessary to fight fires and protect people and their communities. "This is the driest it's been in 50 years," said Campbell. "No one has seen anything like this before."

Rayleigh residents were forced from their homes late on August 1 after a fire raced up Strawberry Hill, northeast of Kamloops. Strong winds swept up the valley, fanning the flames along several kilometres of sage- and grass-covered hillside near Highway 5. A giant smoke plume rose up from Strawberry Hill, rivalling the column from the McLure-Barriere blaze up the valley. Firefighters were surrounded by smoke coming from both fires. The cause of the Strawberry Hill fire was unknown, but it began at a popular roadside stop along Highway 5 where more than 60 cigarette butts were found. The fire quickly grew to 3,370 hectares. Rayleigh residents were allowed to return home on August 4, but evacuation orders remained for residences closer to the blaze. The next day, 110 Edmonton-based troops arrived in Kamloops to help firefighting crews.

Two weeks after it started, more than 200 firefighters were working to control the fire at Strawberry Hill, which had expanded to 4,200 hectares. Flames could be seen from downtown Kamloops, a city of 80,000. Volunteers rescued more than a thousand animals left stranded after their owners were forced to flee. Some had been burned or injured. The SPCA in Kamloops worked hard to find foster homes for strays and to reunite lost pets with their owners. A dog nicknamed Smoky captured headlines after it was found on the banks of the North Thompson River unable to walk due to severe burns on his paws. A two-metre chain was tied to his collar and the hair on his back was singed. He was taken to a veterinary clinic for treatment. Soon after his picture appeared in the *Kamloops Daily News*, the dog was reunited with his owners. They had been ordered out of Louis Creek and were unable to find him before they drove off.

Premier Campbell, who flew over the worst-hit areas a few days after the firestorm, was overwhelmed by the sight. "The homes that are down, you look and you can see just the spindle of a chimney that's managed to stay standing," he said. "It's like a vacuum sucked the life out of the area." Eight thousand people in the North Thompson region had become fire refugees less than a week after the first plumes of smoke were spotted. Many became increasingly angry at the lack of information about their

homes. A visit from Forestry Minister Mike de Jong seemed to help. He told residents he expected them back in their houses within 24 hours.

Sure enough, most residents of Barriere, Louis Creek, and McLure were allowed to return home on August 10. Some found only burned foundations and a lifetime of possessions reduced to charred rubble. If they were lucky enough to find their homes still standing, people quickly discovered their refrigerators reeked with the stench of rotten food due to the power outage. Health officials recommended they avoid opening any fridges and freezers. Instead, residents were told to seal them and move them to the street, where contractors picked them up for disposal.

A recovery centre was established in the Barriere Lions Hall. Health workers offered counselling and emotional support for fire victims in Kamloops. The Salvation Army set up mobile kitchens to serve food to affected residents. Federal and B.C. politicians promised relief money. When Hedy Fry, chair of B.C.'s federal Liberal caucus, visited the area in mid-August, she pledged federal aid. "I'm concerned that 50 per cent of people affected by the fire didn't have insurance," she said. "This is a depressed area hurt by such things as the softwood-lumber dispute. People could not afford the insurance. I want people to know that relief will be here."

As people struggled to turn their lives around, the McLure-Barriere fire raged on. By mid-August, it had mushroomed to 20,000 hectares. More than 800 firefighters were fighting around the clock to keep it in check. It was only 50 per cent contained and still active on the northwest flank. More than 1,500 men and women were working on the front lines fighting the McLure, Strawberry Hill, and Cedar Hills wildfires burning north and east of Kamloops. Until August 17, no one had been killed or seriously injured. Then a forestry helicopter crashed about 80 kilometres east of 100 Mile House while fighting the Bonaparte Lake fire, which burned northwest of Barriere. Berhard George von Hardenberg, a 33-year-old pilot from Mission, was dead.

The same day, people living in the Niskonlith Lake area and Chase were bracing for the worst. A lightning strike had sparked a new fire, which grew over the weekend to 2,160 hectares. Hundreds in the Niskonlith Lake area as well as the Adams Lake and Neskonlith Lake Native reserves were ordered out. Twenty homes, most of them summer cabins, were destroyed. All that remained on many of the sites were chimneys and a few bathtubs in a sea of white ash. The total loss was estimated at $2 million.

The frenzy continued. Gusting winds kicked up mini-tornadoes on August 19 that launched firestorms across firelines and highways, forcing firefighters to back off. The McLure-Barriere blaze forced the re-evacuation of 450 residents north of Barriere – their third in as many weeks. The next day, the conflagration grew to 237 square kilometres. It was 50 per cent contained as 995 firefighters, with heavy machinery and 12 helicopters, built a fireguard around it. People who saw the fire jump creeks compared it to an atomic bomb. Many escaped with only the clothes they wore. Some were so shaken when they fled that they forgot their medication and prescription glasses. They stood in disaster-relief centres to line up for food, clothing vouchers, and army cots. Many stayed in evacuation centres or motels for two weeks or longer.

The McGillivray fire, which broke out August 15, became a crisis for the 2,650 residents of Chase when it roared over the crest of the hills in the north end of town. High winds caused the fire to grow by more than 500 hectares. The flames blew away from Chase but were still very much a threat. As if fire crews weren't stretched enough, another blaze ignited a fire in the Venables Valley, south of Ashcroft. This fire started on August 15 and sprawled to cover more than 6,000 hectares within three days. When winds gusted at 65 kilometres an hour on August 18, they created

dust devils that scattered embers and caused the blaze to storm through containment lines and across a highway. More than 100 homes in the valley were evacuated. A hundred and ten firefighters, 115 pieces of heavy equipment, and two helicopters worked to contain the blaze, but crews couldn't conquer the monster.

By August 19, 646 fires had been reported to the Kamloops Fire Centre since early summer. Seven new fires had started in the previous 24 hours. McGillivray still remained the most menacing of them all. High winds pushed the fire close to the small community of Pritchard, 25 kilometres east of Kamloops on the Trans-Canada Highway. About 850 people living on both sides of the highway fled when the McGillivray fire jumped containment lines. By August 25, the blaze covered 82 square kilometres and was 60 per cent contained. Fire crews protected the town, allowing residents to return five days after they escaped. Some were furious to find looters had ransacked their homes. "It's bad enough to be evacuated, but then to come home and be treated this way by the scum of the earth," said Dennis Zinger. "I'm mad. We're all very mad." Meanwhile, people in Chase were trying to cope with a fire that burned close to homes on the north side of the Thompson River. Fire crews managed to save the two houses that were most threatened.

Finally, the weather improved. On August 27, firefighters took advantage of a cold front that raised humidity and brought cooler temperatures. They extended containment lines and bolstered guards around wildfires that had burned for weeks. There was little growth for several days. Tourists stayed away, hurting operators who depended on a busy summer season for their income. Still, life was getting back to normal. Golfers were hitting the greens and people starved for entertainment rented videos and DVDs. Most evacuation orders were lifted, allowing all but 200 people to return home. On September 2, the final order related to the McLure-Barriere fire, now 262 square kilometres, was rescinded as army reservists prepared to return home.

But the McGillivray fire wasn't done yet. In early September, high winds propelled the blaze over the guards and broadened it by 150 hectares, threatening the Sun Peaks Resort on a nearby ski mountain. The flare-up forced out 750 residents, staff, and guests as the fire got as close as three kilometres. Seventy firefighters hosed down buildings and trees as a precaution. A few days later, the evacuation was rescinded and all were allowed back home. The McLure-Barriere, Venables, and McGillivray fires were fully contained by September 14. At the peak of the crisis, they forced 10,000 people from the Kamloops area to abandon their homes.

The Canadian Red Cross, the Salvation Army, and the North Thompson Relief Fund spearheaded by Kamloops businessman George Evans appealed for donations to support the recovery effort. Volunteers offered to rebuild homes. Twenty teenagers held an awake-a-thon instead of the normal end-of-summer sleepover. They collected $225 worth of pledges before staying awake all night for the relief fund. A concert in Kamloops raised more for the wildfire victims. The all-day festival on September 27, dubbed Fire on the Mountain, included performances by Michelle Wright, Beverly Mahood, Matthew Good, Tracey Brown, Lisa Brokop, Chantal Kreviazuk, Natalie MacMaster, Patricia Conroy, Prairie Oyster, and the Moffats. Nearly 20,000 danced into the night. Some musicians played for free. Others gave a portion of their fee to the relief effort. By October, more than $2 million was raised.

The outpouring of generosity was impressive, but the task of reconstruction was, for some, almost overwhelming. The recovery – and healing – is expected to take years.

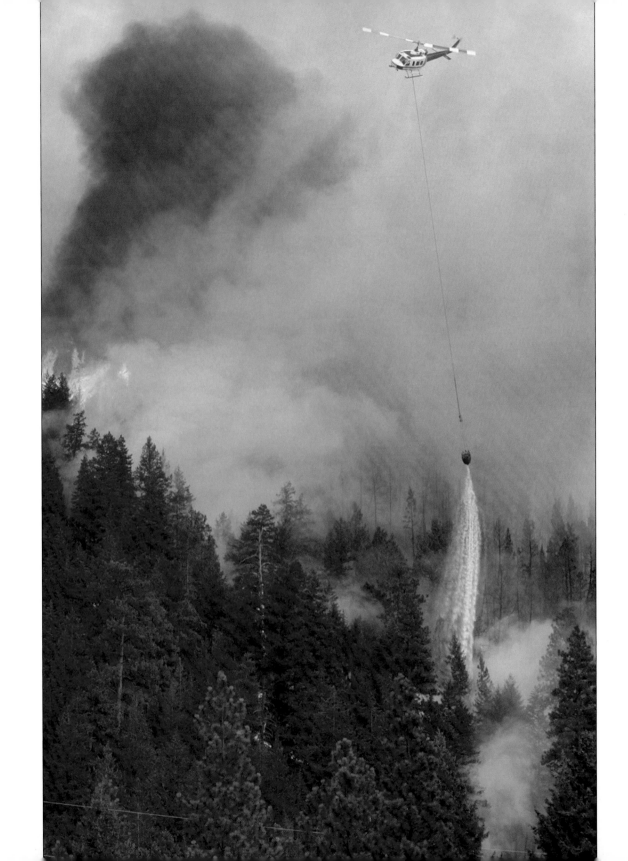

A helicopter dumps a load of water on hot spots at McLure. Helicopters were able to use water from the North Thompson River nearby.

(Murray Mitchell/*Kamloops Daily News*)

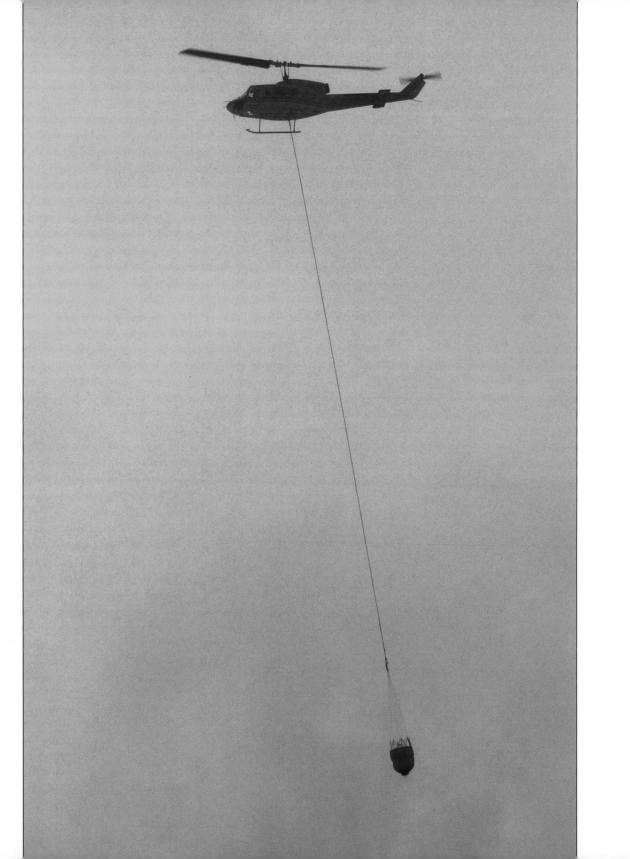

A helicopter carries a bucket of water while battling the blaze near the Tolko Industries Louis Creek sawmill.
(Murray Mitchell/*Kamloops Daily News*)

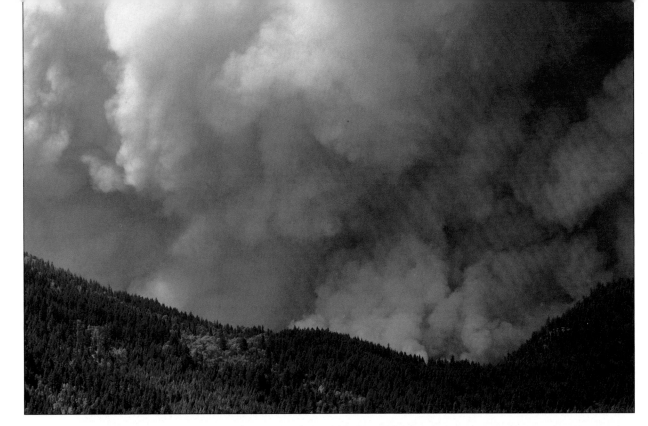

Thick smoke fills the sky above Barriere, as seen from the Heffley-Louis Creek Road in Louis Creek on August 1.
(Murray Mitchell/*Kamloops Daily News*)

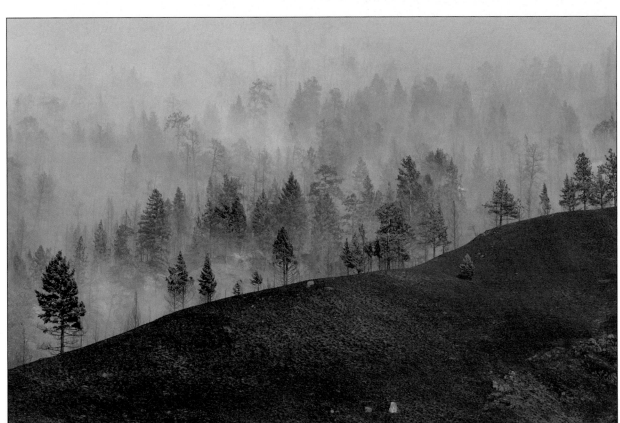

The earth leading up to a smoke-filled forest across from the CN junction in Kamloops is blackened by fire.
(Murray Mitchell/*Kamloops Daily News*)

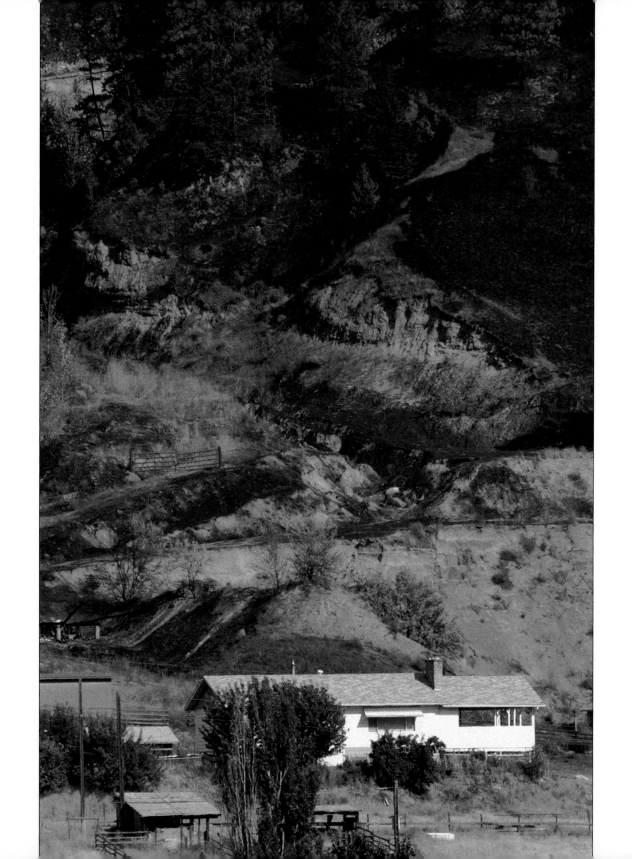

A Rayleigh home was threatened by fire at its back door, but somehow it survived.

(Keith Anderson/*Kamloops Daily News*)

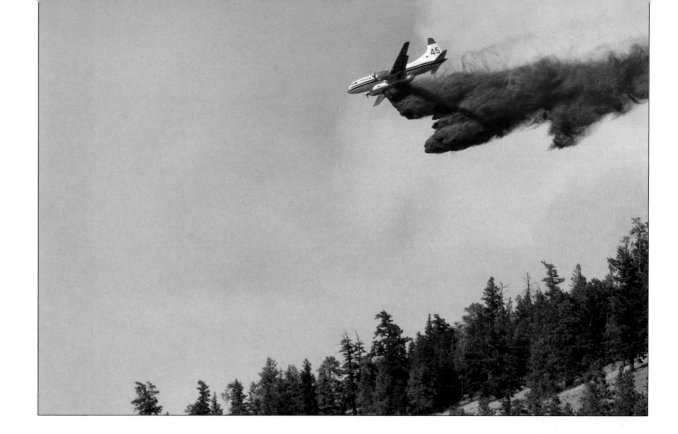

A tanker makes a drop on the edge of the Strawberry Hill fire that is working its way towards the Kamloops neighbourhood of Rayleigh.
(Murray Mitchell/*Kamloops Daily News*)

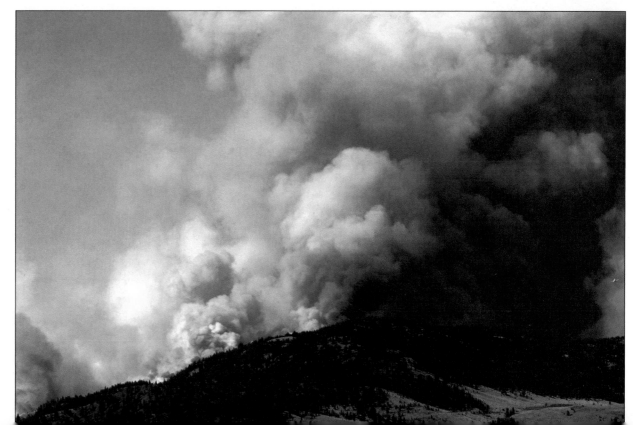

Smoke from the Strawberry Hill fire billows above Mount Paul, which dominates the north Kamloops skyline, after a grass fire spreads into the trees and along the mountainside.
(Murray Mitchell/*Kamloops Daily News*)

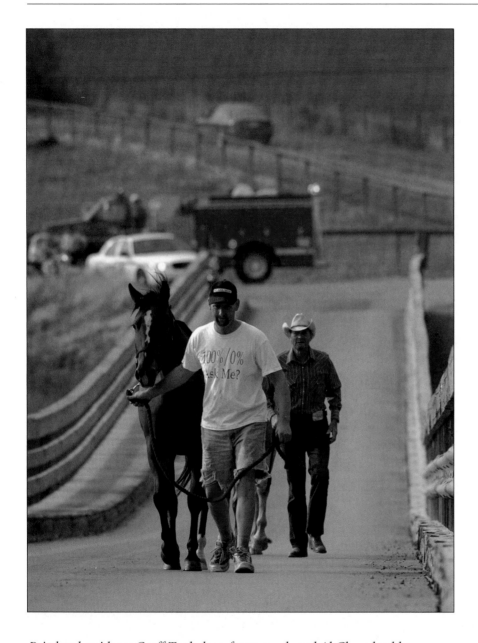

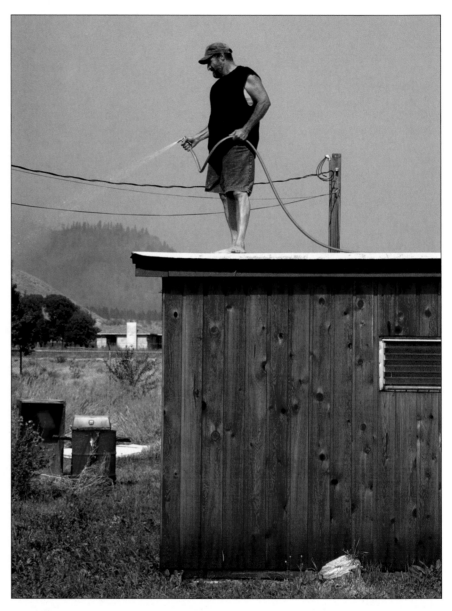

Pritchard residents Geoff Tupholme, foreground, and Al Chase lead horses over the Pritchard Bridge after their community was ordered to evacuate.
(Murray Mitchell/*Kamloops Daily News*)

Robert Beisel wets down his property in Pritchard, shortly before an evacuation order was issued. Beisel was evacuated from another home in Barriere earlier. His mobile home survived the fire but a chicken coop and barn were destroyed.
(Murray Mitchell/*Kamloops Daily News*)

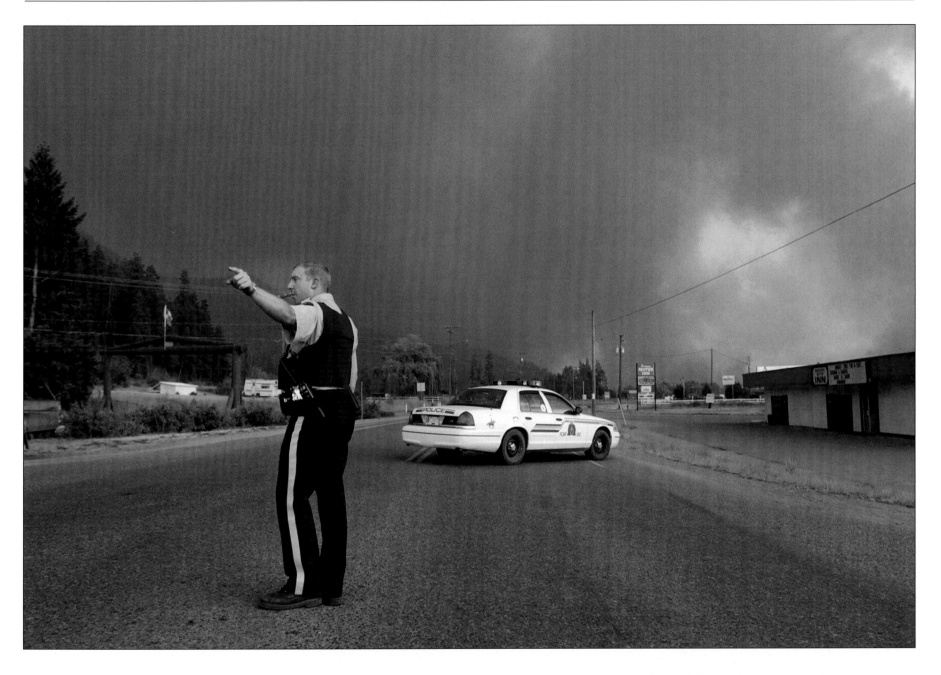

Constable Todd Vande Pol turns traffic away from the advancing wildfire at Barriere on August 1. Residents of the Barriere-Louis Creek area filled their vehicles with photo albums and other mementos before they abandoned their homes. (Robert Koopmans/*Kamloops Daily News*)

A fire engine heads across the Pritchard Bridge, over the South Thompson River, to join the fight against the McGillivray fire after the area was evacuated.
(Murray Mitchell/*Kamloops Daily News*)

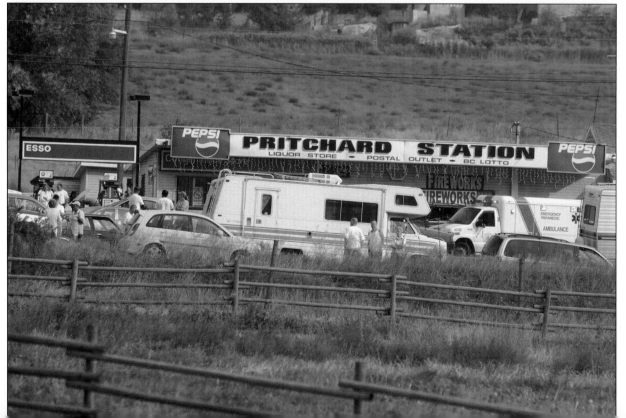

Traffic congestion grows near the Pritchard Station following an evacuation order as the McGillivray fire approaches the community on the South Thompson River.
(Murray Mitchell/*Kamloops Daily News*)

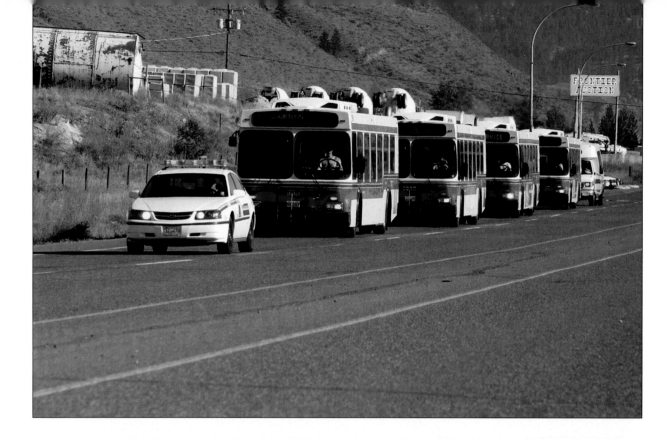

A police cruiser escorts Kamloops city buses to Rayleigh to assist with the evacuation.
(Murray Mitchell/*Kamloops Daily News*)

Police stop traffic on the Yellowhead Highway while crews battle the blaze adjacent to the road.
(Murray Mitchell/*Kamloops Daily News*)

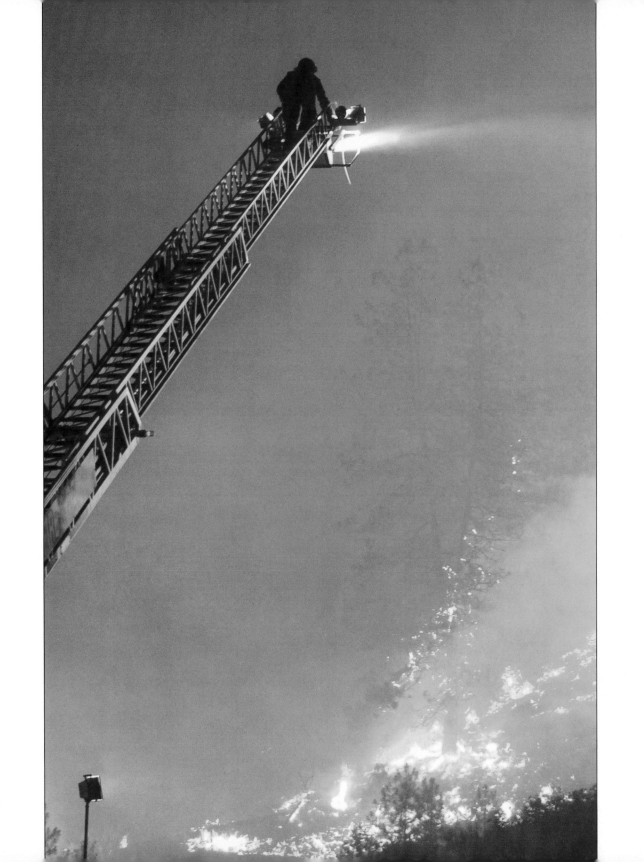

A firefighter sprays water onto the fire in the Westsyde area of Kamloops on August 1.
(Murray Mitchell/*Kamloops Daily News*)

Fire threatens the Tolko Industries sawmill at Louis Creek. The mill was destroyed by the fire and will not reopen.
(Robert Koopmans/*Kamloops Daily News*)

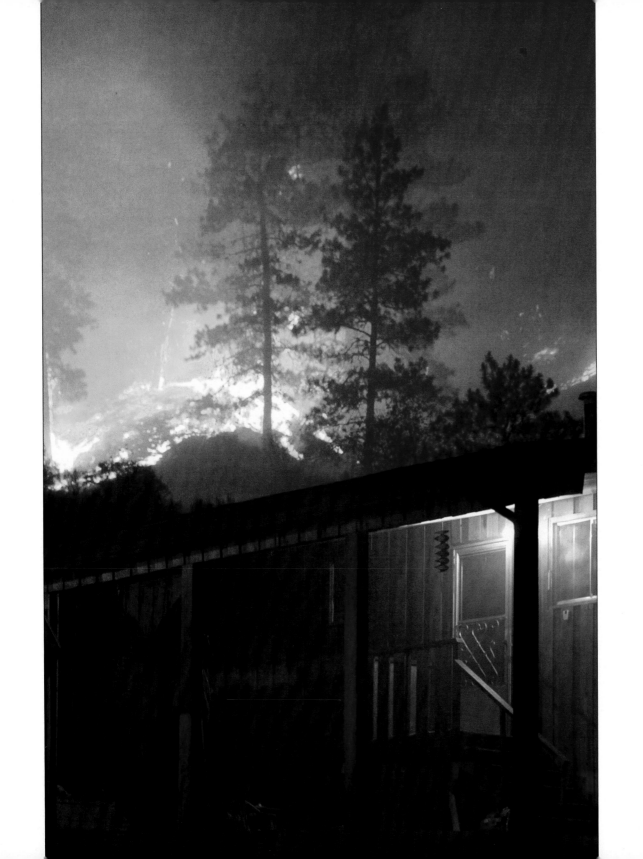

The fire in Kamloops's Westsyde area threatens homes on Rue Chez Nous Road and Kambia Cresent early on August 1. Residents are evacuated while city firefighters and forestry crews battle the fire.

(Murray Mitchell/*Kamloops Daily News*)

Flames move quickly along the ground and in the trees near the CN junction in Kamloops on August 1.

(Murray Mitchell/*Kamloops Daily News*)

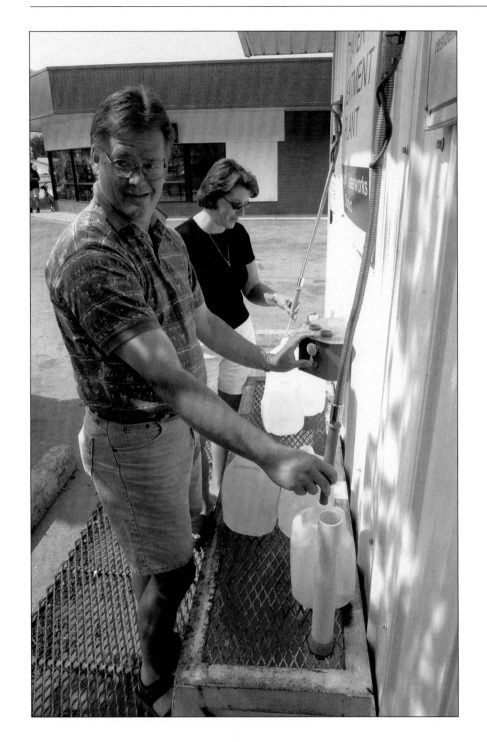

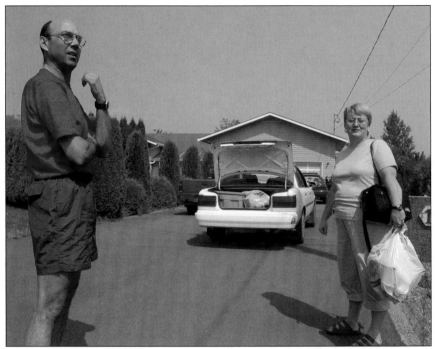

Top: *Bryan and Kim Hurren return to their Rayleigh home after being evacuated because of the Strawberry Hill fire.* (Brendan Halper/*Kamloops Daily News*)
Left: *Rayleigh residents Spencer and Gaylene Woodland stock up on water at the community water-treatment plant after the Strawberry Hill fire made them flee.* (Brendan Halper/*Kamloops Daily News*)

Opposite left: *SPCA volunteer Diane James feeds a baby goat brought in during the evacuation around Kamloops as colleague John Weller, right, lends a hand.* (Keith Anderson/*Kamloops Daily News*)
Opposite right: *Mary Allen of Kamloops gets more affection than she bargained for while playing violin for a horse named Tigger in Kamloops. Allen is helping to soothe some of the sheltered livestock evacuated from the path of the McLure-Barriere and Strawberry Hill fires.*
(Murray Mitchell/*Kamloops Daily News*)

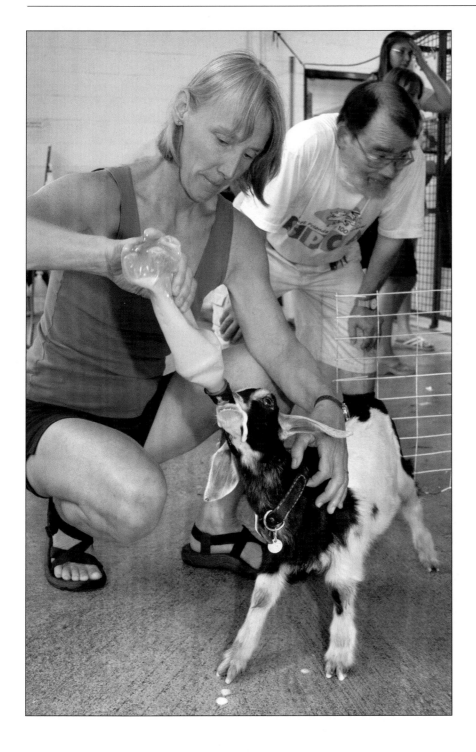

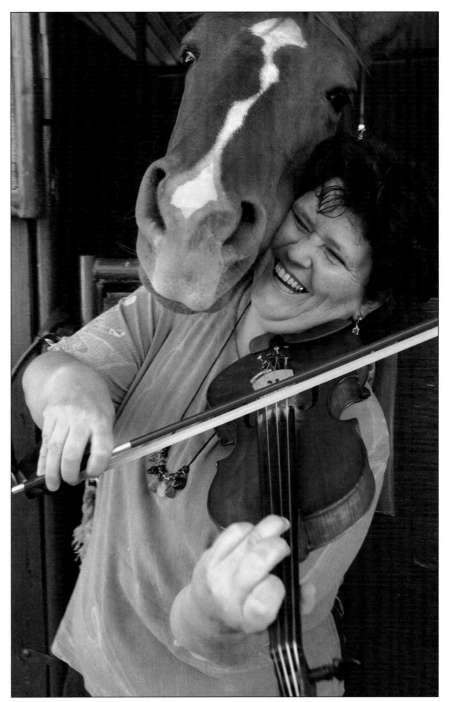

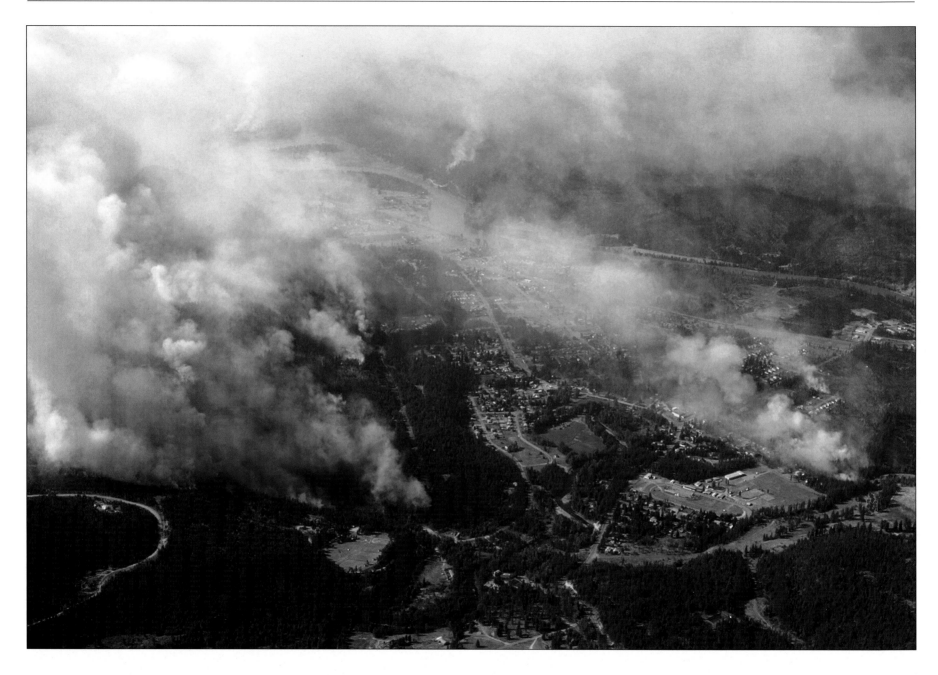

Fires burn in several locations at Barriere on August 2. The area's 2,800 residents were evacuated the day before.

(Murray Mitchell/*Kamloops Daily News*)

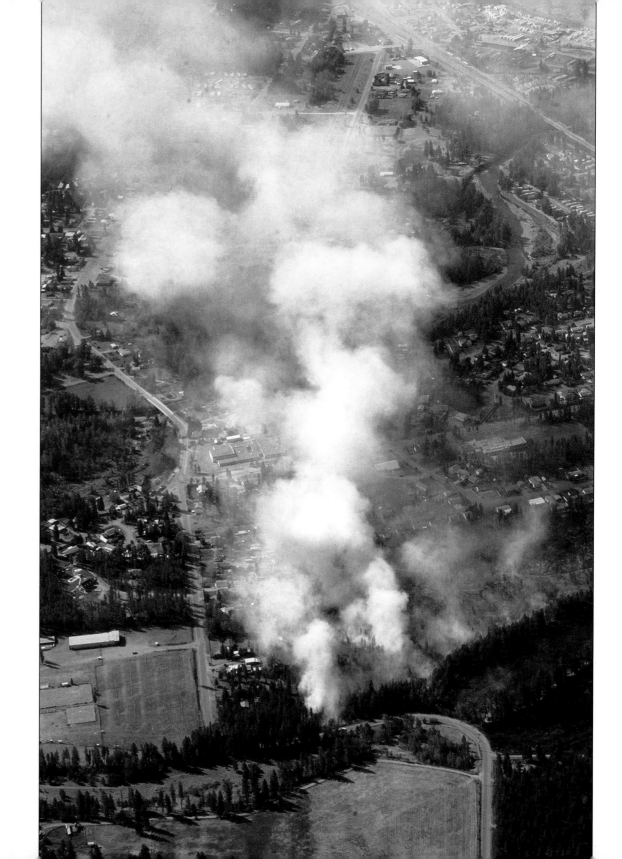

Flames destroyed four businesses in Barriere's industrial district. No homes were lost.

(Murray Mitchell/*Kamloops Daily News*)

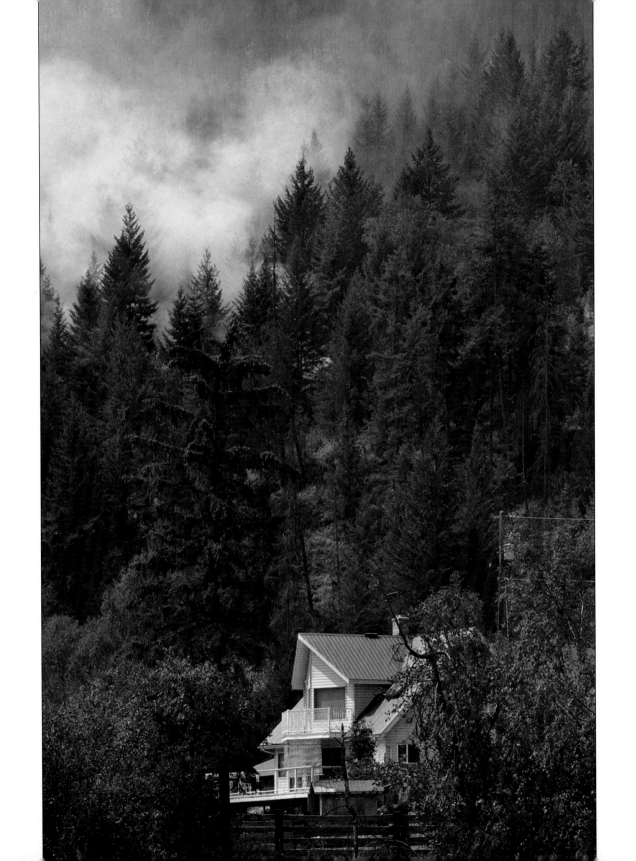

A house near Barriere appears to be doomed as a hot spot ignites trees a stone's throw away. The home was not burned.
(Keith Anderson/*Kamloops Daily News*)

Hot spots in the forest around Barriere make the fire unpredictable. Swirling winds caused flare-ups, creating new headaches for fire crews.

(Keith Anderson/*Kamloops Daily News*)

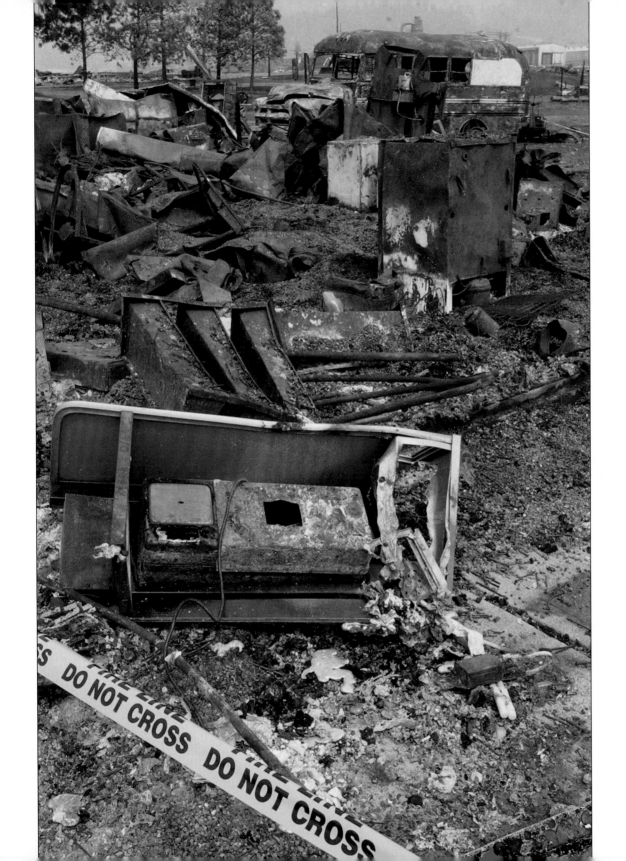

A convenience store at Louis Creek was among the structures consumed by fire.
(Murray Mitchell/*Kamloops Daily News*)

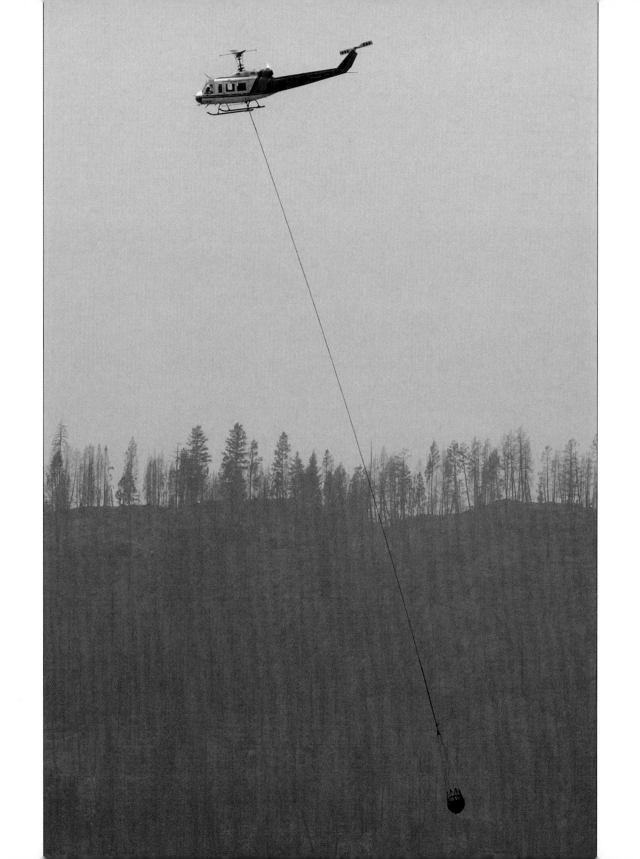

A helicopter scoops water from the
North Thompson River in Barriere
before dumping it on the fire nearby.
(Keith Anderson/*Kamloops Daily News*)

41

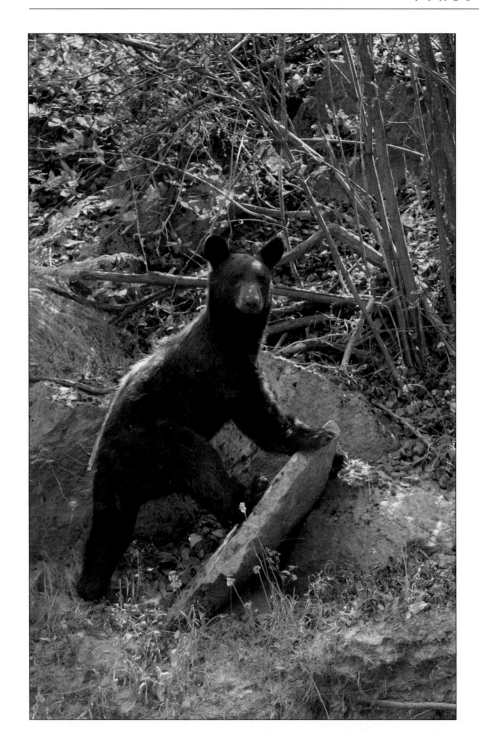

*A black bear yearling runs along the
North Thompson River trying to escape
the fire near Louis Creek.*
(Keith Anderson/*Kamloops Daily News*)

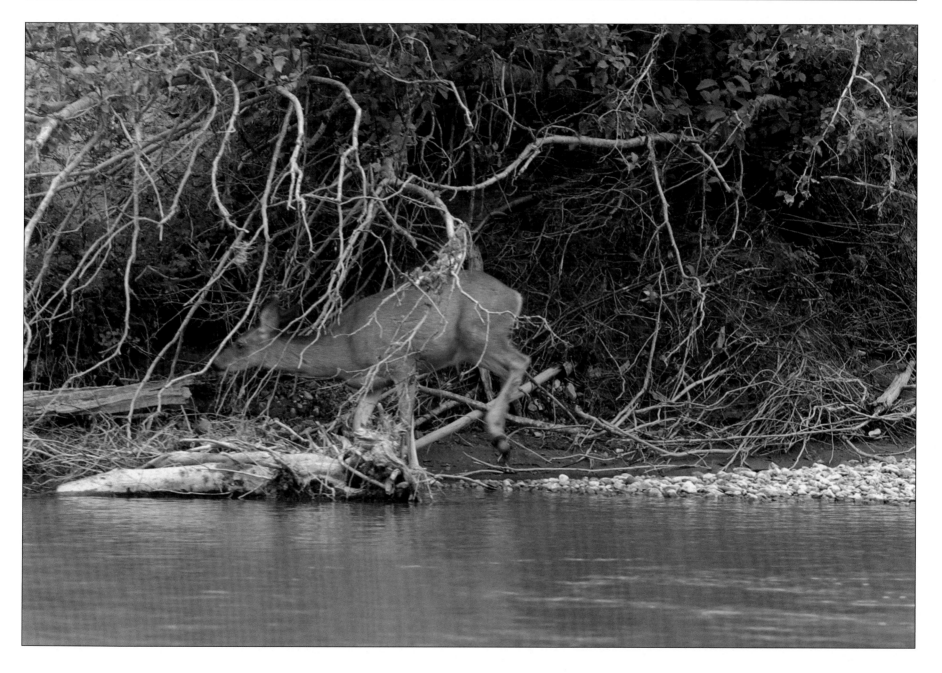

A mule deer scampers along the North Thompson River near McLure as the hillside fills with smoke.

(Keith Anderson/*Kamloops Daily News*)

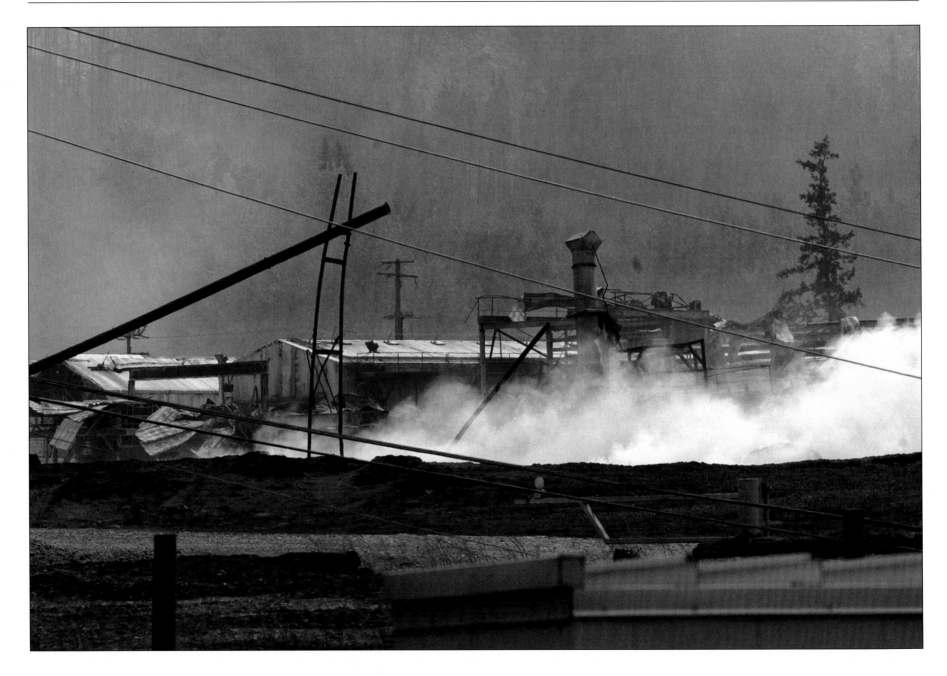

The Tolko Industries sawmill still smoulders after fire raged through the area on August 4.
(Keith Anderson/*Kamloops Daily News*)

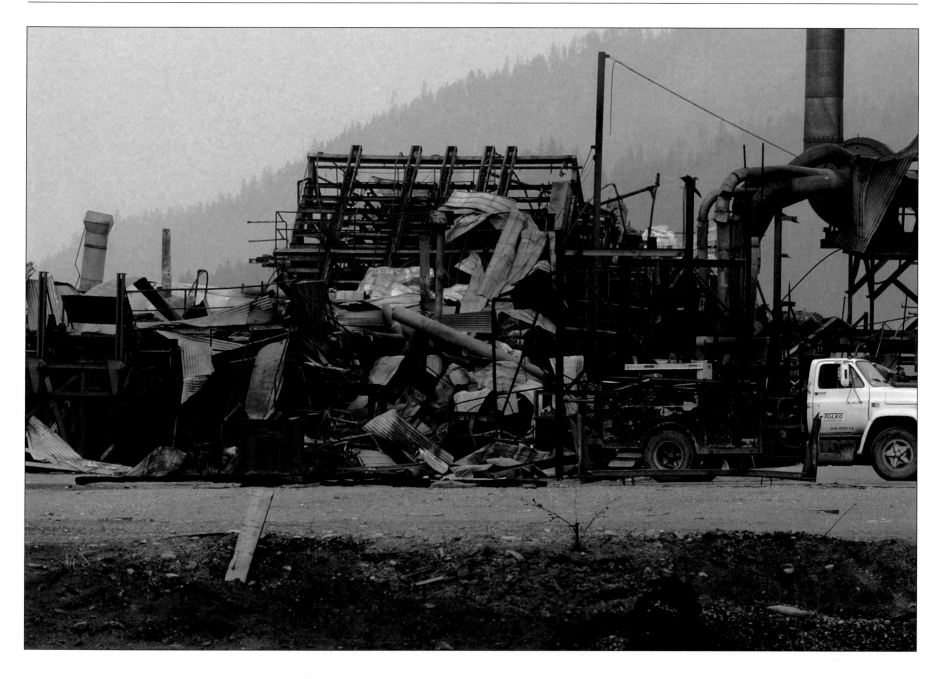

The Tolko Industries sawmill resembles a scrapyard after the fire.
(Murray Mitchell/*Kamloops Daily News*)

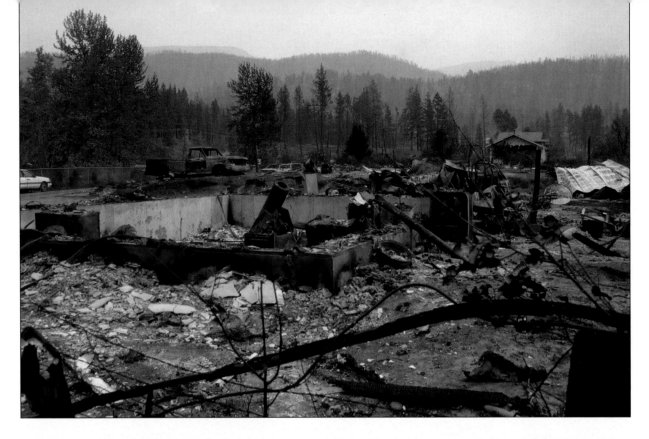

Remnants of a home on First Nations land in the Barriere area. The fire burned around many homes; others were less fortunate.

(Keith Anderson/*Kamloops Daily News*)

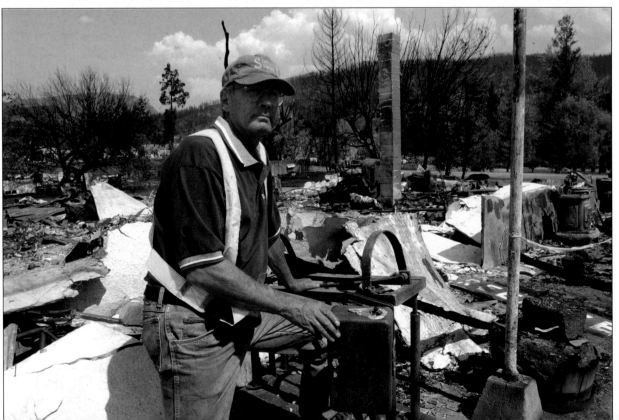

Rob Rutten, owner of Country Antiques in Louis Creek, lost his home and store in the fire. He stands next to the coin-operated horse ride that sat in front of his store.

(Murray Mitchell/*Kamloops Daily News*)

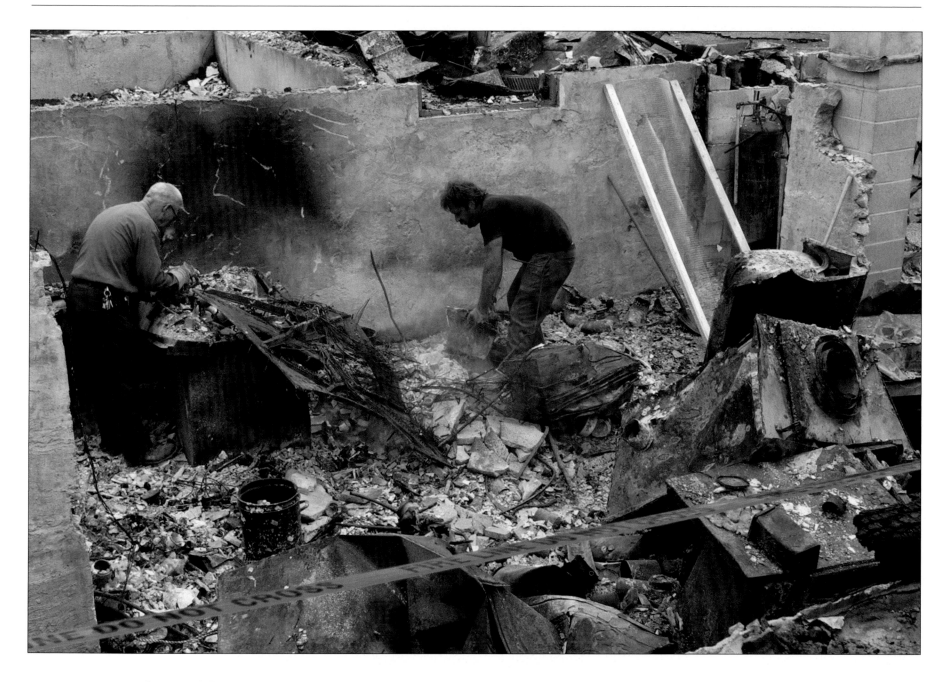

Tom Thomson (left) and another man sift through the remains of the home Tom and his wife, Joan, had moved into just weeks before.
(Murray Mitchell/*Kamloops Daily News*)

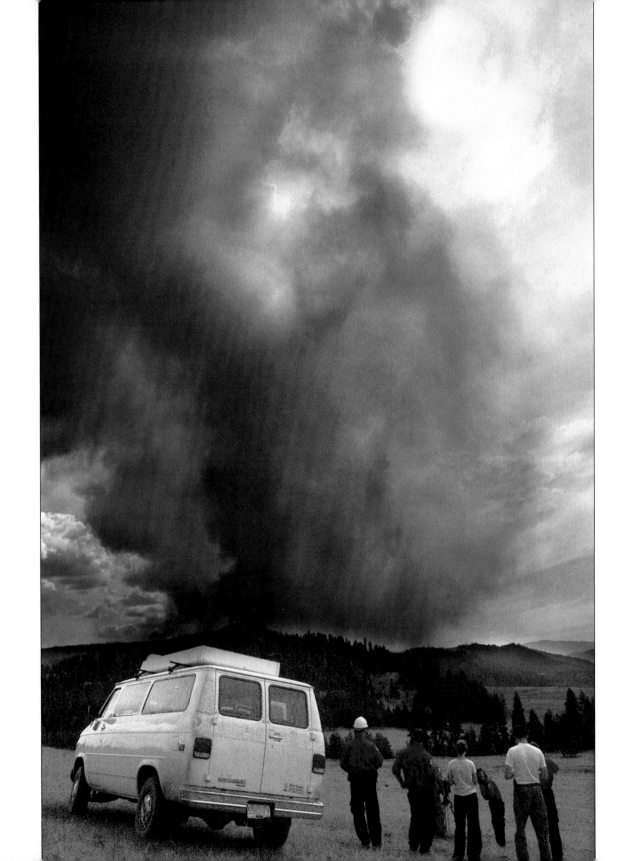

48

Smoke fills the sky above the Strawberry Hill fire in Kamloops as reporters tour the area.
(Keith Anderson/*Kamloops Daily News*)

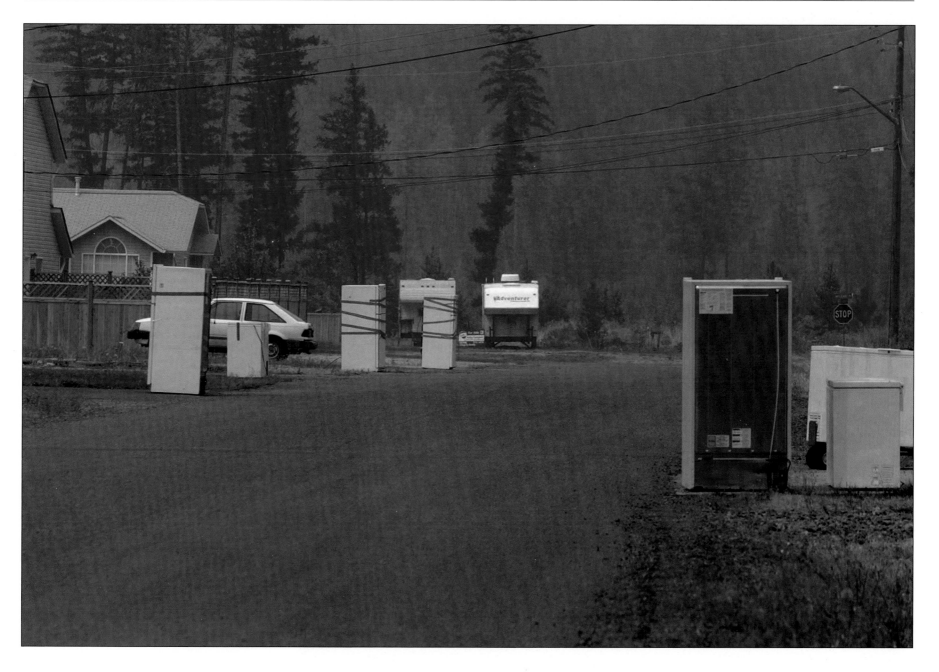

Discarded freezers and refrigerators awaiting disposal line a street in Barriere. Health officials advised homeowners to seal the appliances after a long power outage tainted the food. (Brendan Halper/*Kamloops Daily News*)

Shuswap search-and-rescue team members get help from crews in Kamloops, Vernon, and Kelowna as they distribute evacuation information to residents of Chase.
(Murray Mitchell/*Kamloops Daily News*)

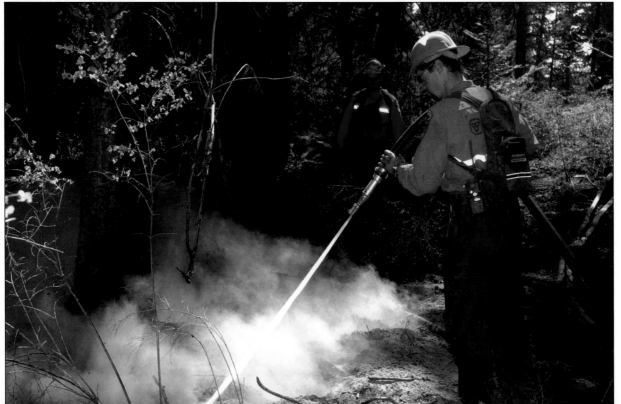

Forestry firefighter Tyler Smith aims water at tree roots burning beneath the soil while fighting the Strawberry Hill fire.
(Murray Mitchell/*Kamloops Daily News*)

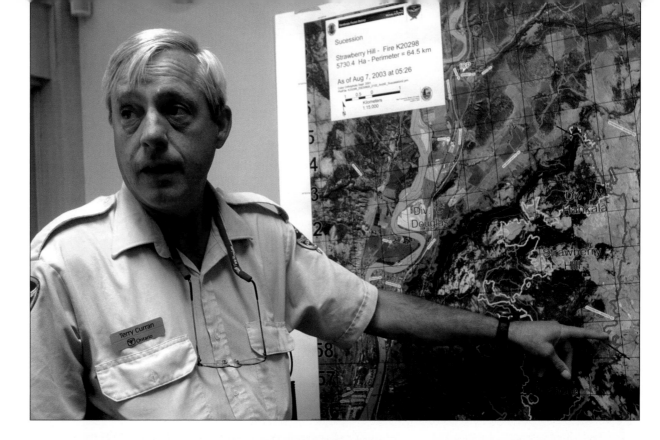

Terry Curran points to a map showing the Strawberry Hill fire perimeter at the temporary command centre set up in Heffley Creek Elementary School.
(Murray Mitchell/*Kamloops Daily News*)

Wilf Bennett, a rancher with a home and property on the north side of the South Thompson River, watches the McGillivray fire with concern from the Chase Petro-Canada station.
(Murray Mitchell/*Kamloops Daily News*)

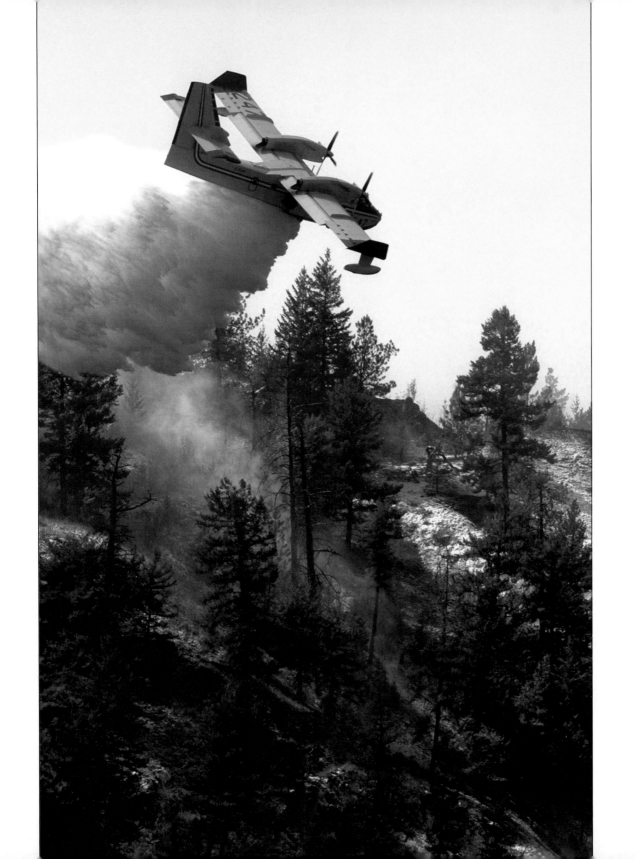

An air tanker drops foam and water on a fire moving towards Pritchard, near Kamloops. Several air tankers and helicopters were attacking the fire, which prompted an evacuation order for 850 people in the area.
(Murray Mitchell/*Kamloops Daily News*)

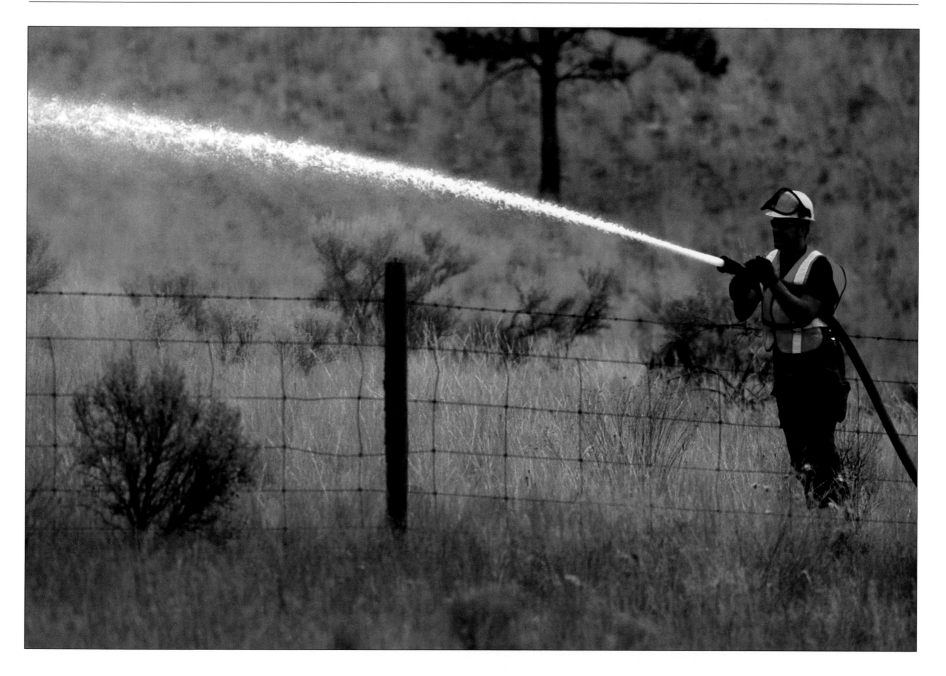

A firefighter soaks grass and brush along the east side of the Trans-Canada Highway, south of Cache Creek, near Kamloops, in an effort to halt the progress of the Venables Valley fire. (Brendan Halper/*Kamloops Daily News*)

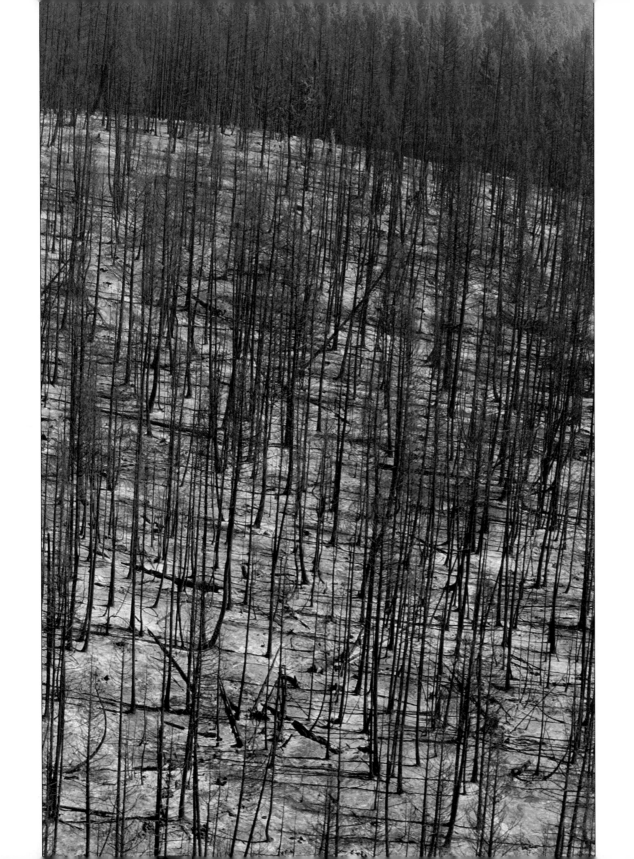

The Strawberry Hill fire was selective – it left some patches of forest intact while destroying others.
(Murray Mitchell/*Kamloops Daily News*)

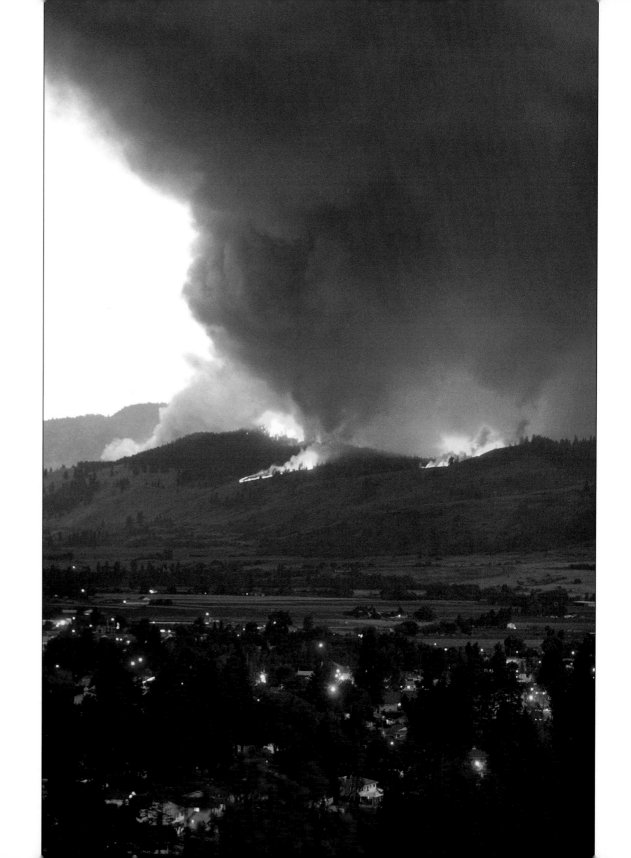

A forest fire rages near Niskonlith Lake
as it works its way towards Chase, B.C.
Residents were told to be ready to evacuate.
(Murray Mitchell/*Kamloops Daily News*)

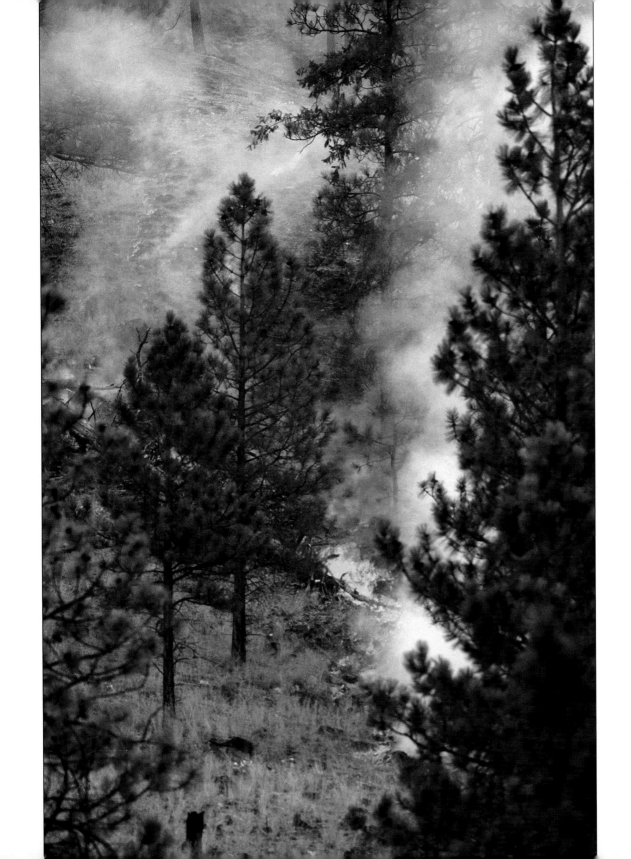

Flames from the Venables Valley fire burn close to the east side of the Trans-Canada Highway, south of Cache Creek, near Kamloops.
(Brendan Halper/*Kamloops Daily News*)

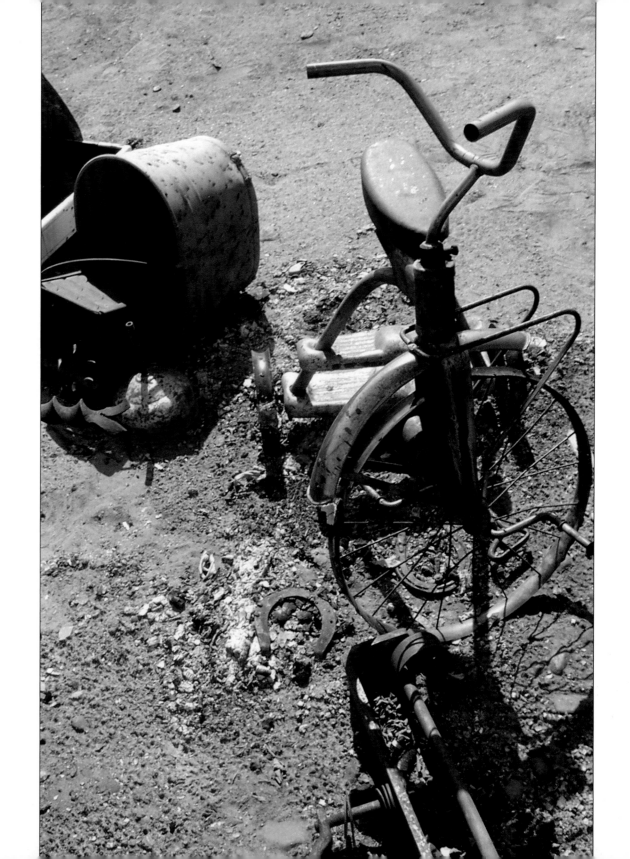

Only the frame of a child's tricycle remains after fire ripped through the community of Louis Creek.
(Keith Anderson/*Kamloops Daily News*)

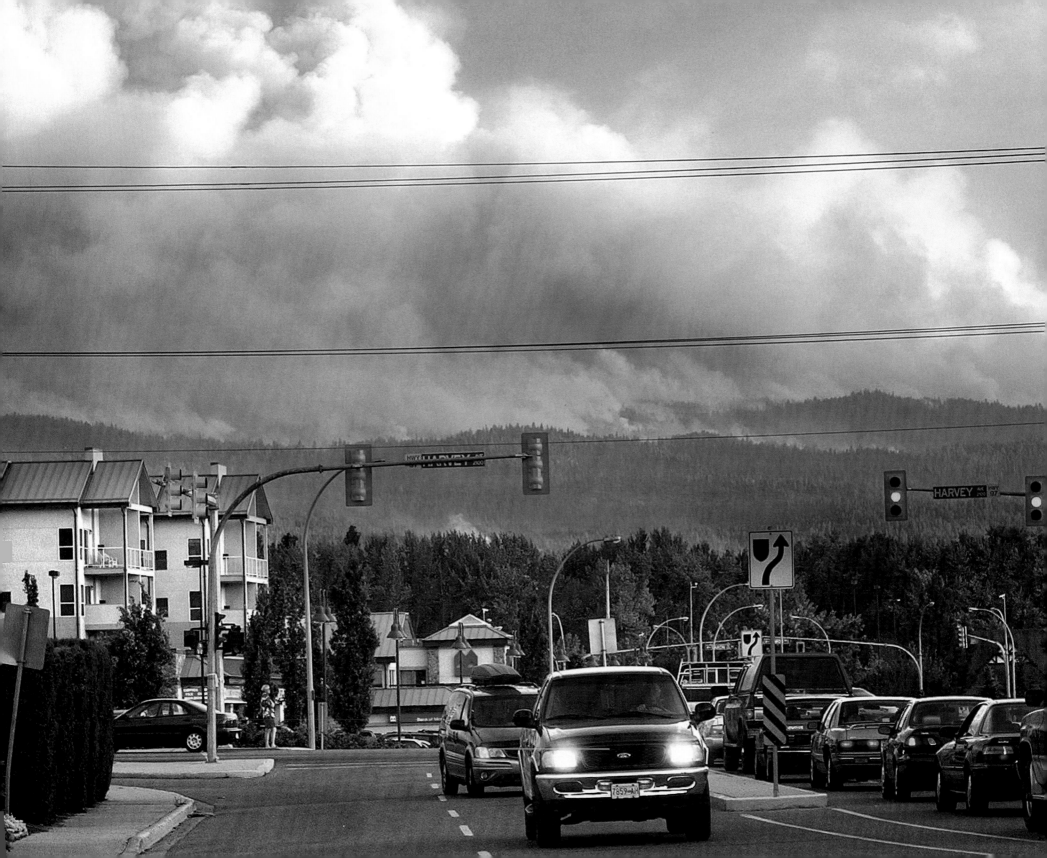

KELOWNA

The Okanagan Mountain Park Fire

A lightning bolt that struck a single tree ignited the most destructive fire in Canadian history.

The fire near Squally Point in the southern part of Okanagan Mountain Provincial Park was spotted by residents across Okanagan Lake soon after the lightning strike at 2:00 in the morning of August 16. Five hours later, the flames had burned 10 hectares of fuel – the dry detritus that had built up on the forest floor over several decades. Two helicopters, three CL 415 air tankers, and ground crews were called in to douse the forest. But a second fire that broke out near Chute Lake 10 kilometres away, and new flare-ups north of Kamloops, forced authorities to divert the air tankers from the Okanagan blaze before noon.

The wind picked up at 12:30 in the afternoon, driving spot fires ahead of the main fire. By the time air tankers returned at 2:00, the flames had exploded across the rugged terrain. The next morning it covered 1,000 hectares. Within four days, the Okanagan's largest park was destroyed. The out-of-control monster ran amok. Swirling winds were pushing it north and south, propelling the inferno at up to 50 metres a minute. In one day it grew from 2,000 hectares to more than 11,000. Firefighting conditions were the worst fire officials had ever seen.

The steady meal of brush and trees made the fire's growth unstoppable. Flames soared 60 metres into the air. Soon they were threatening hundreds of homes and vineyards in Kelowna to the north and Naramata to the south. Ash floated downwind on residential streets ten kilometres from the flames. Residents compared the towering columns of fire and smoke to the gates of hell. The park's steep, rocky ridges frustrated fire crews, who were unable to get their equipment close to the flames. Air tankers and helicopters dropped fire retardant and water. Ground crews bulldozed trees and brush to create a new 17-kilometre-long strip of bare earth along Kelowna's southern flank, but the gusty winds were too powerful. The fire eventually stormed across the 50-metre-wide fireguards and surrounded Chute Lake Lodge, a historic fishing resort just east of the park. Forestry crews managed to save the resort, but there were no breaks in the forest to stop the flames from advancing on Kelowna.

Residents in the city's southern neighbourhoods cleared away pine needles and ran sprinklers on the roofs before fleeing from their homes. Staff at the Cedar Creek winery cut a fireguard 12 metres wide around the

◀ *Traffic moves along Dilworth Road at Highway 97 as the Okanagan Mountain Park fire burns in the background.* (Gary Nylander/*The Daily Courier*)

vineyards. People with breathing problems left town. Insurance companies stopped accepting new applications from homeowners living within 50 kilometres of the fire. By August 21, trees exploded ahead of the advancing front and burning embers rained on city streets. Authorities ordered the evacuation of 10,000 residents living near Kelowna's southeastern edge, and another 50 families from homes north of Naramata. Emergency workers went from door to door, warning residents to leave within minutes. Some left the front door wide open in their haste to depart. The evacuation caused organized panic as traffic jammed the few Kelowna roads leading out of the area. Displaced homeowners, some in tears, poured into disaster-relief centres. Fear and sadness were palpable as smoke and a surreal glow hung over the valley. The front was advancing at a diagonal down Okanagan Mountain towards the lakeshore and the Timberline area at the city's southern rim. People pulled off Highway 97 west of Kelowna for a sweeping view of the inferno. They spoke in soft voices as if at a funeral. The reality was clear. It wasn't just trees that were burning.

The Rimrock and Timberline Road Fires

On August 21, the Okanagan Mountain Park fire was licking at the fringes of Kelowna and Naramata. It had destroyed 6,000 hectares and forced the evacuation of 47 homes in Kelowna, with 1,000 more families ready to flee on short notice. But the fire was still far from the city's heart. Then the teasing stopped: after a day of comparative calm, when conditions seemed to favour the city's defenders, the enemy smiled and struck.

The source of the fire's singular intensity can be explained by the topography peculiar to the lakeside town of Peachland located opposite Okanagan Mountain Park on the Trepanier Bench. Inversions often whip the cool air from the Pacific and push it across Okanagan Lake, where it hits Squally Point, splits, and becomes a double-headed dragon. One flies south towards Penticton and the other rushes north to Kelowna. On this day, the Kelowna-bound wind lashed the fire into a frenzy. There was nothing firefighters could do as it leapt the 50-metre fireguard and turned water from their hoses to steam. Belching flame, the beast embarked upon a seemingly random repast. Some houses not to its taste were left standing, while others were obliterated in a terrible, fiery feast. Flames destroyed one truck but left another pickup rearby unscathed. They consumed one house and left the "For Sale" sign standing. The smoke was so thick that firefighters were unable to see the flames until they got up close. The fire was a twisting orange beast. In its wake were only the black-and-grey bones of charred trees, wind-whipped seas of fine ash, and the naked foundations of 15 homes.

"This fire was extremely hot," said Patrick Crane of the Kelowna Fire Department. "Firefighters on structural fires aren't used to heat like this. Their adrenaline was pumping." Seventeen houses were spared. The house at 183 Timberline Road was gone, while the house next door – 50 metres away – showed no damage. Near the top of Timberline, a house and garden were destroyed but a garden shed a few feet away looked good as new. Under the shed's metal roof were shovels and bedding trays; a paper calendar hung from a hook on the wall. At the Lastwithiel Bed and Breakfast, the flames had encircled the building but stopped just short of the front door. Other homes were so thoroughly incinerated that what did survive – often little more than the stove and fridge – fell into the basement. When the chimney of one house collapsed, some of the fireplace stones were so hot that they popped open like popcorn. In what was once a garage, a boat had melted into an unrecognizable blob of fibreglass. A metal steering wheel was its most identifiable feature. A

family of gardeners kept dozens of plastic flowerpots in a fenced enclosure to keep deer out. The pots had disintegrated, leaving moulded clumps of dirt still standing upright. The remains of a cement mixer were parked in front of the house, testimony to a home-improvement project for which there was no longer a home. A truck sat burned in a driveway while a utility trailer a few steps away was intact.

Firefighters were taken aback by the speed of the fire. "This is something none of us has ever seen before," said Kelowna Fire Chief Gerry Zimmermann. "We were talking about doing a back burn when all of a sudden the wind shifted. The next thing, our men were running out." The following afternoon, Zimmermann delivered the bad news to the 15 families left homeless. They gathered with neighbours at Trinity Baptist Church, where the chief fought back tears as he read aloud the doomed addresses. Residents consoled one another and promised to restore the neighbourhood to its former dignity. A city reflected on the heavy loss. But the worst of the fire's fury was still to come.

The Firestorm of August 22

No one was prepared for the horror of the firestorm on the night of Friday, August 22. Southwest winds gusting up to 70 kilometres per hour whipped the Okanagan Mountain Park fire into a new fury, forcing the evacuation of another 17,000 people. Nearly a third of Kelowna residents were now barred from their homes. Firefighters described the front as a war zone. Flames shot more than 100 metres above the trees. The rank-six fire – the most dangerous – charged across the city's South Slopes at 100 metres a minute. The damage covered an area of 170 square kilometres, and growing. A hundred elderly residents of the Sutherland Hills Rest Home were evacuated to Vernon, Armstrong, and Enderby, some by ambulance. People in Black Mountain and southeast Kelowna were ordered to boil their water because firefighters removed chlorine cylinders in the fire's path. Traffic across Okanagan Lake Bridge to the west side was backed up more than a kilometre because only one outbound lane was open. More than a thousand motorists trying to leave the city inched along, moving the length of a city block every 15 minutes.

The fire roared into neighbourhoods as if they were part of the forest. Gusts blasting out of the southwest sent the flames into subdivisions willy-nilly, laying waste to million-dollar houses and property. They raced up the steep hillside of Crawford Estates and eliminated 68 homes. They ignited whole city blocks, destroying houses on Okaview, Viewcrest, Curlew, and Chute Lake Roads, and in the Kettle Valley subdivision. In one night, 223 homes were razed. The fire obliterated a $250,000 playground in Kettle Valley, destroyed the St. Hubertus winery, and ruined much of a popular Boy Scout camp. Insurance payouts were expected to far surpass $100 million.

The fire created its own swirling currents. A curve in the road, a hill, or gully was enough to steer it in a new direction. The flames often leapt from treetop to house, passing over gardens, lawns, and shrubs. Only a chimney stood on a green property that looked otherwise pristine.

In two instances, firefighters were trapped by the fire. Eight hunkered down on a treeless lawn in Bertram Creek Regional Park as flames raced up both sides of Lakeshore Road. Soon the fire came above them, surrounded the lawn, and continued to move ahead. The men and three vehicles were encircled, with no escape route. "It was warm," said Lieutenant Brian Minchin, a task-force commander with the Kelowna Fire Department, but he didn't feel threatened. A crew on board a fire-department rescue boat waited just offshore but the fire burned between them. The firefighters waited 20 minutes until the inferno surged north

along the lake and uphill towards the Kettle Valley subdivision and Okaview Road. Within an hour, the fire levelled a row of seven lakeshore houses but left the eighth home unscathed. Minchin drove a bush truck north on Lakeshore Road while the others headed south in the other vehicles towards the Rimrock area. He manoeuvred the vehicle into the ditch to avoid the downed electrical wires and deadfall. When he realized he could get through, he doubled back to rejoin his men and led them out. Other emergency crews accompanied Minchin's convoy. The crew driving in a Kamloops truck used wire cutters to clip the fallen wires and clear a path. An air tanker dropped red retardant along the road as the vehicles passed. The fire crews continued on to Crawford Estates, where they resumed the business of foaming more houses.

About 25 firefighters were cornered in the Kettle Valley subdivision after flames blocked their exit. Homes exploded as flames leapt around them. A group retreated towards a playground, which they designated a safety zone. There they met other stranded firefighters. Instead of waiting it out, they ran hoses off the hydrants, started dousing three burning houses, and jumped on smaller fires. One firefighter said the burning embers were like rivers of sparks flowing down the street. When the fire burned past the road, they drove out unharmed.

City utility crews struggled to keep firefighters' hoses filled with water. Electrical workers scrambled to restore power so that the pumps would continue to supply water to the hydrants. One operator kept a Stellar Drive pumphouse running by hand as houses burned nearby. As houses collapsed, the heat melted the water lines supplying them. Precious water was leaking underground and depleting the pressure firefighters needed. Utility staff used metal detectors to locate the valves and shut them off.

Two hundred and fifty Forestry firefighters had to withdraw from the inferno. City firefighters trained to protect houses had to hit the ground because the smoke and flames sucked up the oxygen. When they stood up, homes were burning from the ground to the rooftops. In less than half an hour, houses built on the forest's edge were collapsing. Trees candled and burned like torches. "There is nothing you can do to fight a fire like this. It's a once-in-a-lifetime fire. We've never had a fire sweep through a community like this," Forestry Information Officer Kevin Matuga said at the height of the crisis.

The city firefighters didn't know where to turn. When possible, they concentrated their hoses on the homes still standing at the ends of burning blocks. When it got too dangerous, they retreated to open fields. After regrouping, they went back into the burning neighbourhoods. Occasionally, they had to make a tough decision – one side of the road they would surrender to the fire, the other side they would try to protect. Three city firefighters lost their houses that night, but worked anyway.

The next day, calm winds and cooler temperatures allowed reporters to be taken in for their first look. They were struck by the same erratic pattern of destruction that marked the Rimrock and Timberline fires: one house levelled while the gazebo with the shake roof next to it looked exactly as it had the day before. The stucco of houses sometimes remained standing after the wooden structure that had supported it was gone: one light shove against the stucco could topple it. A blackened bicycle frame stood on its kickstand. A plastic *Daily Courier* newspaper box was melted, but inside the paper was unscorched. Garden daisies were still yellow but crumbled to powder at a touch.

Residents assembled for the second dose of bad news at Trinity Baptist Church. Neighbours were asked to sit next to one another to comfort those who had lost their homes. They gave Chief Zimmermann a standing ovation when he walked onto the stage. Then officials handed

out manila envelopes containing the doomed addresses. Psychologists began counselling the newly homeless.

Favourable weather over the next few days kept the fire from causing any new damage and gave the city a short reprieve. All over town, firefighters, soldiers, and emergency crews were hailed as heroes. Without them, hundreds more homes would have been lost. Hand-painted messages of gratitude and yellow ribbons sprang up on streets all over town. But the fire was still out of control, encompassing 190 square kilometres. The relentless drought and forest fuels continued to feed the dragon, with no rain in sight.

Counting the Losses

Fire crews took advantage of the lull and doused hot spots still smouldering in burned-out neighbourhoods. The roots of trees were burning. With fresh soldiers at their disposal, Forestry bosses gave some of their battle-weary staff a break. Three hundred and fifty regular forces and reservists helped to defend the fire's perimeter, building control lines and reinforcing them by burning fuels near the most active areas. A thousand troops had arrived by August 25. They set up green tents in Kelowna's Apple Bowl as if it were a compound in Bosnia. Hundreds of firefighters from across Canada, Alaska, Oregon, and Idaho joined the battle. Fire stations became parking lots for trucks from all corners of B.C. and Alberta.

The 20,000-hectare Okanagan Mountain Park fire was 40 per cent contained. Prime Minister Jean Chrétien was on political business in Nunavut when he made a sudden visit to Kelowna August 24. He spent several hours shaking hands and meeting people who had fled their homes. Chrétien expressed his shock after he flew over the fire and saw some of the damaged neighbourhoods. He promised federal aid at a news conference before flying out that afternoon. The visit lifted the spirits of emergency workers.

The fire continued advancing eastward. Thousands of evacuees living farther from the hottest areas were allowed to return, but 16,000 people remained out of their homes. Eighty per cent stayed with friends or family and 15 per cent were put up in hotels and motels. Others moved into Skyreach Place, or a youth centre at Trinity Baptist Church, or simply left town. Utility crews slowly restored power and water to burned neighbourhoods. Residents were bused in to see the destruction, estimated at $160 million in lost property and contents. Many felt better after having seen that their homes were razed: they could not accept the loss until they saw it for themselves. Most were covered by insurance and vowed to rebuild.

The city's gratitude for the work of the emergency workers reached a fever pitch. An offhand remark by Chief Zimmermann that he and his men could use a cold beer led to a flood of suds being delivered to the main fire hall. Kids showed up at the hall with chips, cookies, and more beer. Residents drew huge "Thank You" signs on the roads. People lined up to buy commemorative T-shirts and hats. The proceeds went towards fire relief.

As more evacuees were allowed to return home, the flames closed in on the Myra Canyon trestles, a popular tourist attraction that comprised part of the historic Kettle Valley Railway. These trestles were upgraded in the 1990s to allow cyclists, hikers, and horseback riders to enjoy sweeping views of the canyon. Fifty thousand tourists a year visited the Okanagan for the chance to travel the railbed and cross the 18 trestles, which had recently been designated a National Heritage Site. Sixteen of the 18

bridges were made entirely of wood, coated with flammable creosote, and built above steep canyons where fire could spread quickly. Helicopters dropped foam and fire retardant to protect them, but brisk winds whipped the fire across guards in five places on September 1. Two days later, 3,200 people were ordered out of their homes in southeast Kelowna, a few kilometres from the trestles, for the second time. The fire later swept into Myra Canyon, where it overpowered the defensive efforts of firefighters, and vaporized six of the railway trestles. By September 12, another six had been destroyed.

Losing the trestles was a blow to both the community and the firefighters. Tour operators and hoteliers in Kelowna and Naramata saw tours cancelled and much of their livelihoods vanish. Premier Gordon Campbell and Rick Thorpe, the minister responsible for tourism, promised to rebuild them. Federal Heritage Minister Sheila Copps pledged federal aid in the restoration and suggested A-list Canadian musicians stage a benefit concert to raise funds for the project. Vancouver rocker Bryan Adams announced he would perform in Kamloops, Kelowna, Prince George, and Vancouver in November, with a portion of the ticket price earmarked for fire relief. Engineers inspected the six remaining trestles and declared that the others could be rebuilt for about $15 million. The Myra Canyon Trestle Restoration Society predicted reconstruction would take at least two years.

Rain allowed all evacuees to return home and prompted the province to ease its restrictions on back-country travel on September 8. Fire-relief fundraisers to help those hardest hit were in full swing. By October, the Canadian Red Cross had collected more than $3 million for fire relief across British Columbia. Local organizations raised more than $700,000. Scores of stricken homeowners were starting to rebuild.

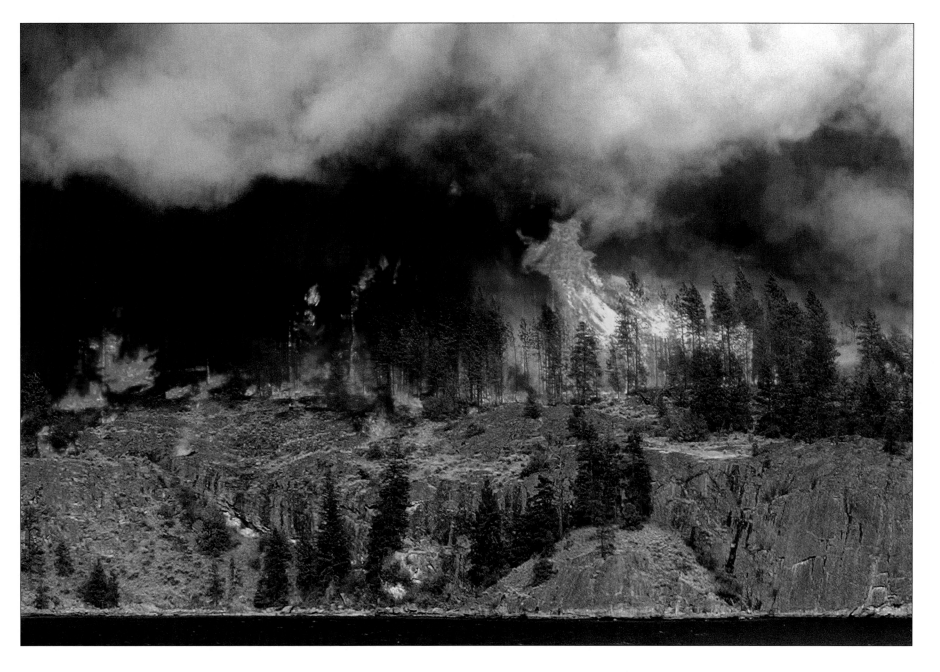

The Okanagan Mountain Park fire breaks out on August 16.
(Gary Nylander/*The Daily Courier*)

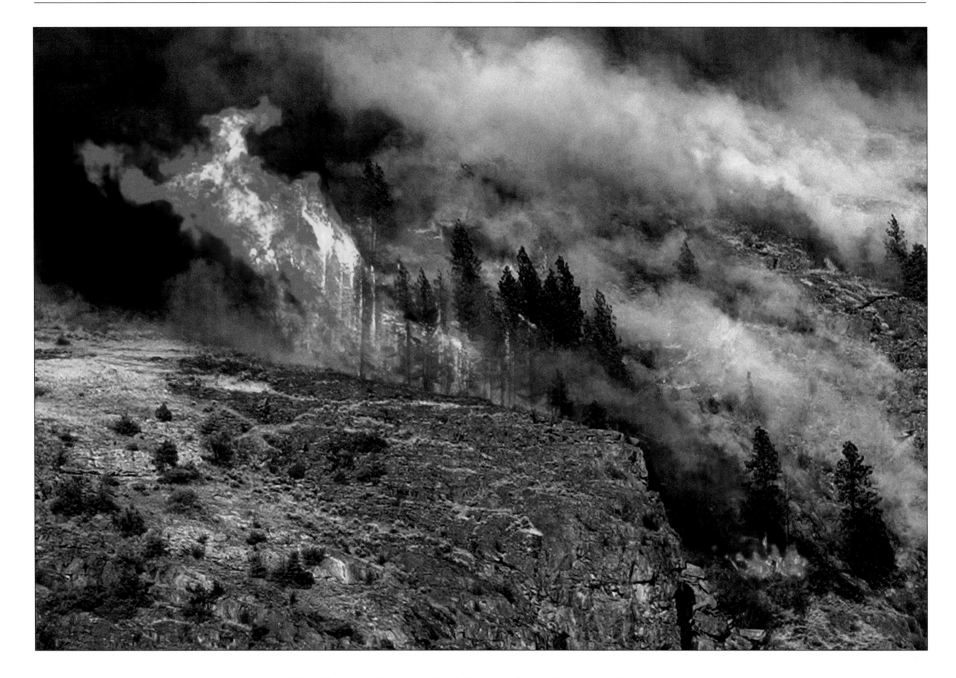

The Okanagan Mountain Park fire spreads up the slope on August 16.
(Gary Nylander/*The Daily Courier*)

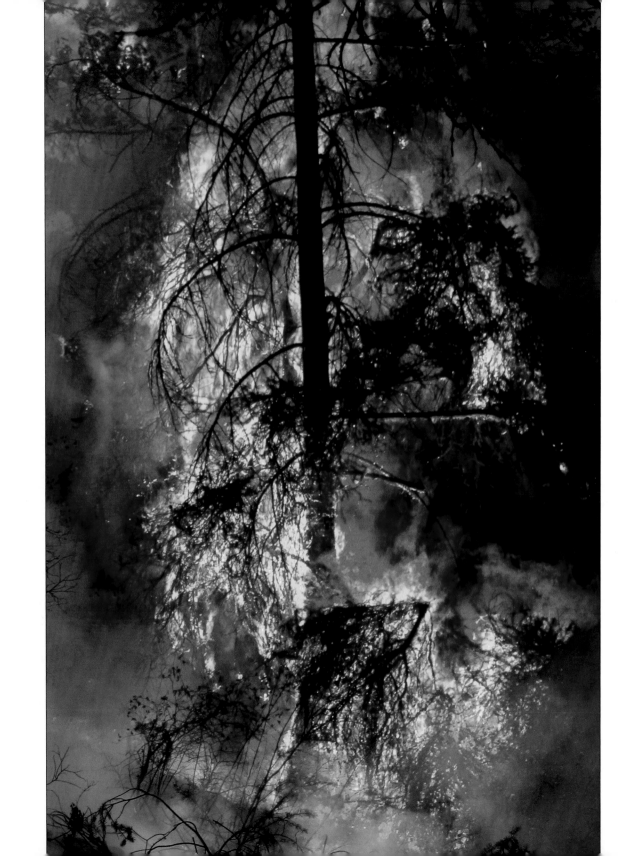

*A tree candles in
the Okanagan
Mountain Park fire.*
(Kyle Sanguin)

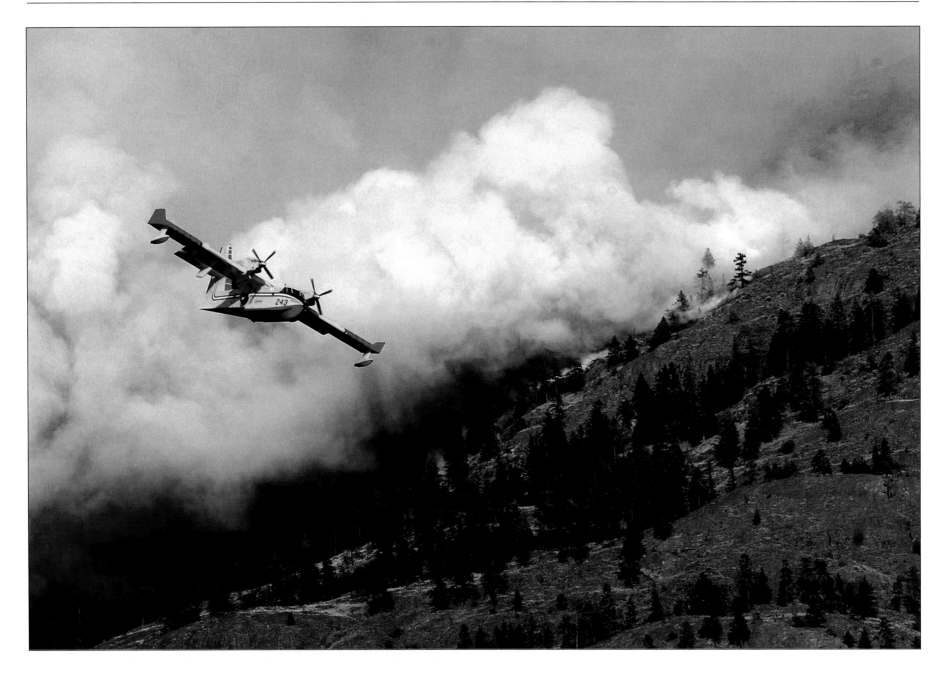

An air tanker heads back to Okanagan Lake after spraying its load on the fire.

(Gary Nylander/*The Daily Courier*)

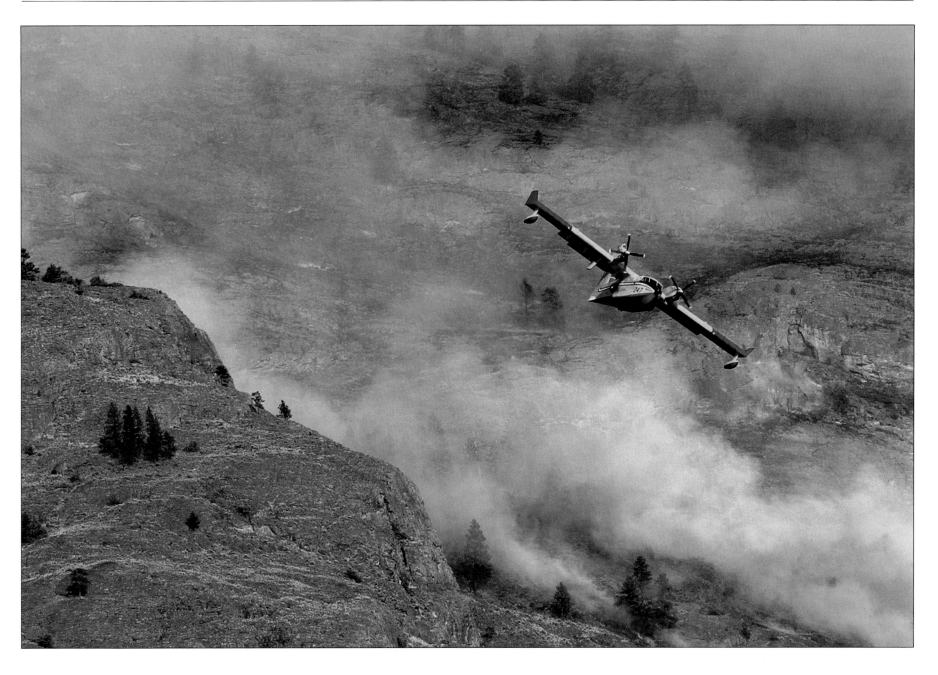

Difficult terrain and blinding smoke made the job of the air-tanker pilots especially dangerous.

(Gary Nylander/*The Daily Courier*)

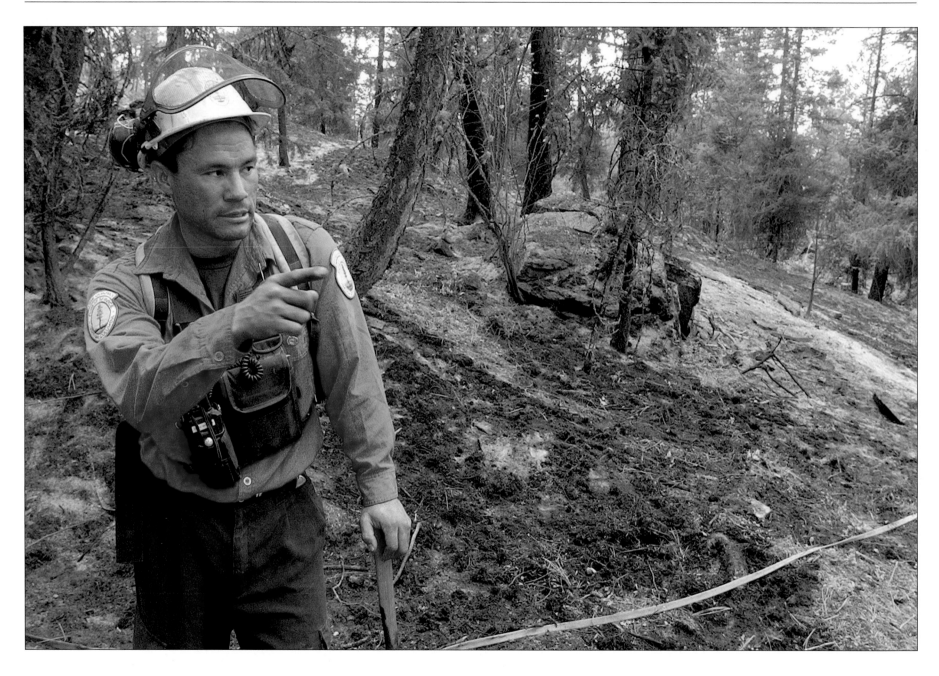

Crew chief Rod Bolan stands amid burned trees in an area above June Springs Road in southeast Kelowna.

(Darren Handschuh/*The Daily Courier*)

A ground fire burns in Okanagan Mountain Park north of Naramata on August 21.

(Yukon Ellsworth)

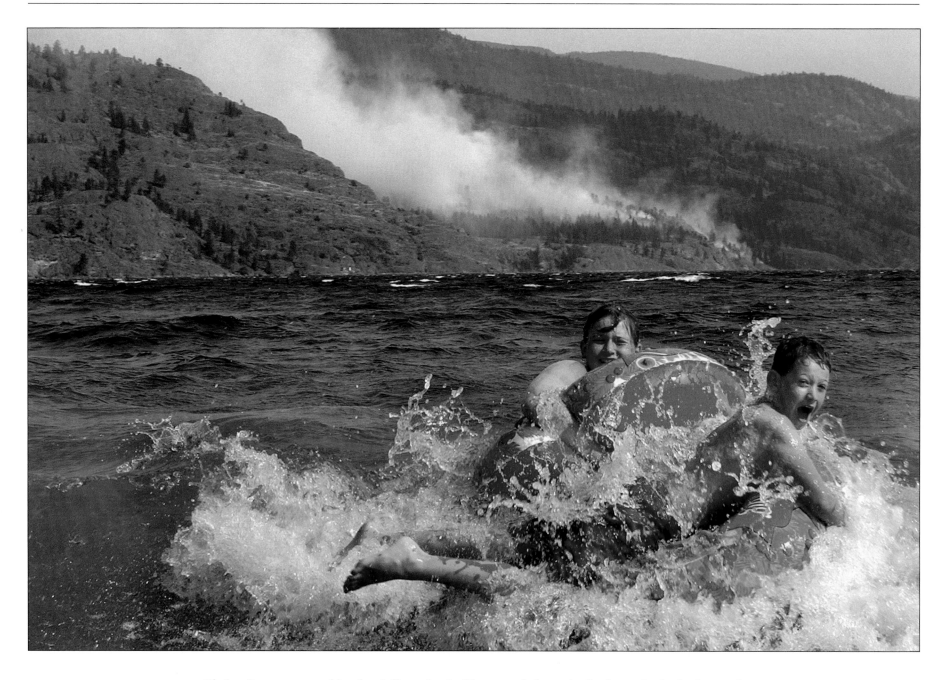

Christy Degano, 13, and brother Jeff, 11, play in Okanagan Lake as the fire burns in the background.
(Gary Nylander/*The Daily Courier*)

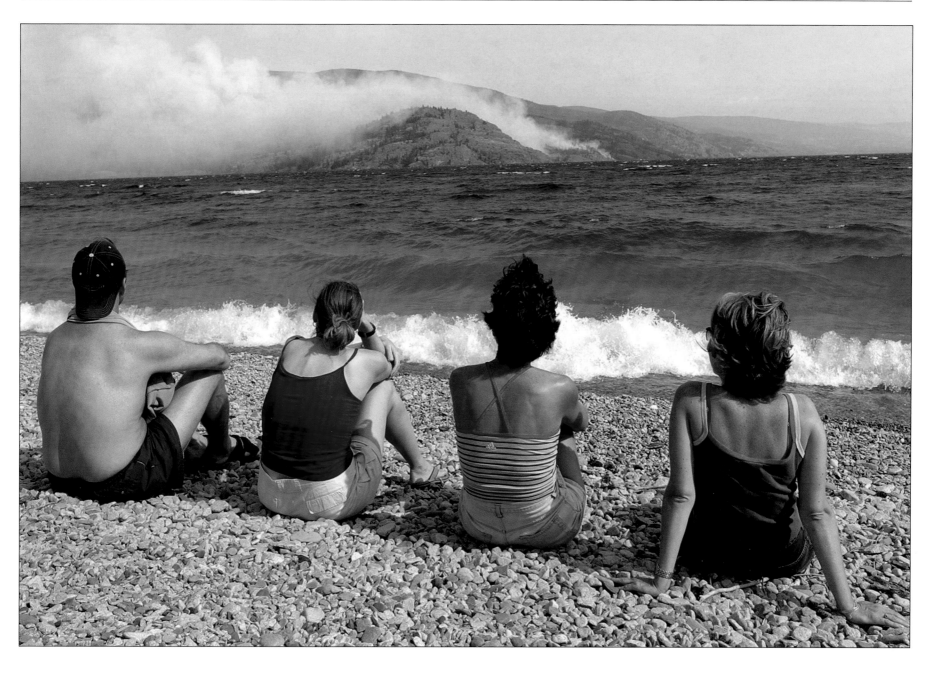

Local residents gather at Antlers Beach on the west side of Okanagan Lake to watch the fire climb up the hillside of Okanagan Mountain Park.
(Gary Nylander/*The Daily Courier*)

Paul Jussila of Delta, B.C., watches air tankers and fire crews attack the fire.

(Gary Nylander/*The Daily Courier*)

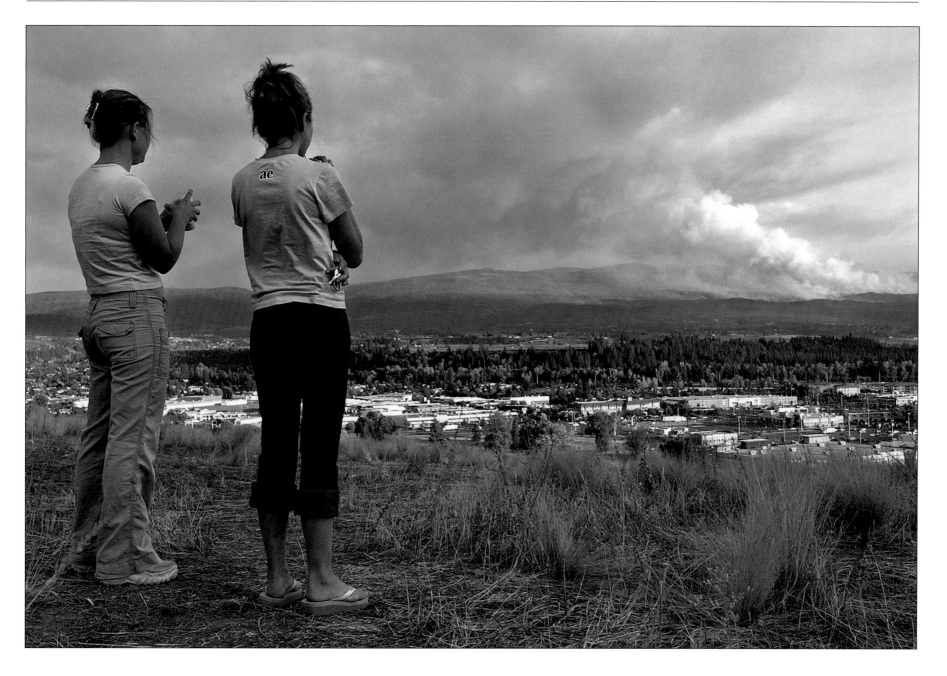

Marcie Gratrix, left, and friend Cassia Helina of Kelowna watch the Okanagan Mountain Park fire from Dilworth Mountain.

(Gary Nylander/*The Daily Courier*)

A pall of smoke hangs over apartment
buildings in the central part of the city
while the fire rages in the background.
(Gary Nylander/*The Daily Courier*)

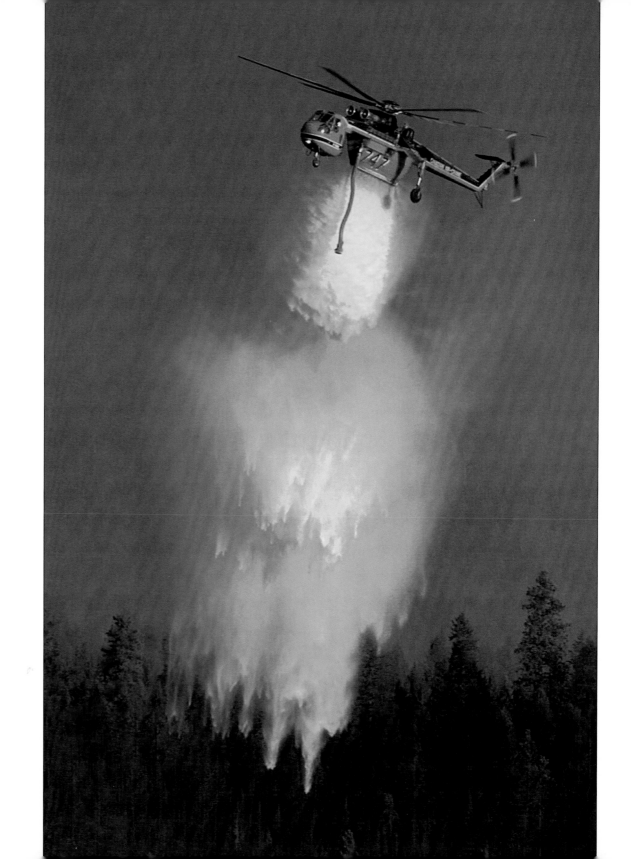

A helicopter drops its load of water on fires burning on the outskirts of Kelowna before heading back to Okanagan Lake for a refill.
(Courtesy Department of National Defence/ Cpl. Bill Gomm)

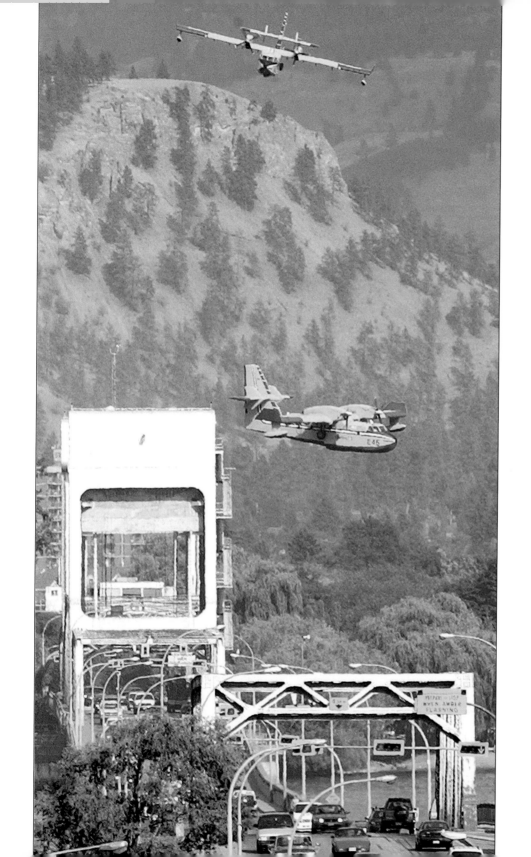

Air tankers fly over Kelowna's
floating bridge before scooping water
out of Okanagan Lake in the fight against
the Okanagan Mountain Park fire.
(Darren Handschuh/*The Daily Courier*)

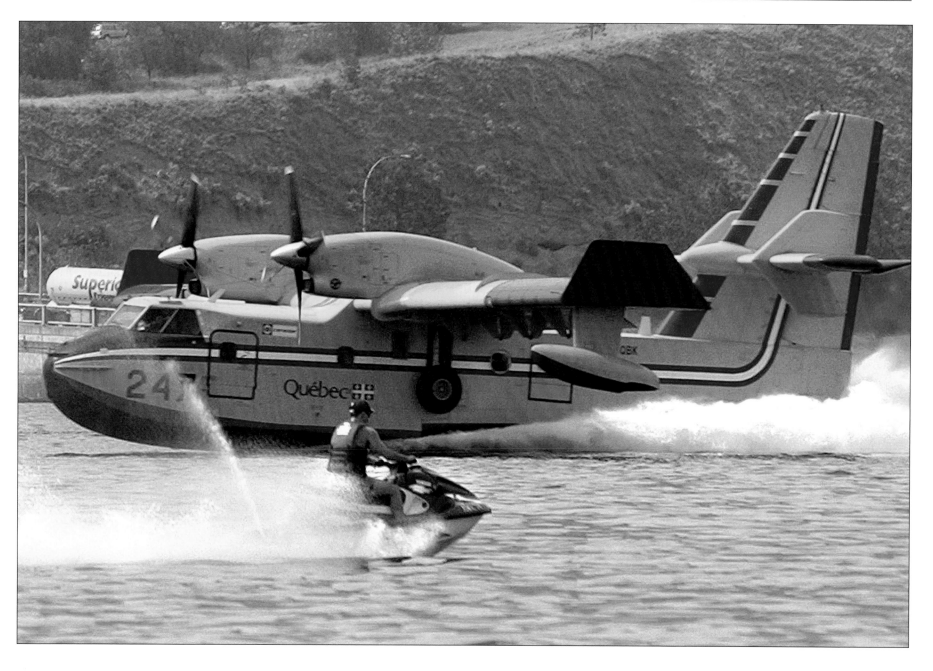

A jet skier races past a CL 415 air tanker as it scoops up water while helping to fight the Okanagan Mountain Park fire.

(Gary Nylander/*The Daily Courier*)

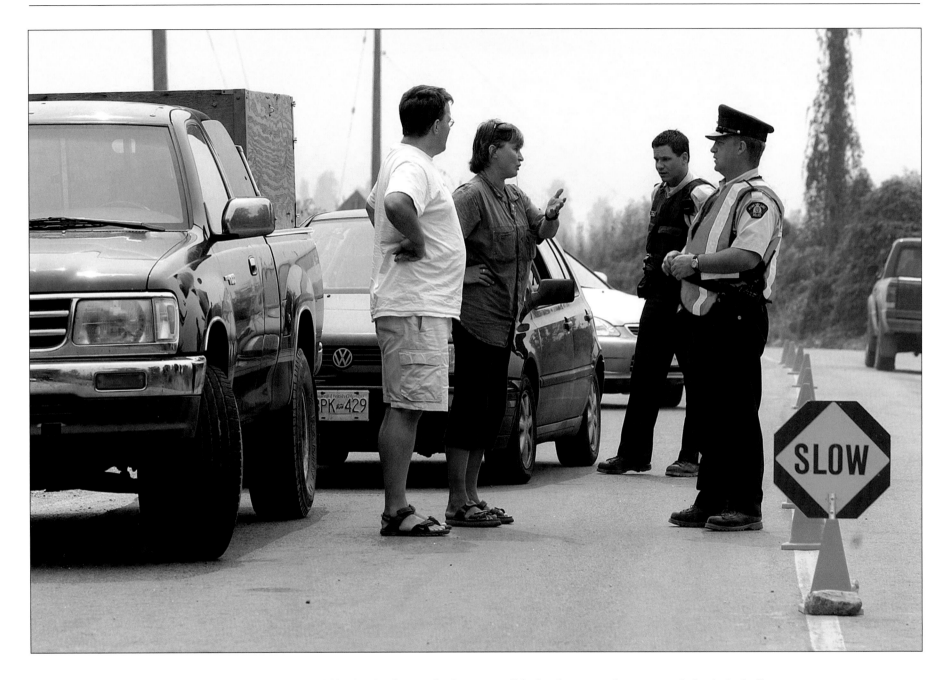

RCMP officers had many difficult jobs during the fire. At roadblocks, they turned many people back, including residents who demanded to know the status of their homes. (Gary Nylander/*The Daily Courier*)

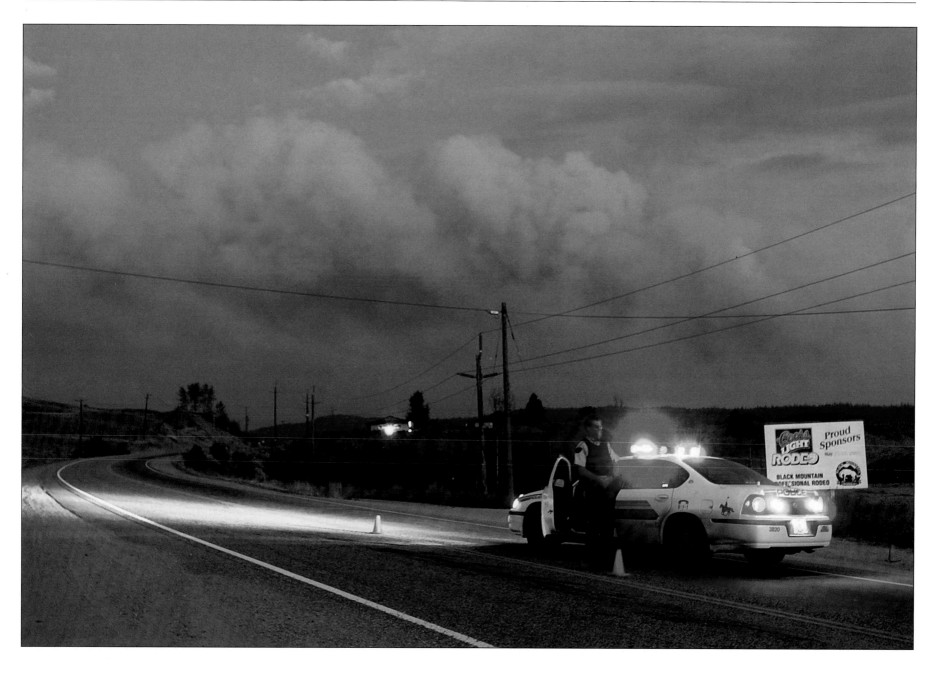

A lonely RCMP officer mans a roadblock along Highway 33 as smoke from the Okanagan Mountain Park fire rises in the background north of Kelowna. (Gary Nylander/*The Daily Courier*)

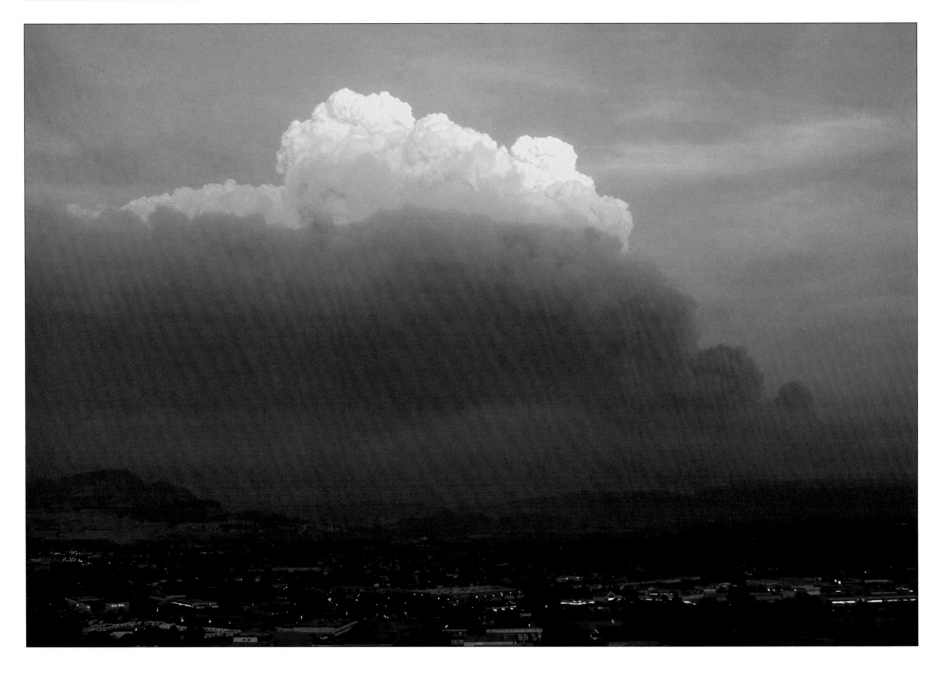

Smoke billows above Kelowna after the fire springs back to life.
(Gary Nylander/*The Daily Courier*)

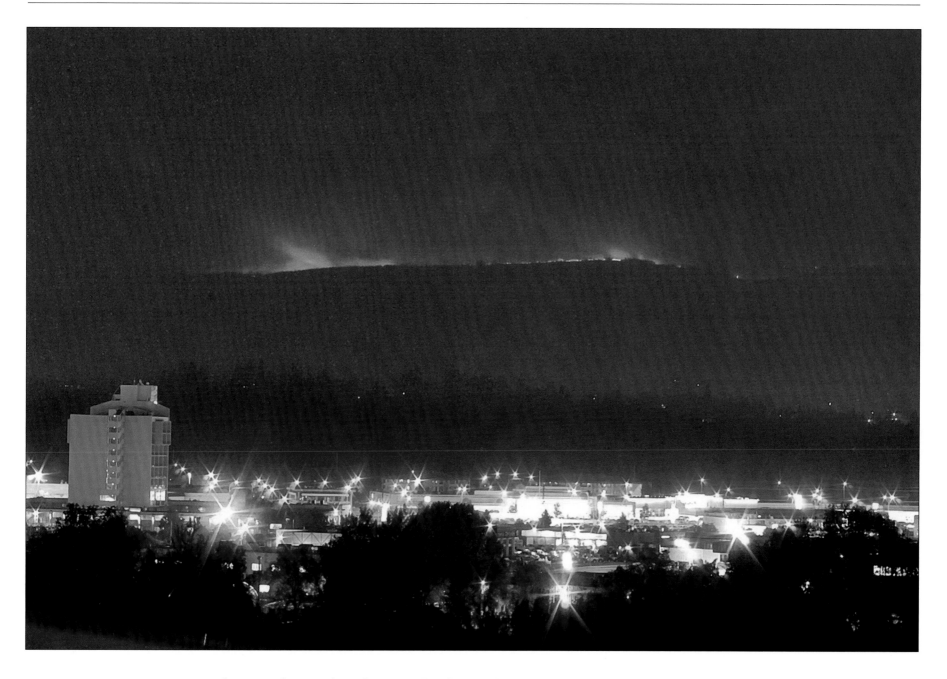

Flames can be seen above the city in this photograph taken from Dilworth Drive on August 20.
(Gary Nylander/*The Daily Courier*)

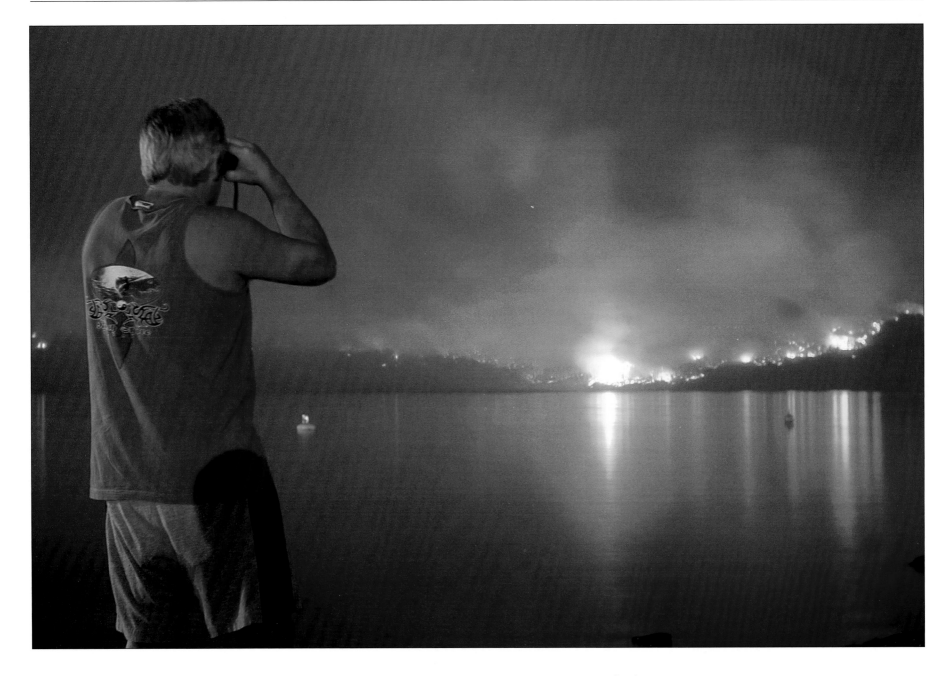

Bob Friesen watches as flames creep closer to homes in the Mission area of Kelowna on August 21.

(Gary Nylander/*The Daily Courier*)

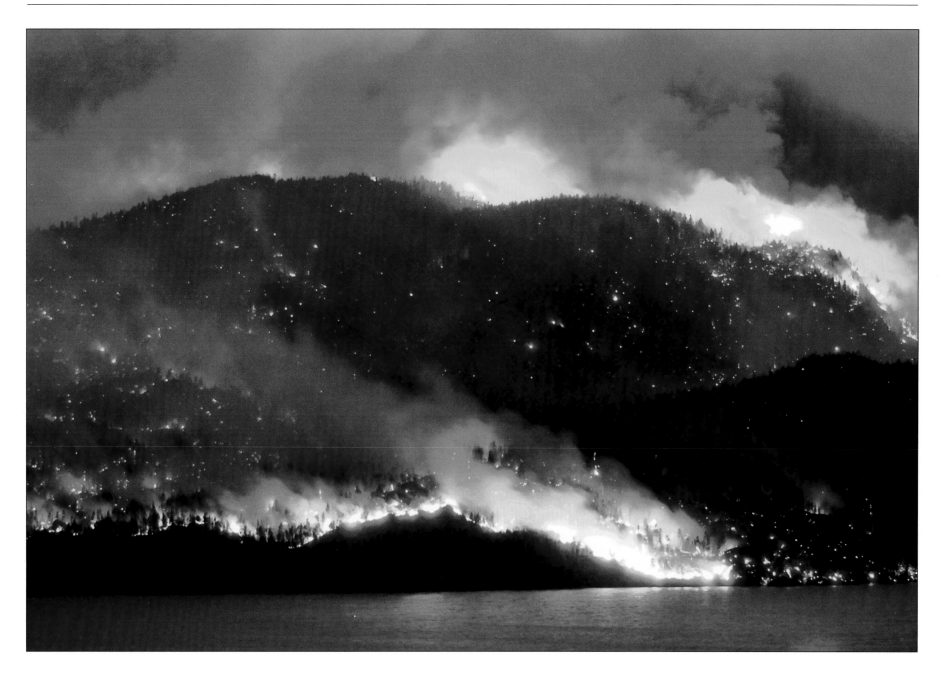

The fire that started with a single lightning strike engulfed Okanagan Mountain Park within two days.

(Kip Frasz/*The Daily Courier*)

Farm buildings in Kelowna's Black Mountain area are illuminated by the Okanagan Mountain Park fire.

(Gary Nylander/*The Daily Courier*)

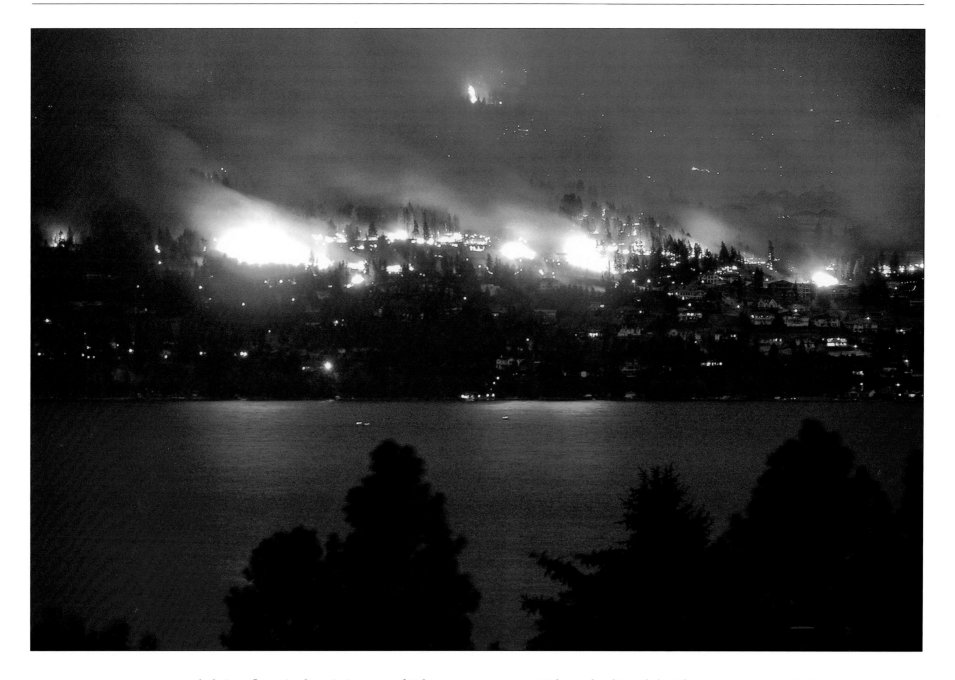

Homes explode into flame in the Mission area of Kelowna on August 22. High winds whipped the Okanagan Mountain Park fire into fury, causing the incineration of 223 homes and the evacuation of another 17,000 people. (Stan Chung)

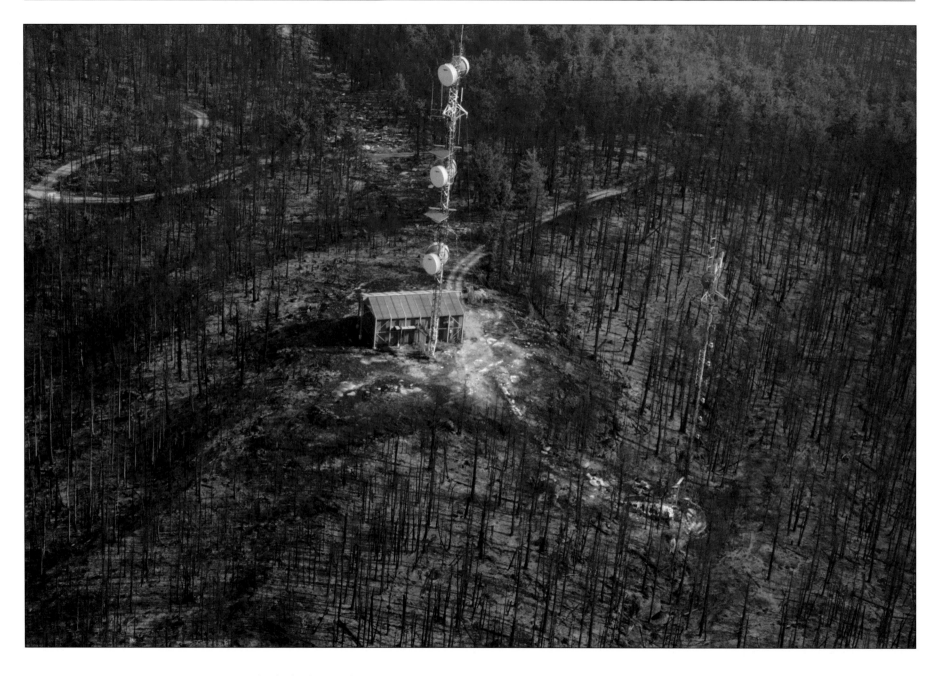

Microwave towers north of Glenfir on Okanagan Mountain sustain damage as a result of the Okanagan Mountain Park fire.

(Alan Heaven)

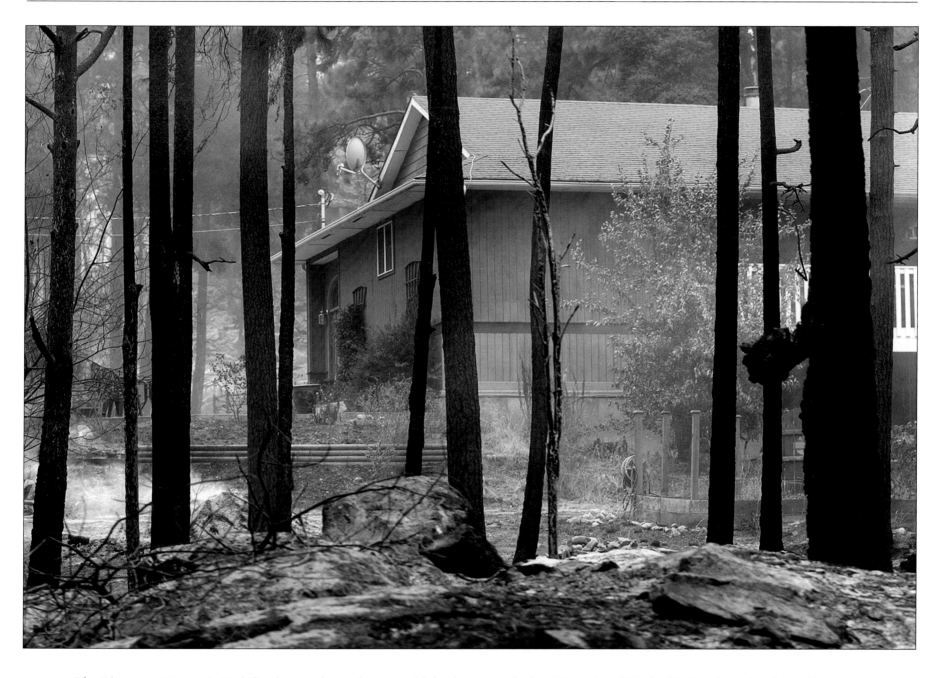

The Okanagan Mountain Park fire destroyed some homes and left others unscathed on Rimrock and Timberline Roads on the night of August 21.
(Gary Nylander/*The Daily Courier*)

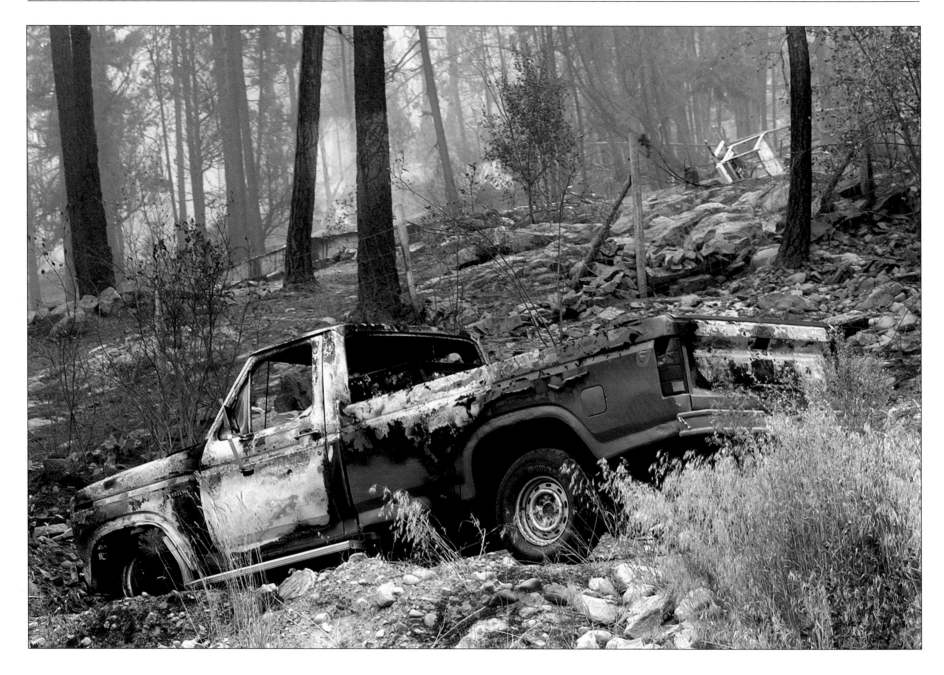

A scorched pickup truck rests amid the devastation on Rimrock and Timberline Roads.

(Gary Nylander/*The Daily Courier*)

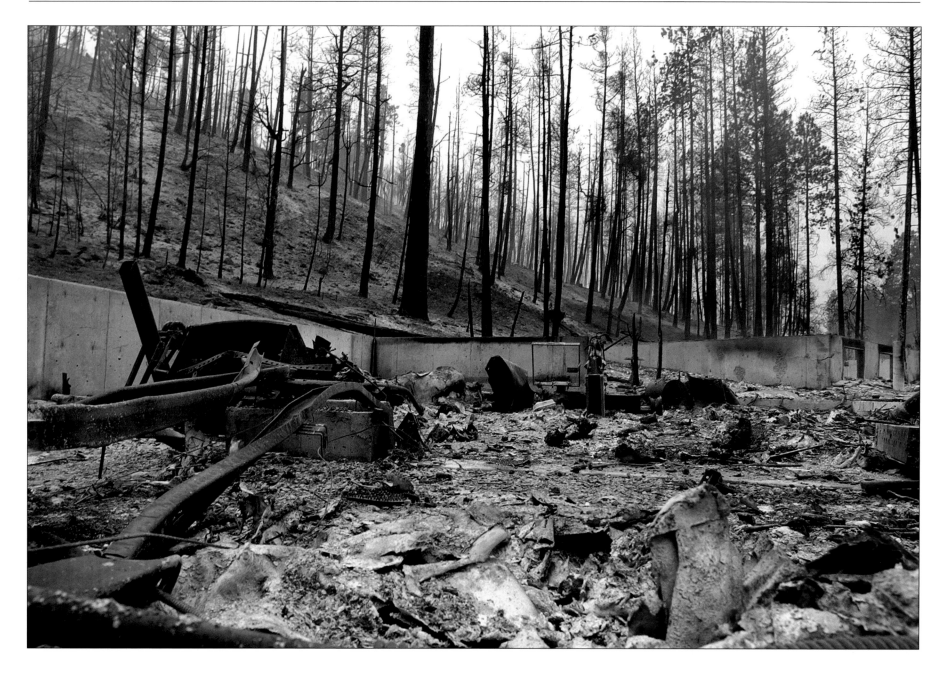

The intense heat of the firestorm reduced homes to piles of twisted metal, rubble, and dust.
(Gary Nylander/*The Daily Courier*)

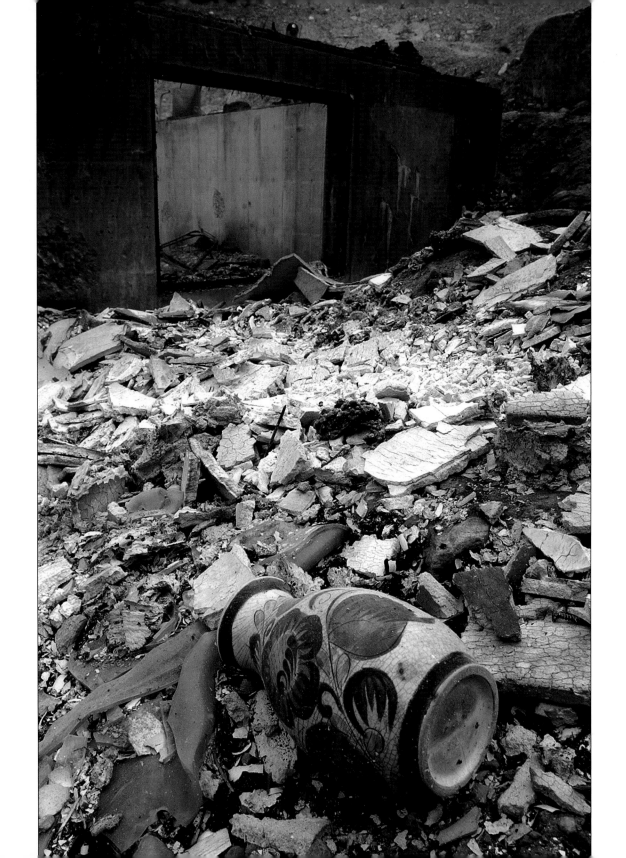

Odd items – like this vase – somehow survived the firestorm that consumed everything around it.
(Gary Nylander/*The Daily Courier*)

Tools are ready for use as members of the media tour the fire damage in Kelowna's Timberline area.
(Gary Nylander/*The Daily Courier*)

93

Alex Bird and his family pack valuables from their Kettle Valley home after the evacuation order for his neighbourhood is announced.

(Kip Frasz/*The Daily Courier*)

Tia Jones, 12, is among the evacuees from Black Mountain who take refuge in Trinity Baptist Church. Her family's home survived the fire.

(Darren Handschuh/*The Daily Courier*)

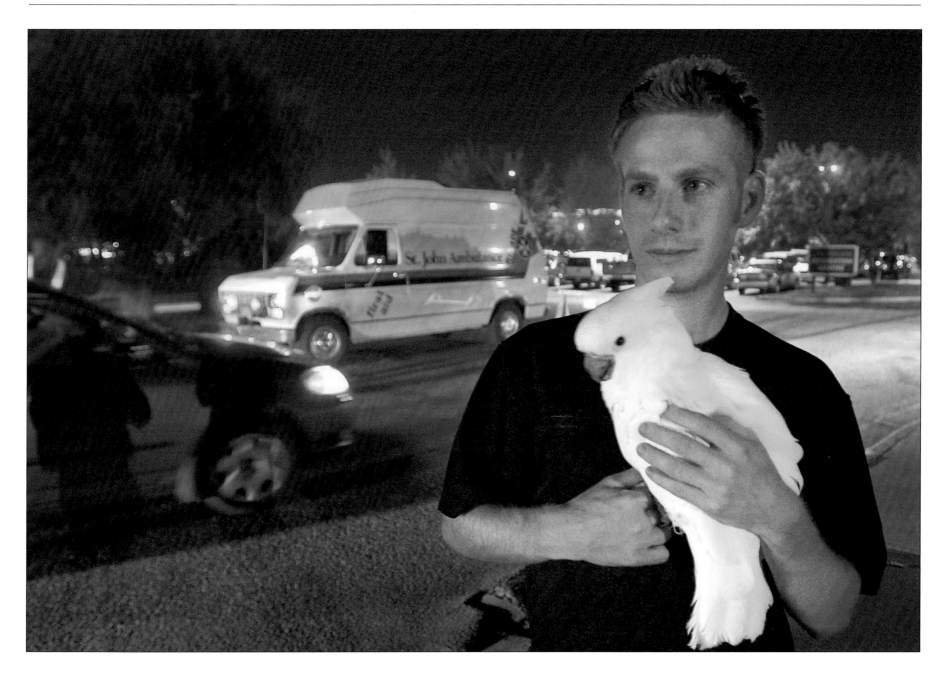

Kyle Grant, 20, and his cockatoo, Triton, were evacuated twice from their Gallagher's Canyon—area home.
(Gary Nylander/*The Daily Courier*)

A volunteer carries supplies into the Parkinson Recreation Centre in Kelowna where many of the 27,000 evacuees registered.

(Gary Nylander/*The Daily Courier*)

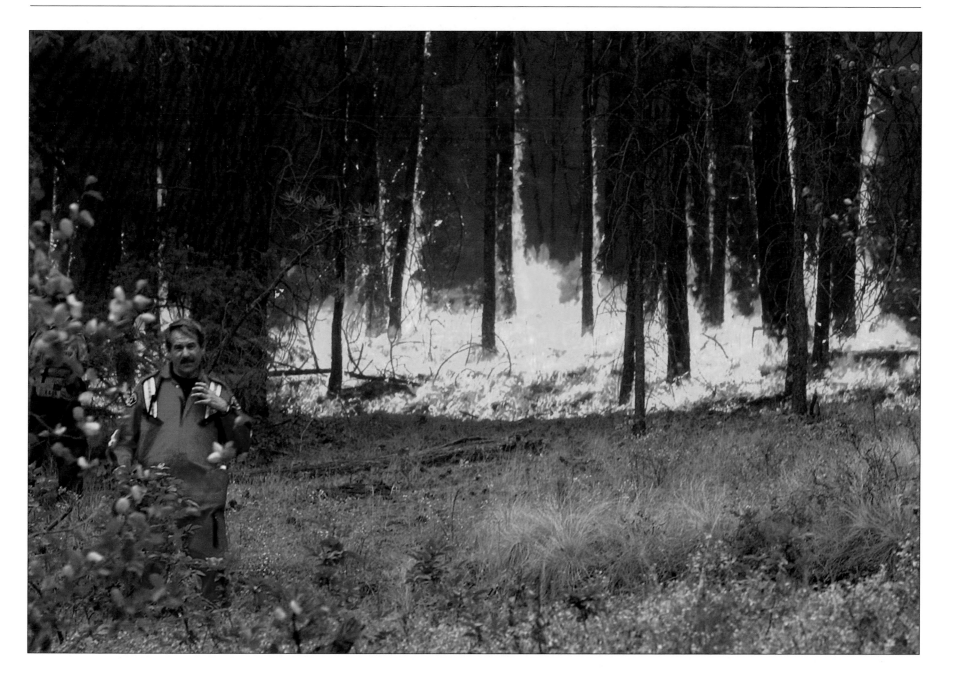

A firefighter takes a break from battling flare-ups in the Okanagan Mountain Park fire.
(Gary Nylander/*The Daily Courier*)

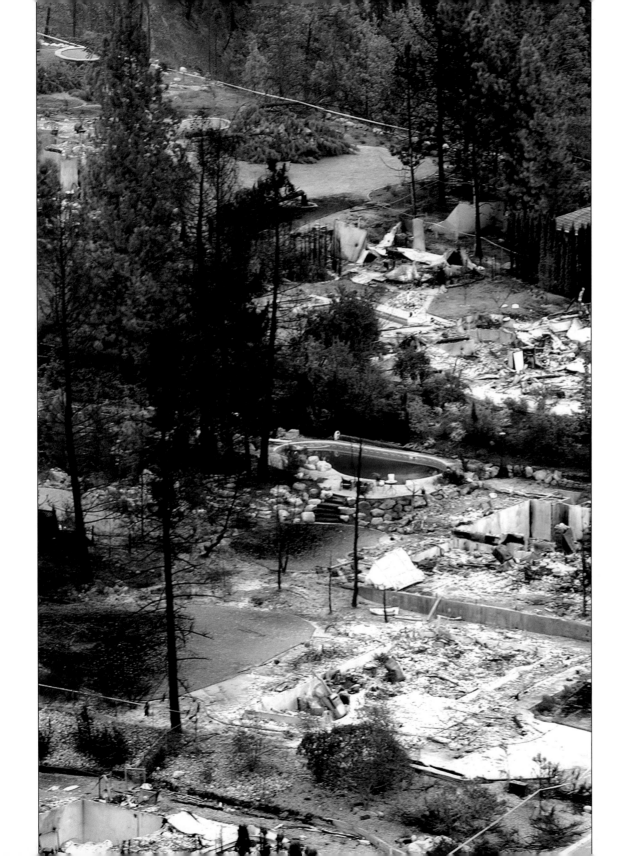

An entire block of the Crawford Estates area of Kelowna is in ruins after the Okanagan Mountain Park fire roared through.

(Darren Handschuh/*The Daily Courier*)

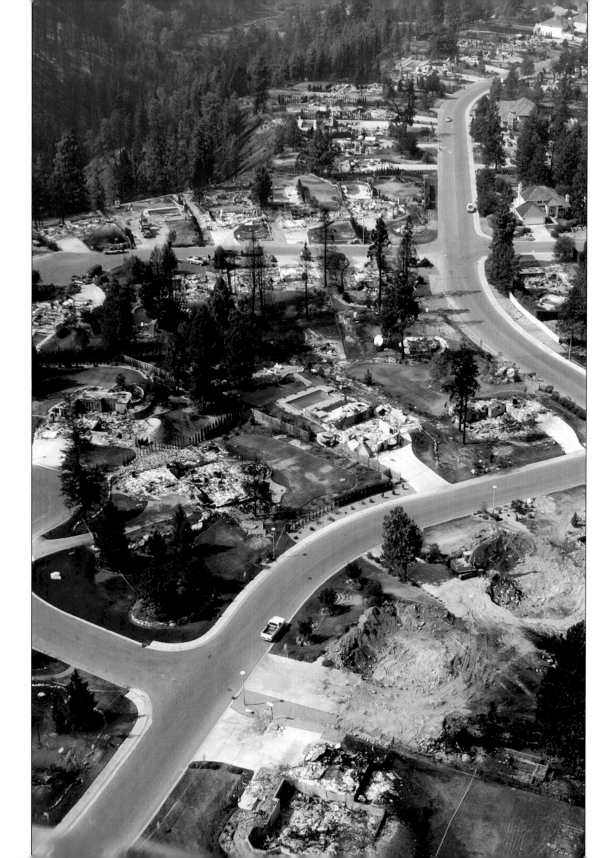

The Crawford Estates neighbourhood was hit hard by the August 22 firestorm. It destroyed 68 homes in the area and 155 more in Kelowna's south end.
(Kip Frasz/*The Daily Courier*)

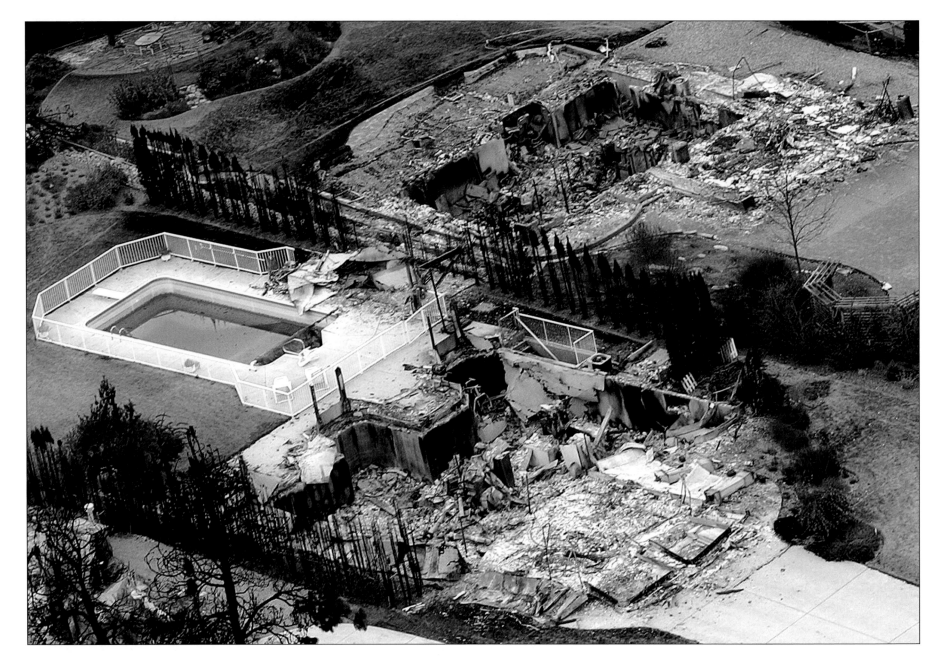

Only the pool remains of a home in the Crawford Estates area of Kelowna.

(Darren Handschuh/*The Daily Courier*)

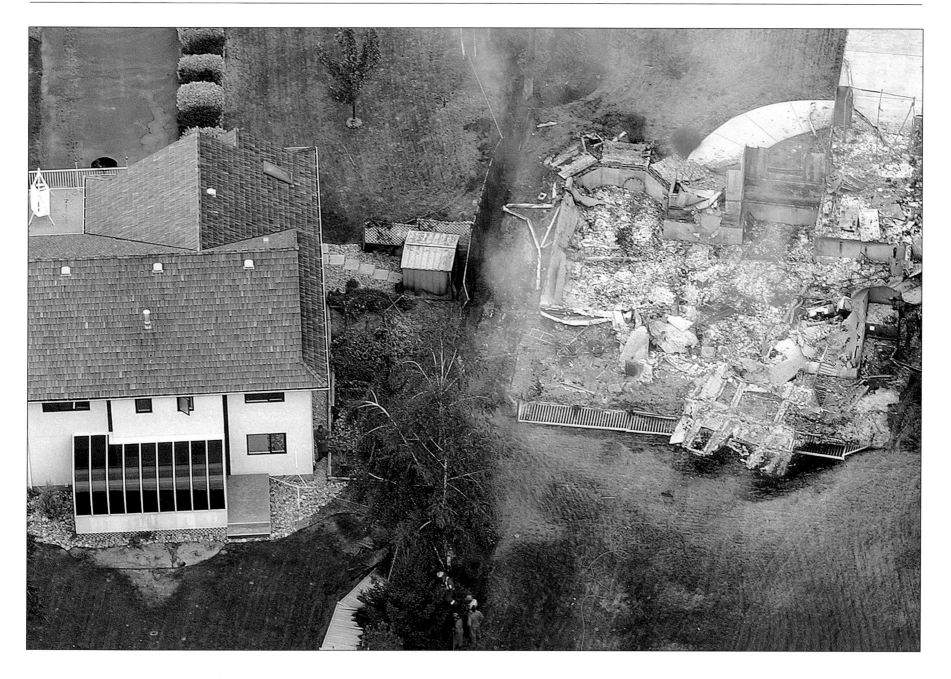

Fire crews search bushes in the Crawford Estates area of Kelowna for a hot spot. The burned-out shell of a house smoulders beside them.
(Darren Handschuh/*The Daily Courier*)

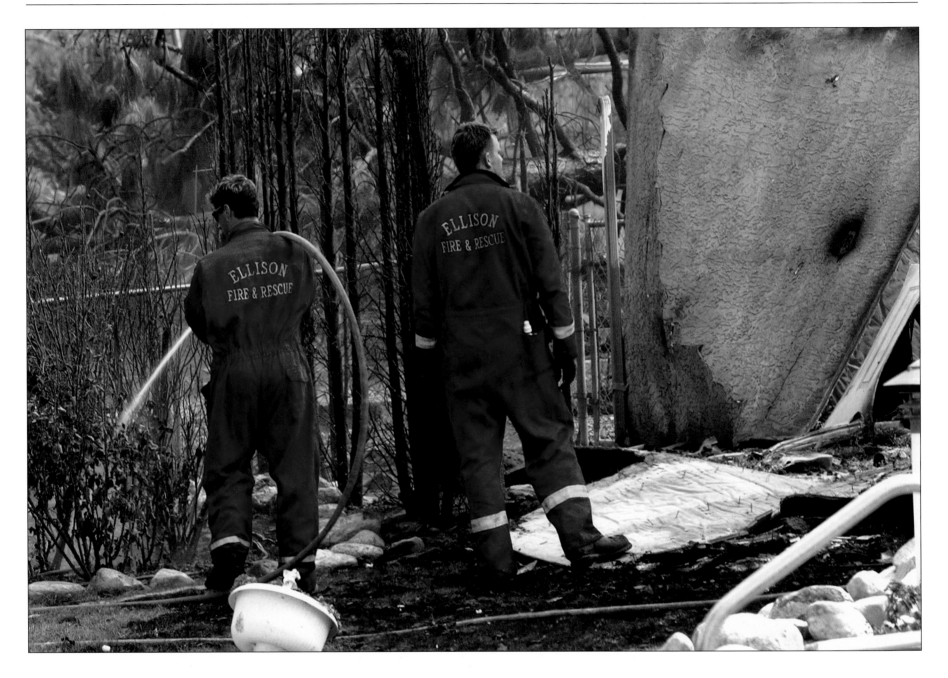

Firefighters hose down hot spots after fire swept through the Crawford Estates area of Kelowna.

(Gary Nylander/*The Daily Courier*)

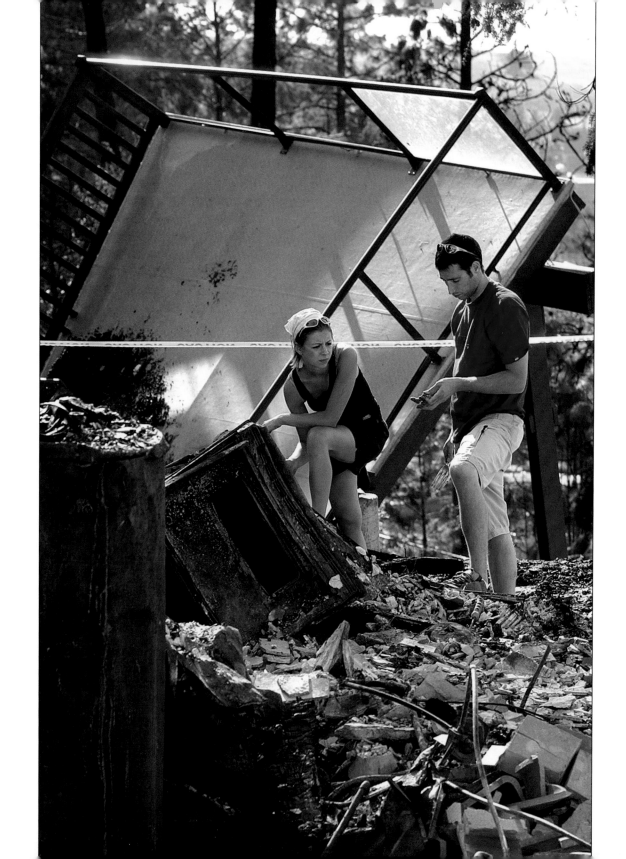

Trisha Kostesky, left, and Sean Varnel look through what remains of the basement apartment they rented in a house on Okaview Road.
(Gary Nylander/*The Daily Courier*)

103

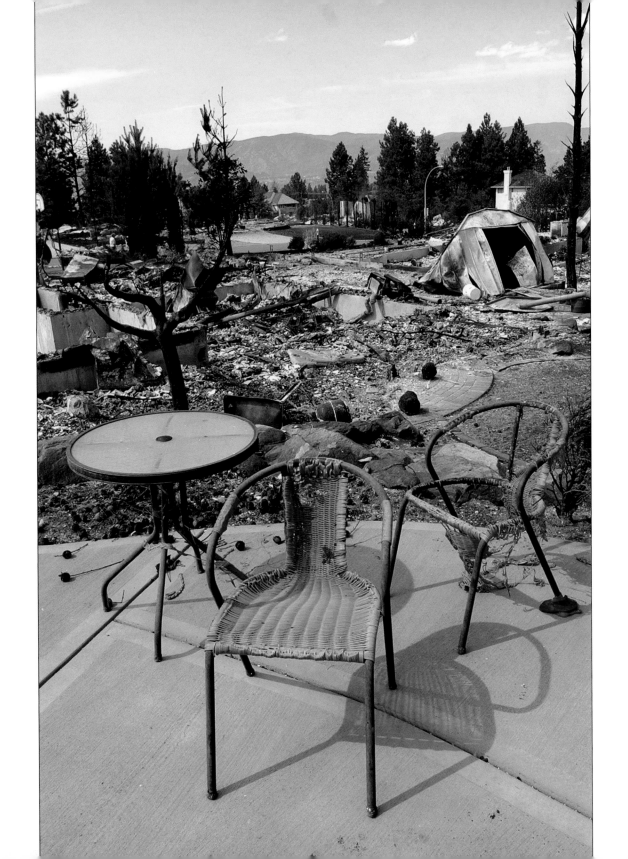

Patio furniture sits in the midst of devastation in the Crawford Estates area of Kelowna after the fire.
(Gary Nylander/*The Daily Courier*)

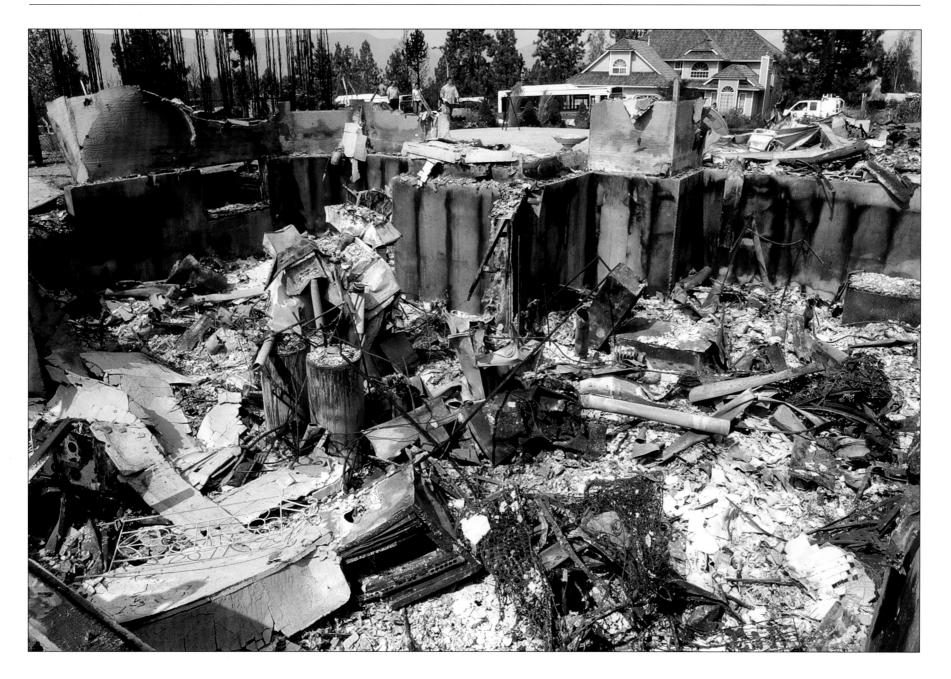

Only scorched foundations remain after fire devastated houses in the Crawford Estates.

(Gary Nylander/*The Daily Courier*)

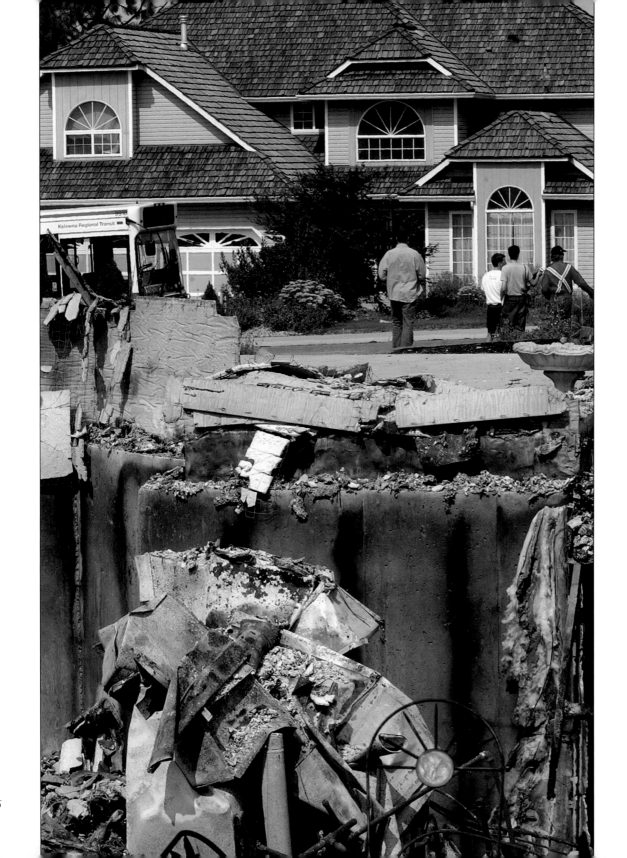

Residents are escorted by officials to see what remains standing in Crawford Estates.
(Gary Nylander/*The Daily Courier*)

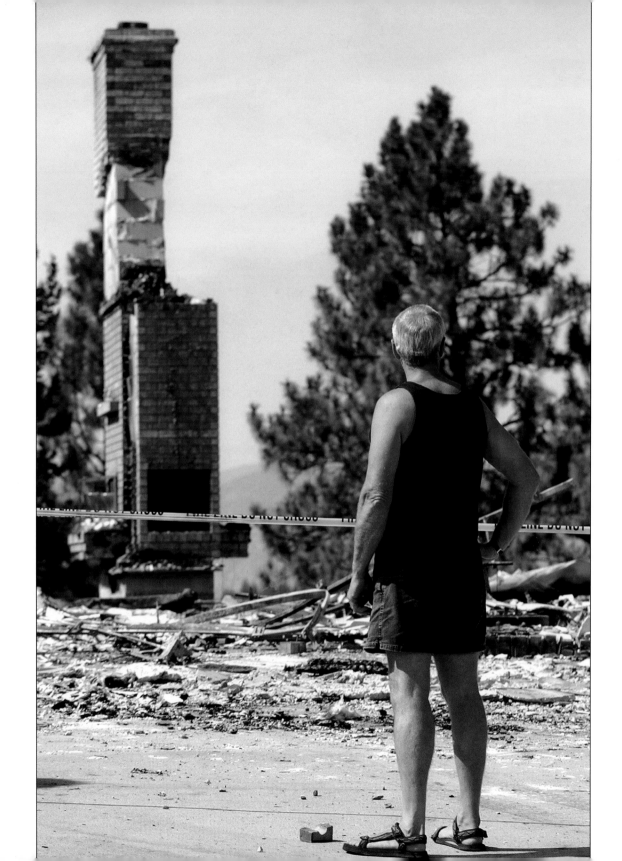

A resident of Crawford Estates contemplates the destruction caused to homes of friends and neighbours by the Okanagan Mountain Park fire.
(Kip Frasz/*The Daily Courier*)

107

A group of people compares notes outside Trinity Baptist Church.
(Darren Handschuh/*The Daily Courier*)

A distraught woman leaves Trinity Baptist Church after residents were told who had lost their homes in the firestorm.
(Darren Handschuh/*The Daily Courier*)

Neighbours console each other outside
Trinity Baptist Church after fire officials
announced which homes were lost in
the Okanagan Mountain Park fire.
(Darren Handschuh/*The Daily Courier*)

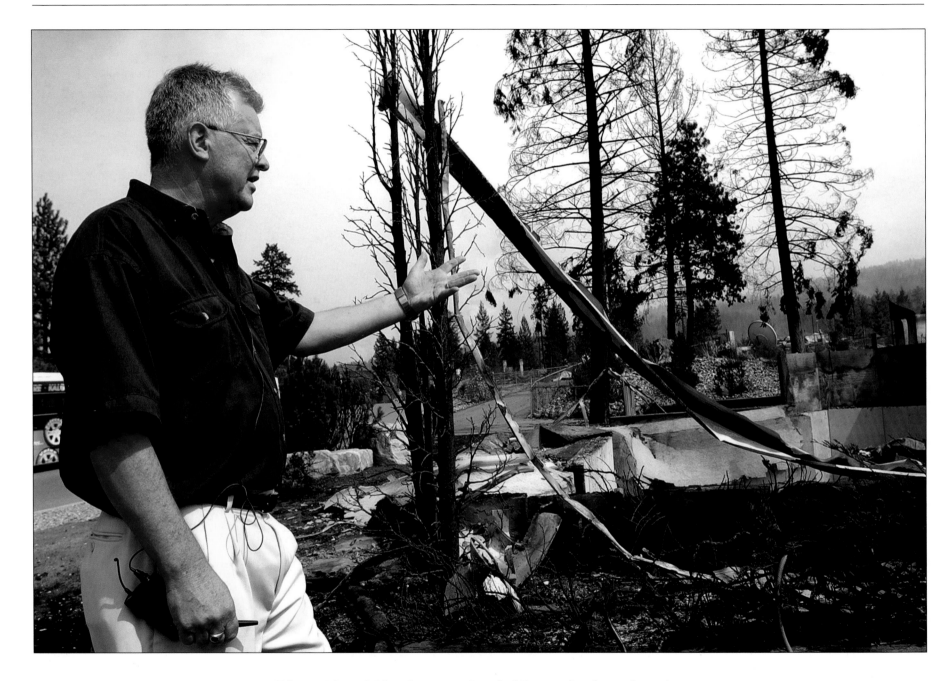

Kelowna Mayor Walter Gray tours Crawford Estates after the conflagration.

(Gary Nylander/*The Daily Courier*)

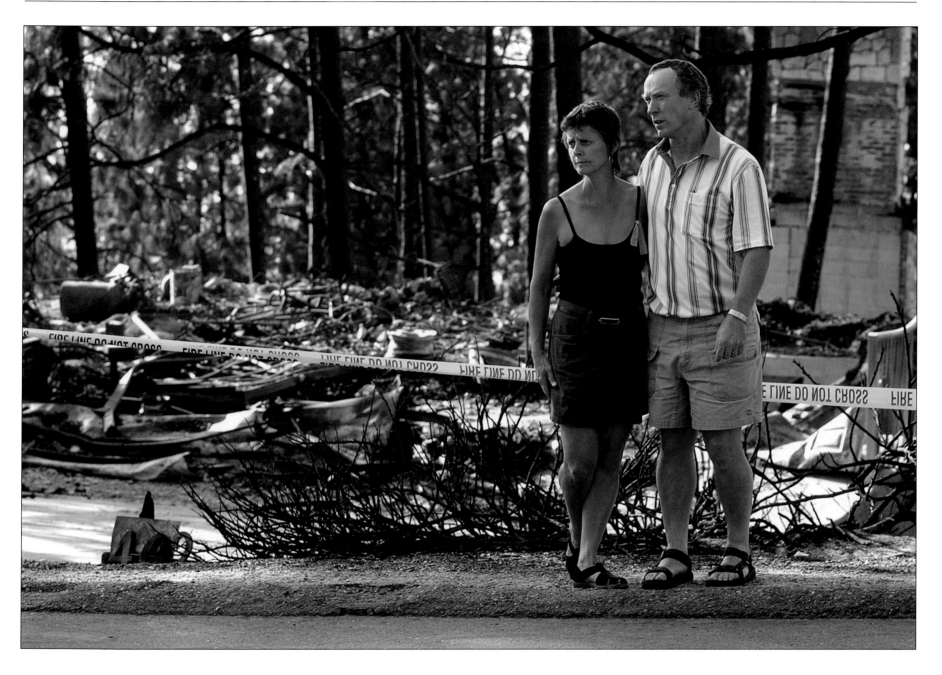

Kelowna city councillor Sharon Shepherd and her husband, Michael, walk through their neighbourhood along Okaview Road after residents were allowed back in. (Gary Nylander/*The Daily Courier*)

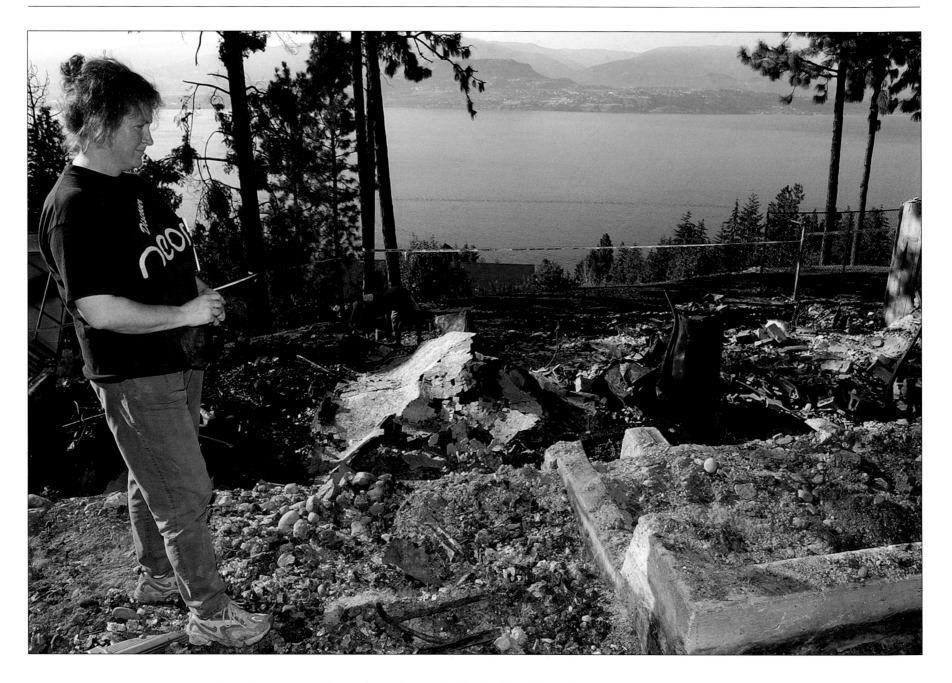

Tannis Trevor-Smith stands at what used to be the front door of her house on Okaview Road.

(Gary Nylander/*The Daily Courier*)

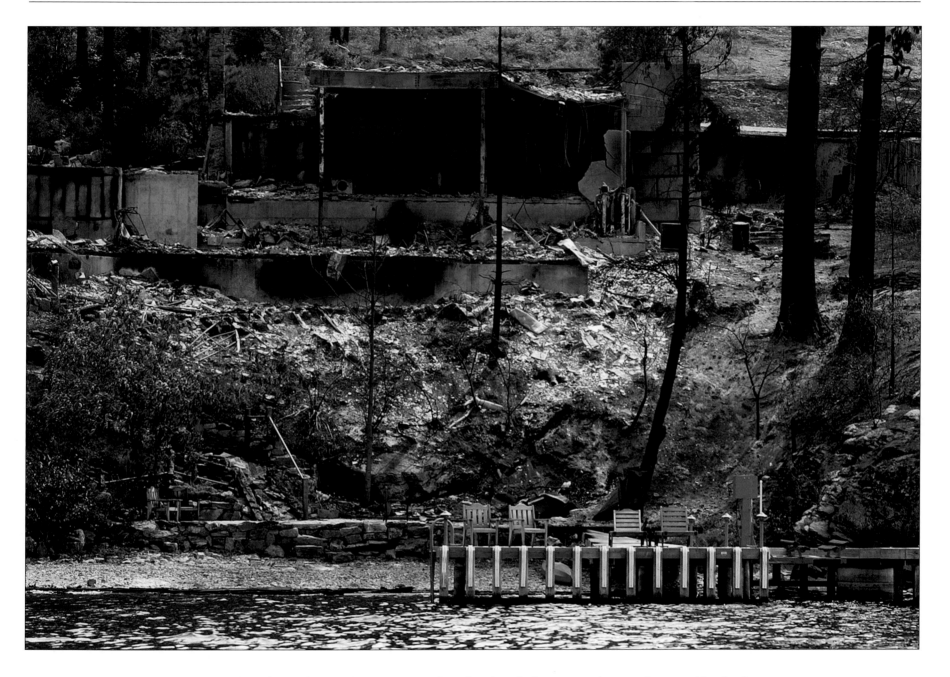

Homes along the south end of Lakeshore Road on the edge of Okanagan Lake were devastated by the fire.

(Gary Nylander/*The Daily Courier*)

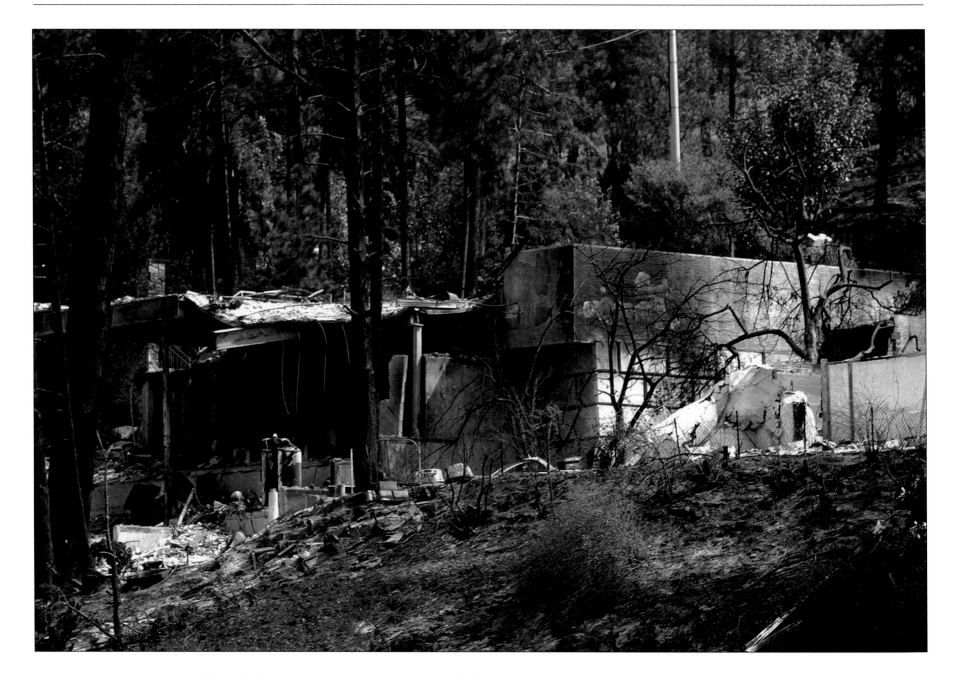

This is all that remains of a home destroyed in the fire that raced through Kelowna on August 21 and 22.
(Gary Nylander/*The Daily Courier*)

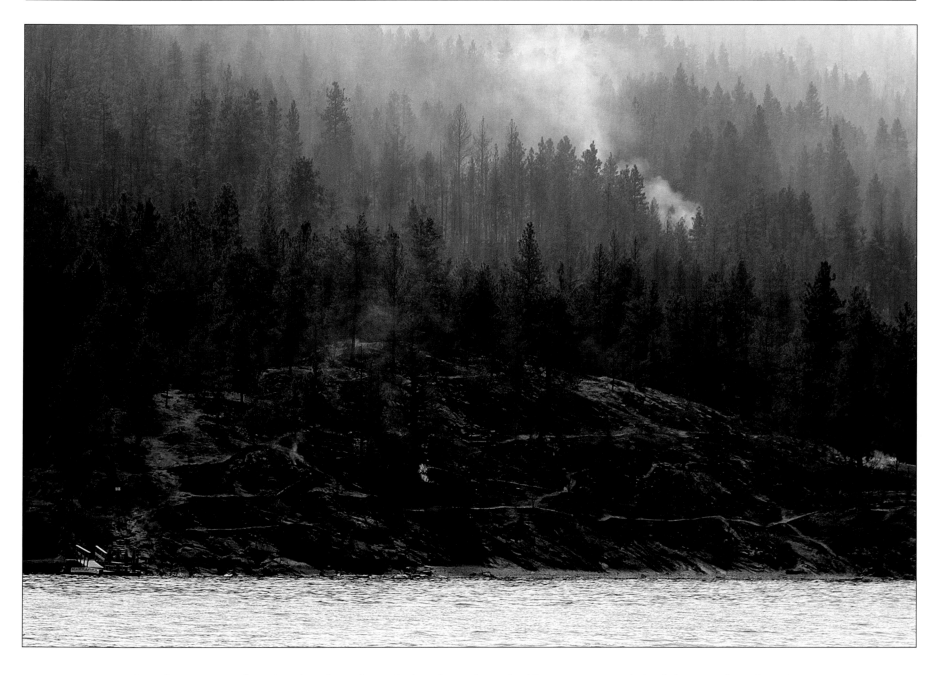

A section of Bertram Creek Regional Park was burned when flames from the Okanagan Mountain Park fire surged north on August 22.

(Gary Nylander/*The Daily Courier*)

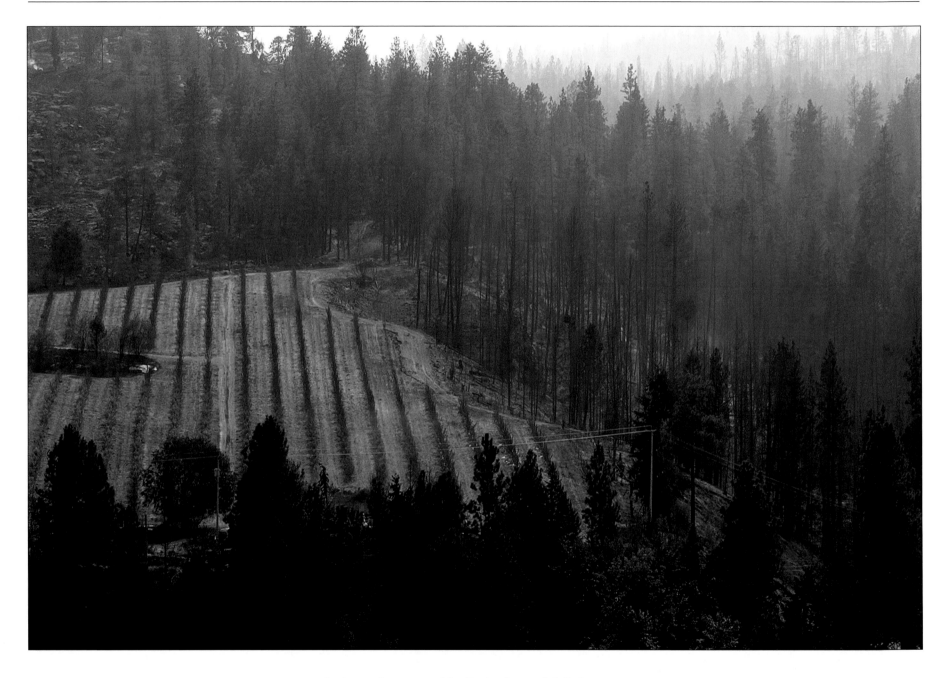

A vineyard was seared by fire in the south Mission area.

(Gary Nylander/*The Daily Courier*)

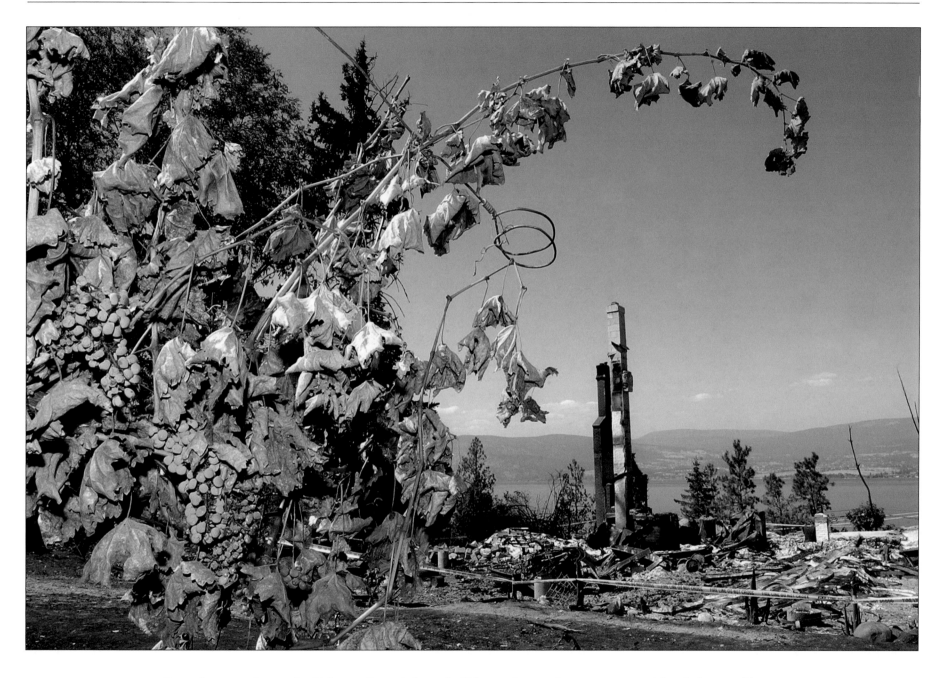

Burned grapes vines at St. Hubertus Estate Winery in Kelowna frame winery owner Leo Gebert's destroyed home.
(Gary Nylander/*The Daily Courier*)

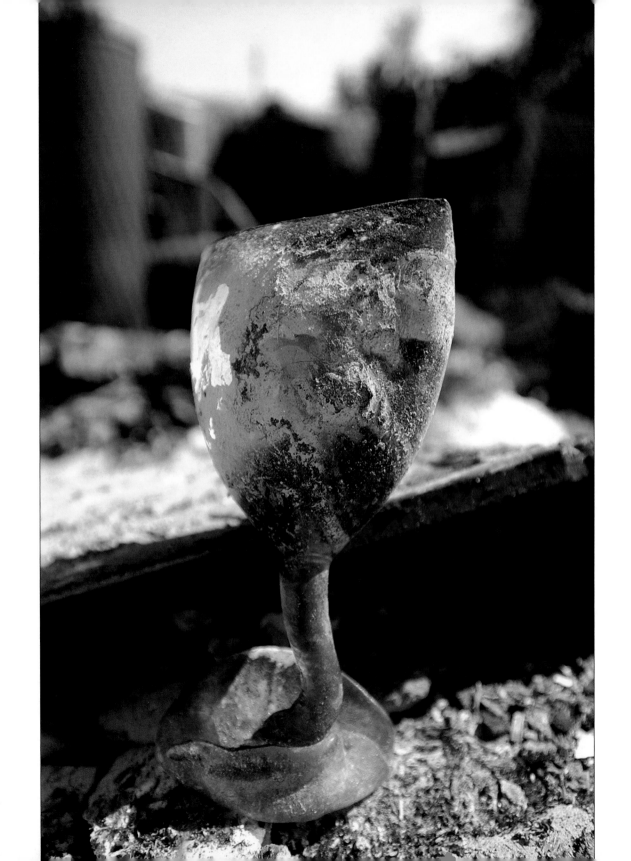

A melted wine glass sits amid the debris at St. Hubertus Estate Winery in Kelowna.
(Gary Nylander/*The Daily Courier*)

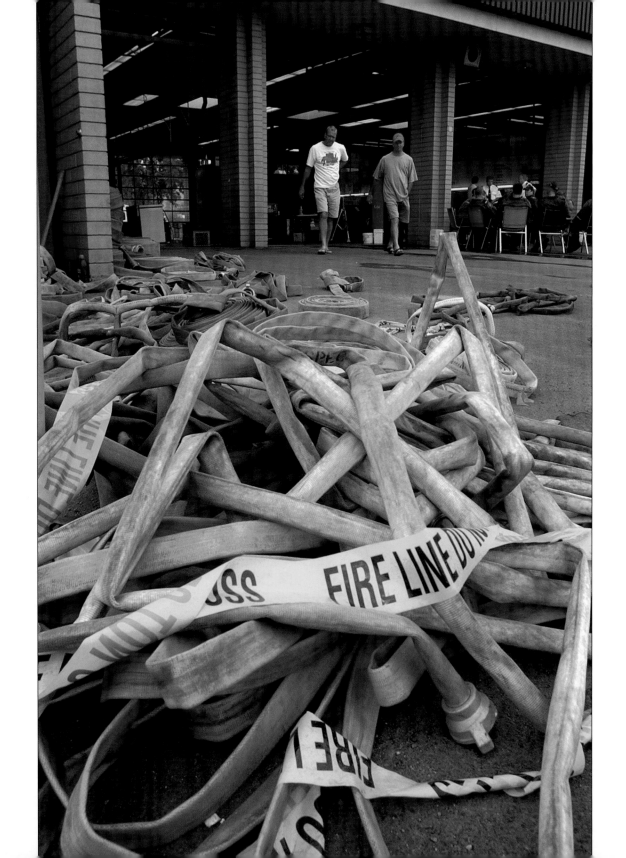

Hoses are piled up at the Kelowna fire hall.
(Gary Nylander/*The Daily Courier*)

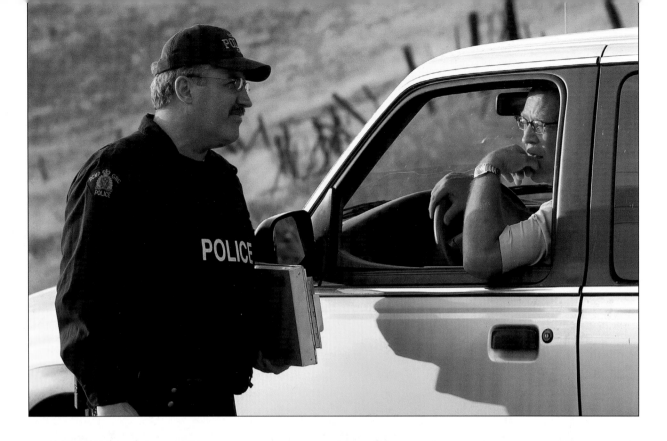

RCMP Constable Al Smith talks to a driver at a roadblock on Highway 33, east of Kelowna.
(Gary Nylander/*The Daily Courier*)

Gordon Hopp and his nine-year old son, Wesley, were happy to return to their Peret Road home in the Mission area of Kelowna after being evacuated.
(Gary Nylander/*The Daily Courier*)

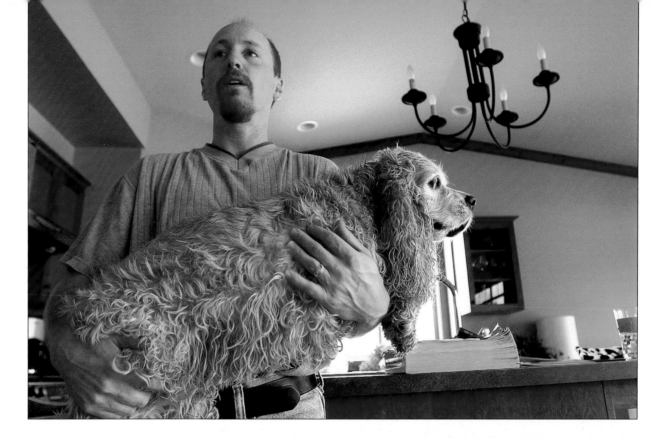

Andrew Murdoch holds his dog, Jessica, as he prepares to return home in the Mission area of the city.
(Gary Nylander/*The Daily Courier*)

Shelley Hewitt and her dog, Monty, were happy to be moving back home after the evacuation order was lifted.
(Gary Nylander/*The Daily Courier*)

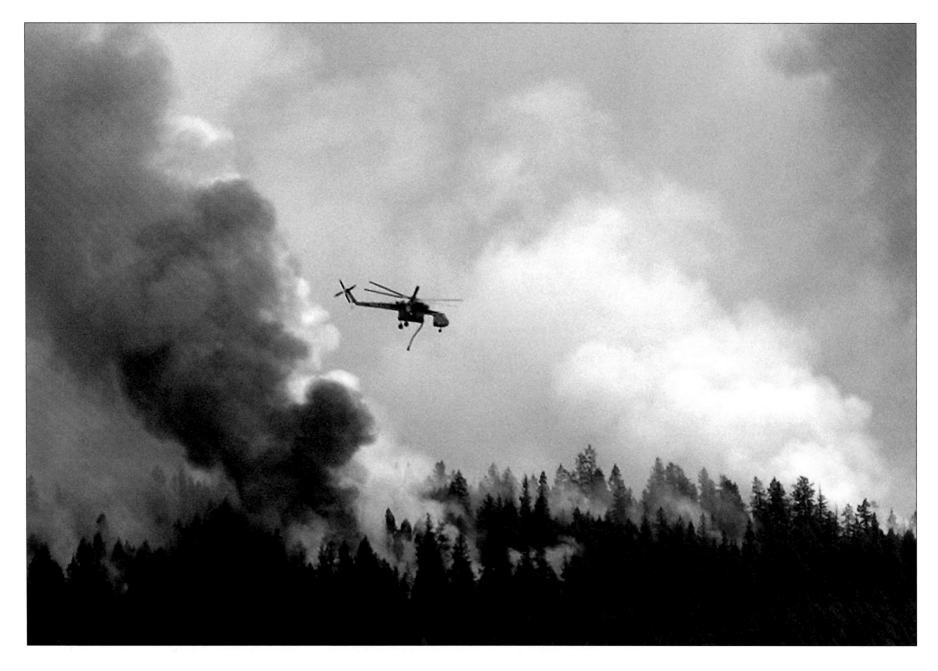

A Sikorsky helicopter hovers above the smoke and flames near the Gallagher's Canyon subdivision.

(Kip Frasz/*The Daily Courier*)

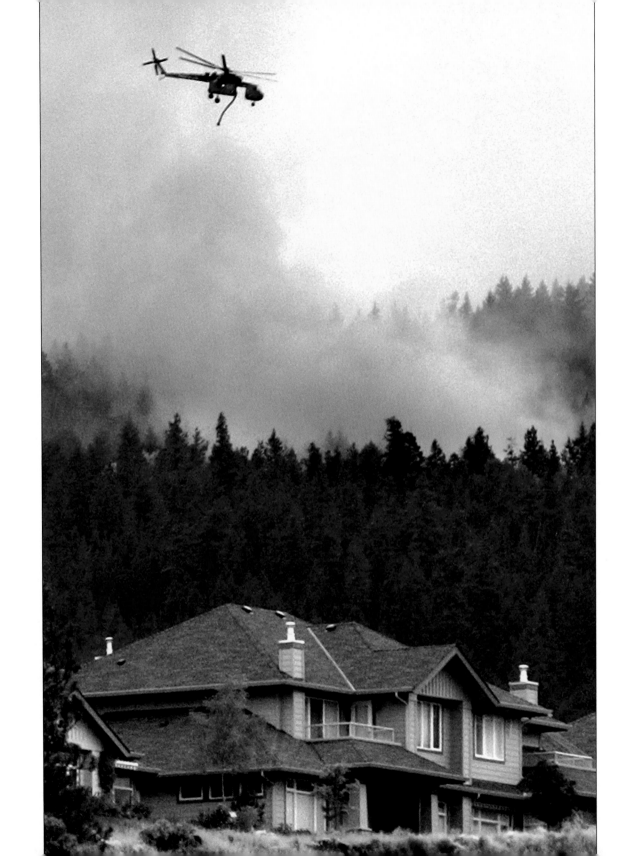

A Sikorsky helicopter tries to protect homes in the Gallagher's Canyon neighbourhood.
(Kip Frasz/*The Daily Courier*)

123

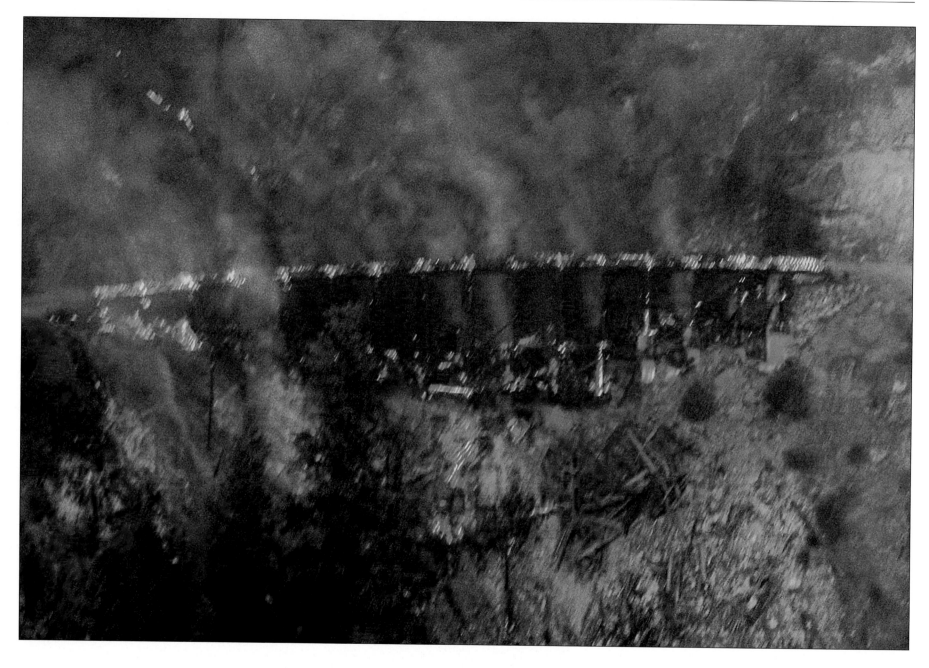

This photograph, taken from a helicopter, shows one of the historic Kettle Valley Railway trestles engulfed in flames.
(Bill Atkinson)

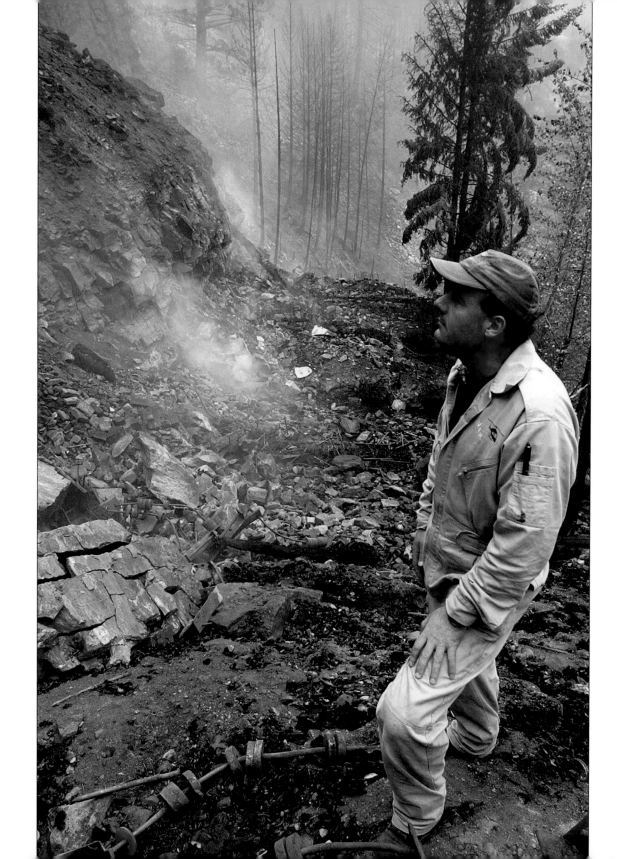

Helicopter pilot Mark McCaughan looks over the remains of Trestle Number 11 on the Kettle Valley Railway.

(Kip Frasz/*The Daily Courier*)

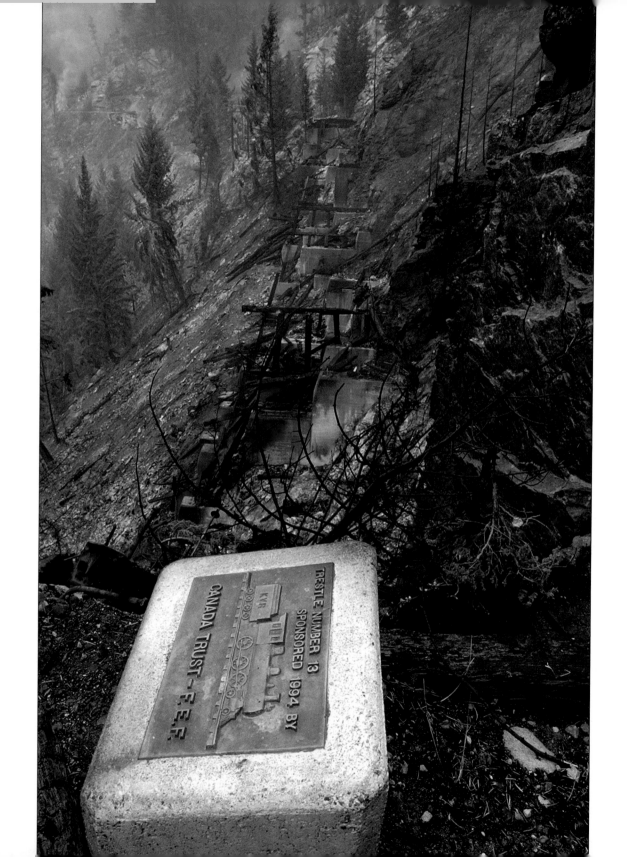

The plaque reads:

TRESTLE NUMBER 13
SPONSORED 1994 BY
CANADA TRUST–E.E.F.

A plaque marks the spot where
Trestle Number 13 once stood.

(Kip Frasz/*The Daily Courier*)

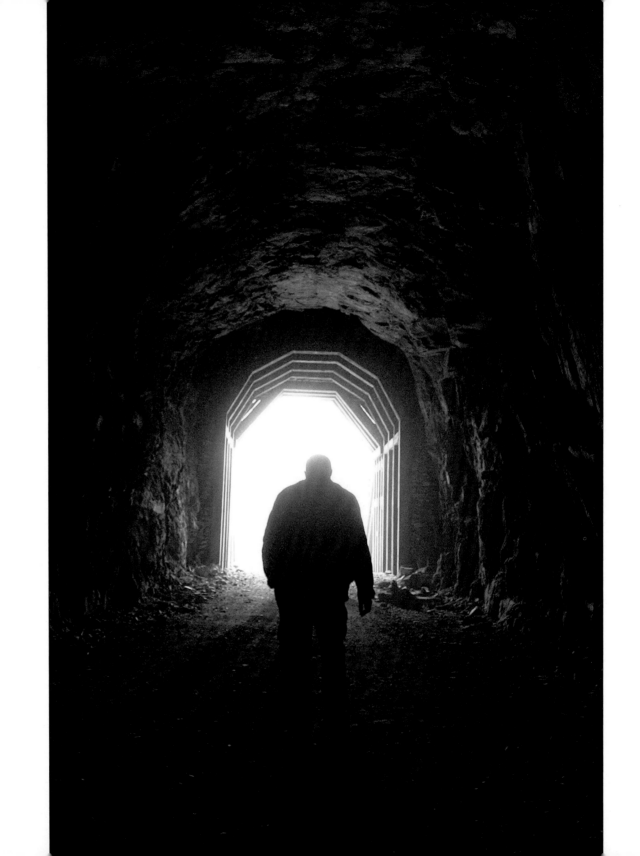

The tunnel near Trestle Number 12 on the Kettle Valley Railway. This is one of the four wooden trestles that survived the Okanagan Mountain Park fire.
(Kip Frasz/*The Daily Courier*)

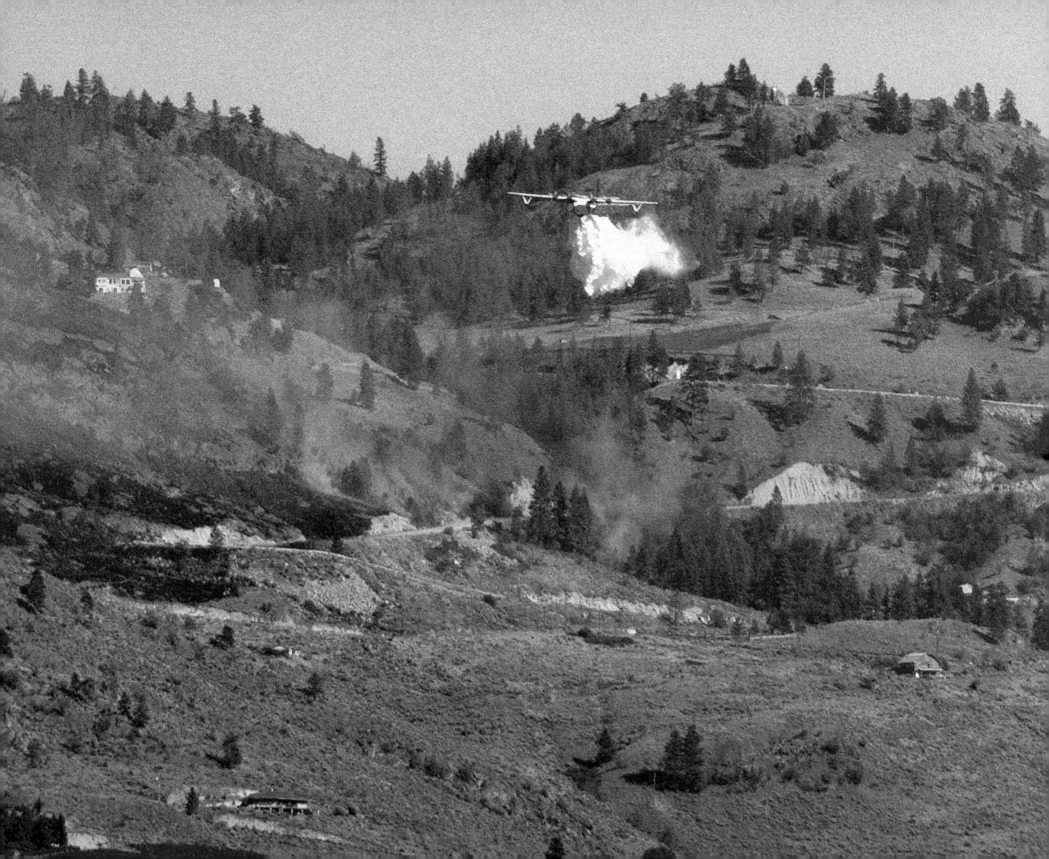

FIGHTING ON OTHER FRONTS

Many fires that swept through the Interior in the summer of 2003 were ignited by lightning. Against lightning, there is no defence. But others, including the fire that threatened Falkland, were started because a smoker carelessly flicked a lit cigarette from the open window of his vehicle. The cigarette landed on a bed of dry pine needles and, within minutes, a conflagration was born.

British Columbia was clogged with smoke, much of it caused by people who could not be bothered to safely extinguish their cigarettes. The Cedar Hills fire near Falkland started just after midnight on August 2, about 300 metres from the Whispering Pines Café on Highway 97. The area was put on evacuation alert and the highway closed for three days.

Many rural residents were awakened in the middle of the night by a knock on the door. Emergency workers told them they had to evacuate immediately. Farmers were often obliged to abandon their livestock, and residents, their pets. Only one house and two outbuildings were lost due to the stupidity of the careless smoker, but to the one family, it was a profound loss. After the 1,500-hectare fire ripped through the area, all that

◀ *A Martin Mars water bomber drops its load of water on the Anarchist Mountain fire.* (S. Paul Varga/*Penticton Herald*)

remained of their home were charred pots and pans, stairs that went nowhere, a chimney, and the skeletal remains of an all-terrain vehicle.

Fortunately, the Cedar Hills fire was not pushed by strong winds as were other fires, and consequently did not attain their ferocious power. But dense smoke often prevented air tankers from bombing the blaze, which proved hard to contain until wind blew the flames back into burned-out areas. Dew formed for the first time in weeks. Then, the fire burned into a flatter area, where heavy equipment could gain access in order to establish a fireguard.

As one fire was tamed, another blaze started. In a remote, hilly area 60 kilometres to the east of Falkland, crews had to rappel down from helicopters to tackle the blaze. Even though firefighters hit the fire early with bucket-equipped helicopters and air tankers, it proved stubborn. But tenacious firefighters ultimately stopped it. A blackened forest and charred trees served as a reminder that even a small fire could be dangerous. Penticton and Okanagan Falls farther down the valley weren't as lucky when the fire at Vaseux Lake erupted. Small fires become big ones quickly when forests are dry. The result, again, was that families were forced out of their homes and wide swaths of forest were destroyed.

On August 22, an osprey nest atop a hydro pole on Vaseux Lake caught fire, fell, and ignited the grass near Okanagan Falls, 15 kilometres

south of Penticton. Three hours later, the wind had blown the blaze across 200 hectares. It grew overnight to 1,200 hectares. Helicopters, air tankers, and a Martin Mars water bomber, the largest in the world, scooped water from nearby Skaha Lake and dropped it on the spreading fire. Still, the fire soon threatened outlying areas of Penticton along the lake. Twenty homes were evacuated for a day. Before it was stopped, the fire had grown to 3,300 hectares. It danced around the Weyerhaeuser mill in Okanagan Falls and forced the closure of a stretch of Highway 97. The fire disabled three power lines, causing a blackout that affected 60,000 people. Crews rebuilt two lines and replaced dozens of hydro poles. When the fire jumped to level five, the second-highest classification, burning branches rolled down slopes and trees candled. Firefighters held the line at the leading southeast corner of the fire and air tankers helped cool it off. Firefighters worked frantically to save the Vaseux Creek canyon, the prime winter grazing ground for California big-horn sheep. The sheep escaped to a nearby canyon. When the fire kept spreading in spite of all efforts to stop it, 247 Canadian soldiers joined 700 firefighters from 11 B.C. fire departments. They were backed up by firefighters from Alaska, Yukon, the Northwest Territories, and Ontario.

Nine days after it started, even with all that manpower and resources, the fire had grown to 33 square kilometres. Firefighters were engaged in a pitched battle to hold the ridge on the north slope of Skaha Lake. Because the terrain was too steep for heavy equipment, firefighters built a fireguard by hand and started small fires to burn back against the main blaze. While they toiled to keep the fire away from adjacent grasslands, where it would spread faster, ranchers were rounding up cattle, keeping them ahead of the flames.

Despite the smoke that was choking the valley, the Ironman Canada triathlon went ahead as scheduled on August 24. Two thousand athletes swam, ran, and biked in air made acrid by the Okanagan Mountain Park and Vaseux Lake fires. The marathon route, usually an out-and-back race to Okanagan Falls, was changed. When athletes finished the 2.4-mile swim and 112-mile bike ride, they had to run 26.2 miles in three loops around Penticton.

Farther south, crews were still mopping up after the Anarchist Mountain fire above Osoyoos, an Okanagan town near the U.S. border, about 60 kilometres south of Penticton. Two houses were annihilated and 1,200 hectares of forest scorched a month earlier, when B.C.'s first major interface fire of the season ran up the mountain and singed dozens of homes. Fire officials suspect a spark that flew off the brakes of a truck touched off the Anarchist Mountain blaze on July 16. The flames spread up the slope in steep, rocky terrain towards the crest, forcing the highway to close for a day and 30 families to evacuate. The fire burned past many rural homes and several bed and breakfasts, causing minimal harm. But it destroyed one house under construction and a summer log home. A third house was damaged when a tree beside its sundeck caught fire and sent flames into the front room. Firefighters from Osoyoos, Oliver, and local volunteers helped extinguish the flames before they spread further. Horse owners moved out their animals. No rangeland was threatened, but plenty of timber went up in smoke. A Martin Mars water bomber flew in from the B.C. coast to dip into Osoyoos Lake and drop water on the fire. Twin-engine CL 415s dumped water and foam after the fire jumped a guard July 18. A Conair tanker unloaded long-term retardant. The imminent threat passed after the first week and residents returned home. Water tenders and bulldozers helped firefighters contain the blaze by the second week.

A helicopter pilot was still working the area a month later when the Okanagan Mountain Park fire broke out. Eric Stoof of Penticton was

getting ready to resume bucketing the Anarchist Mountain blaze. He was sent north to Kelowna instead, making him the first pilot to attack the most destructive fire of the summer.

Over in the Kootenays, fires proved more stubborn than Anarchist Mountain, and much more effort was required to finally douse them. Nelson, which hadn't had a major forest fire since 1896, was encircled by them, with 140 burning in the vicinity. The biggest was Kutetl, the sixth-largest fire in B.C. at 7,808 hectares. But there were other fires tearing up the area: Woodbury, Hidden Creek, Sitkum Creek, Crawford Creek, Hamill Creek, and Staubert.

A lightning strike ignited Kutetl on August 9, ten kilometres and two valleys away from historic Nelson. It spewed large clouds of smoke and blanketed the surrounding area with ash. The blaze burned through recreational forest, portions of Nelson's primary watershed, and large tracts of raw timber. Just as in Kelowna's Okanagan Mountain Park fire, down-drafts at night pushed the fire downhill, causing problems for the 250 firefighters, pilots, and heavy-equipment operators. The approaching flames prompted evacuation plans for the nearby villages of Harrop and Procter. If the two tiny communities had been forced to uproot, the 650 residents, with all their vehicles, would have escaped by ferry.

The lightning storm that started Kutetl also ignited the Woodbury Creek and Hidden Creek fires, and created an intense haze. Hidden Creek only blackened 155 hectares of forest before its final flicker. The Woodbury Creek fire was a bigger problem. It worried hikers and back-country skiers because of its proximity to pristine Kokanee Glacier Park and the threat to two popular high-country cabins. Flames smouldered and jumped through 1,472 hectares of prime Selkirk Mountain wilderness, wildlife habitat, and threatened two cabins. Both structures were wrapped in a protective fireguard.

The blaze at Hamill Creek at the northern tip of Kootenay Lake burned only 505 hectares, but it concerned outdoors lovers because the Hamill Creek trail, which winds through a large grove of huge, ancient cedar trees, is a popular tourist draw and the gateway to the renowned Earl Grey traverse. In the Slocan Valley to the west, near Nakusp, 450 people were put on evacuation alert and five ordered out of their homes due to the Ingersol and Burton fires. Ingersol, 25 kilometres south of Nakusp on the west side of Arrow Lake, started on August 10 and destroyed 6,700 hectares. The Burton fire, across the lake on the east side, started August 7, and torched 530 hectares.

In the East Kootenay region, fire officials were trying to get the upper hand on a series of potentially dangerous fires that threatened homes south of Cranbrook, a city of 18,000 people. The lightning-caused blaze flared up on August 11 in the Lamb Creek Valley just west of Moyie Lake. Crews had to be pulled from the fire, which sent billowing clouds of smoke north over the city. A new fire at Plumbob Mountain, 35 kilometres southeast of Cranbrook, also erupted, prompting the Forestry Department to order four families out of its path. Firefighters could not slow the advance of the flames, despite the assistance of air tankers and bucket-equipped helicopters operating from above. Embers fell on Cranbrook and covered decks with a layer of ash. The Kootenays became the new fire hot spot, with more than 300 fires burning.

The Lamb Creek fire, 15 kilometres south of Cranbrook, was buffeted by a strong wind and grew to 500 hectares by August 13. The Plumbob Mountain fire was also burning out of control. It grew to 1,000 hectares by August 14.

Lamb Creek was the hardest to fight because it burned in steep, difficult terrain. Firefighters battled to re-establish control lines around the fire as it spread. On August 26, strong winds fanned it more. Evacuation

orders drove 100 residents from the area. Another 1,000 prepared for a hasty departure as gusting winds threatened to make matters worse. Helicopters and air tankers discharged water as bulldozers and excavators built new containment lines to keep the 8,000-hectare blaze in check. Then stronger, gale-force winds grounded helicopters and forced crews to retreat the next day. The blaze jumped fireguards and headed towards Lumberton, 12 kilometres southwest of Cranbrook. Blowing embers started spot fires two kilometres in front of the fire line. Another 80 people were told to get out of their houses and cottages as the fire grew. The front was 500 metres from the nearest residence. Smoke and ash fell on Cranbrook for days. Firefighters put sprinklers atop buildings, which saved them from the 80 kilometre-an-hour firestorm. By August 28, 211 people had been forced out. On September 1, the Lamb Creek fire covered 110 square kilometres and Plumbob Mountain fire, 29 square kilometres.

In the midst of the crisis, hundreds of firefighters were overjoyed to put their blackened hands on the Stanley Cup. Scott Niedermayer, defenceman for the NHL champions New Jersey Devils, brought hockey's holy grail to his hometown of Cranbrook as a morale booster for the exhausted crews. Like a pied piper, Niedermayer carried the Cup through the Moyie Lake camp, stopping for group pictures. Sections of the fire stayed active, but the crews held the lines. Their prayers were answered on September 8 when 15 millimetres of rain dampened the blaze. Nature had a hand in starting the fires and was decisive in bringing a fiery season to an end.

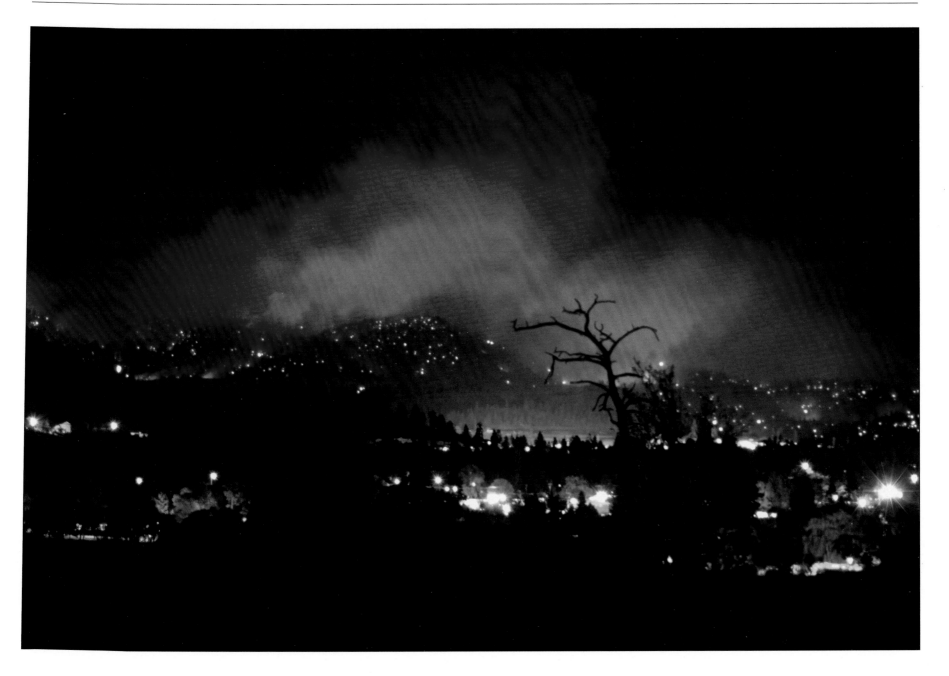

The Vaseux Lake fire was barely 12 hours old when winds blew it north and east, away from the town of Okanagan Falls early on August 24. (S. Paul Varga/*Penticton Herald*)

The wharf of Fred and Gloria Hoeschmann, evacuated residents of Monroe Lake near Cranbrook, was hit by a fireball and destroyed.
(Joey Hoeschmann)

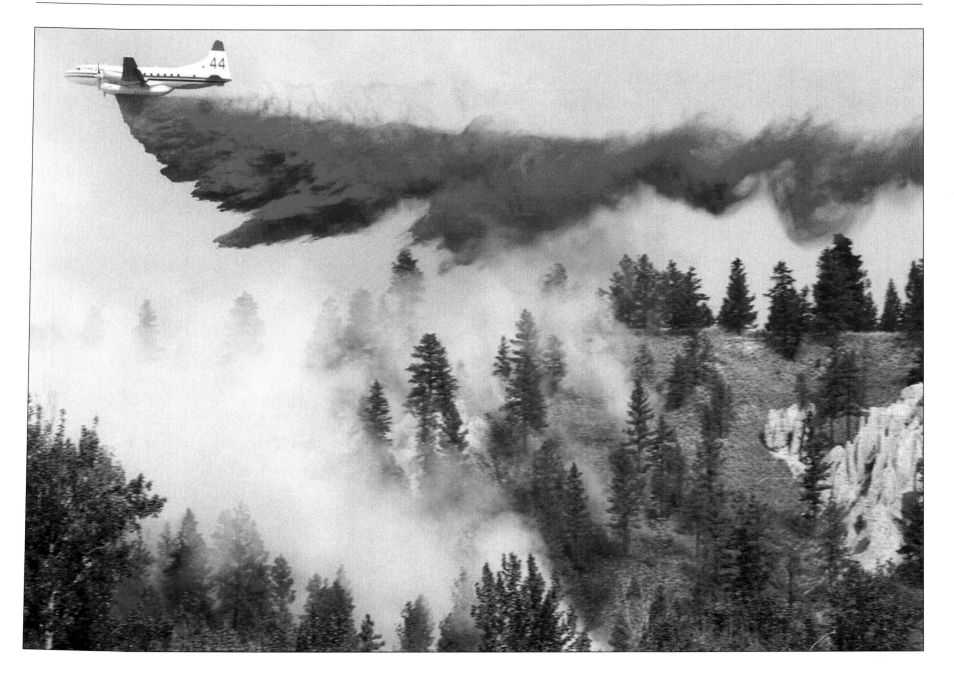

A Forest Service air tanker dumps a load of fire retardant over a bush fire near St. Eugene Mission, 10 kilometres north of Cranbrook.

(Troy Hunter/*Cranbrook Daily Townsman*)

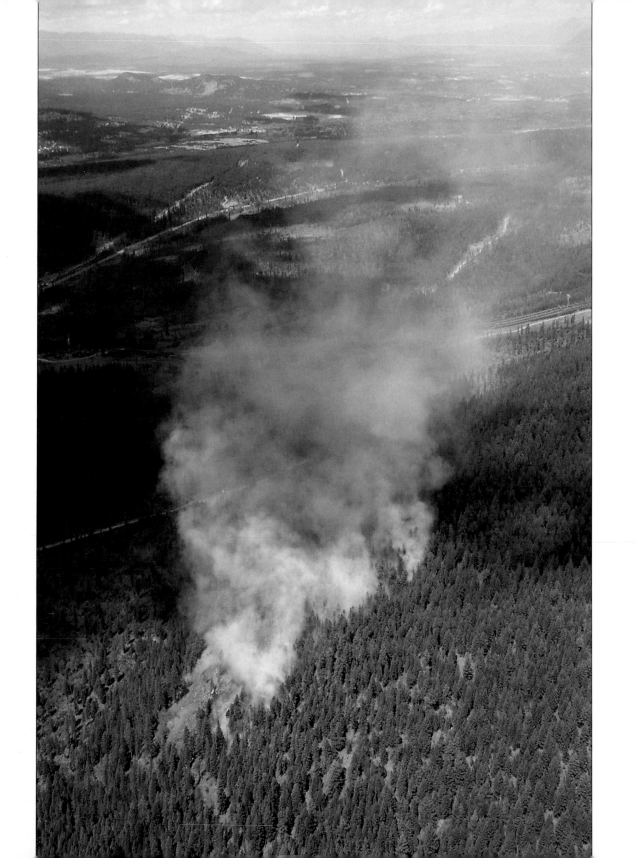

Smoke billows from the crash scene where a four-engined Lockheed 188 Electra crashed on July 16 as it was trying to douse a small forest fire 10 kilometres south of Cranbrook. The impact killed the pilot, 41-year-old Ian MacKay of Rossland, and the 36-year-old co-pilot, Eric Ebert of Toronto.

(Chris Marchand/*Cranbrook Daily Townsman*)

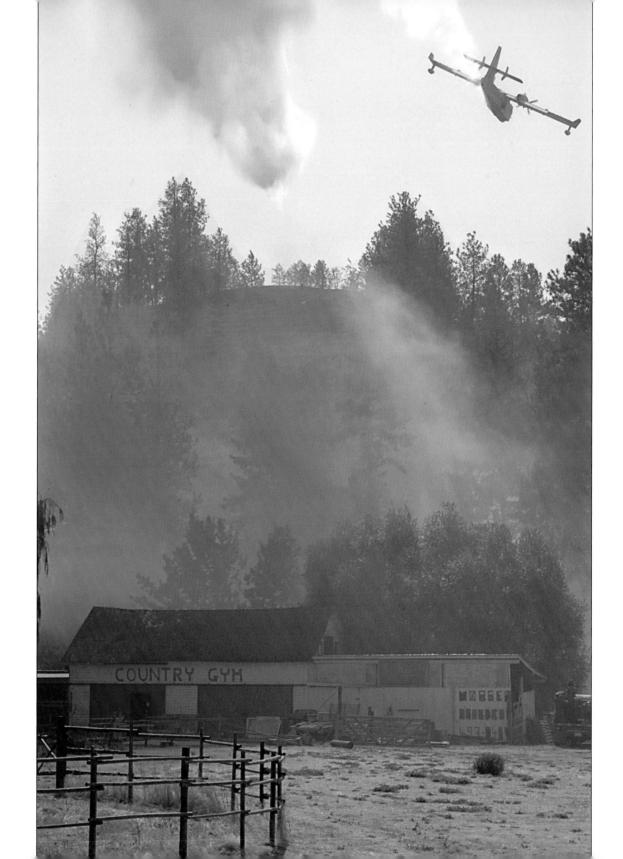

A one-hectare fire off McLean Creek Road just north of Okanagan Falls was fought by Okanagan Falls volunteer firefighters, the Penticton Fire Department, and B.C. Forest Service ground-based firefighters and air tankers.

(S. Paul Varga/*Penticton Herald*)

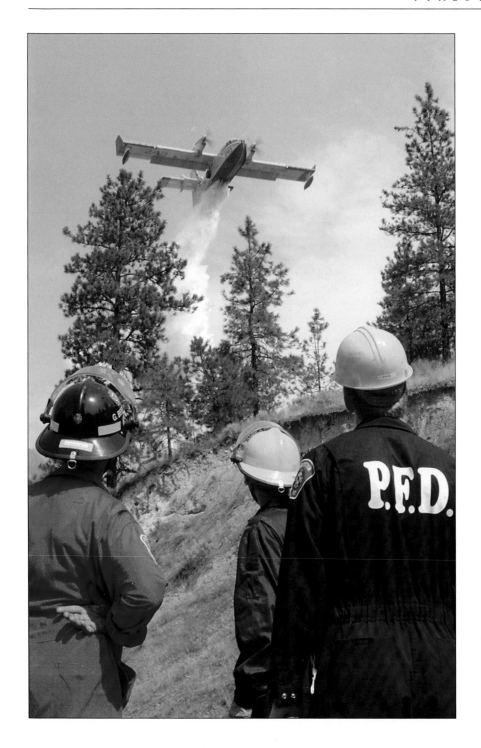

The Martin Mars bomber draws close attention from people stopped along Highway 97 near Okanagan Falls as it prepares to pick up another load of water from the south end of Skaha Lake. (John Moorhouse/Penticton Herald)

Full-time Penticton Fire Department member Glen Beirle and volunteers Mark Woods and Scott Gardiner watch a Quebec-based air tanker drop a load of water on a one-hectare fire near McLean Creek Road. Okanagan Falls volunteer firefighters and B.C. Forest Service ground-based firefighters also took part in the action. (S. Paul Varga/Penticton Herald)

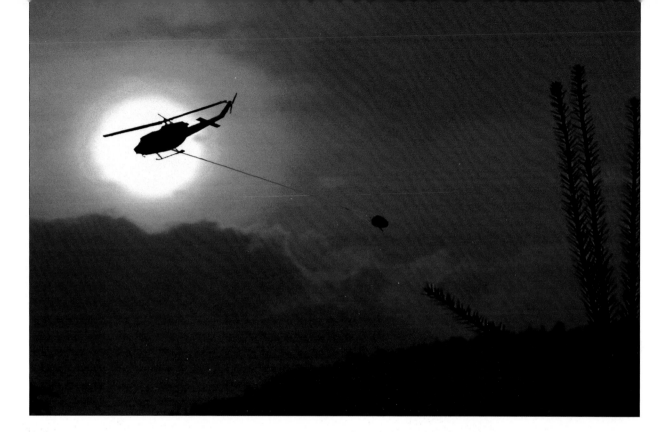

A helicopter heads to the Kutetl Creek fire near Nelson on August 15, the most dramatic day of the summer for residents who woke up to a brilliant, orange blaze. That afternoon, they were sweeping ash off their cars. (Margaret Hughes)

Rick Fleming, Okanagan Falls Volunteer Fire Department Safety Officer, left, works with B.C. Forest Service Fire Information Officer Jerome Jang to create a "boot-guard" around a stump which burst into flame just as a fire-information tour drove by. (S. Paul Varga/*Penticton Herald*)

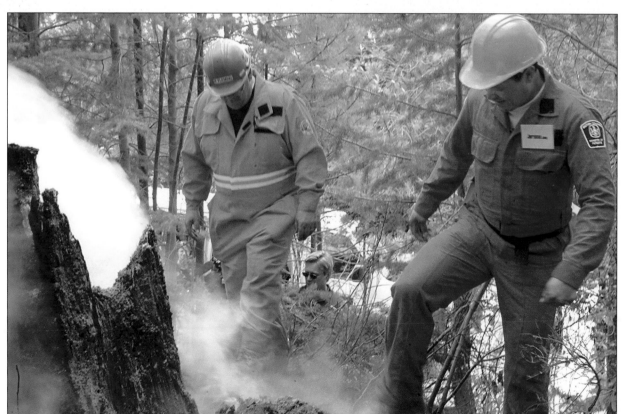

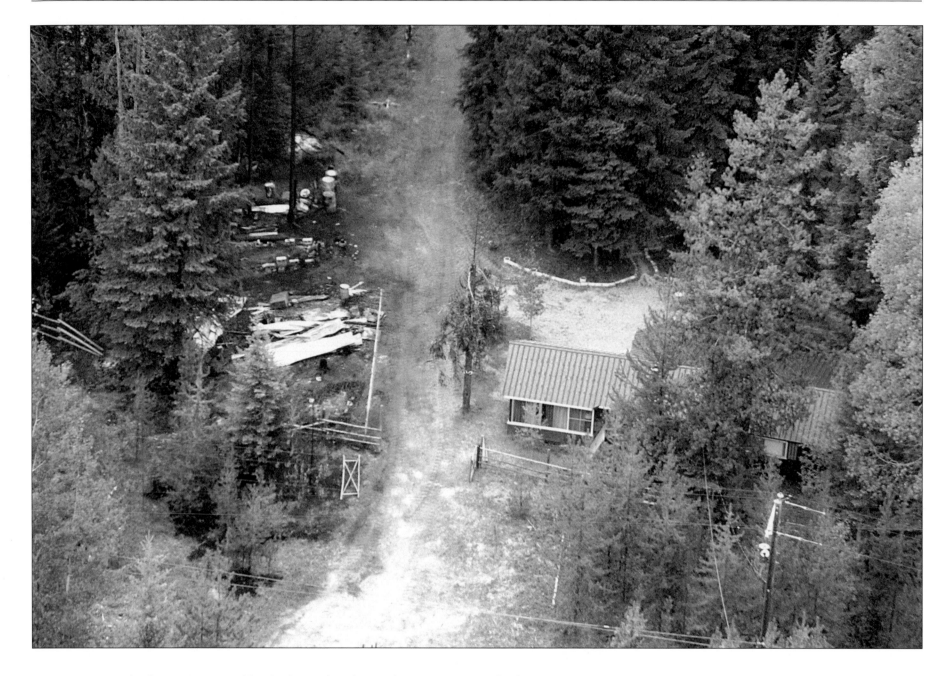

The destruction caused by the fire in the Chute Lake Resort area north of Naramata came close to, but did not touch, this building.

(Alan Heaven)

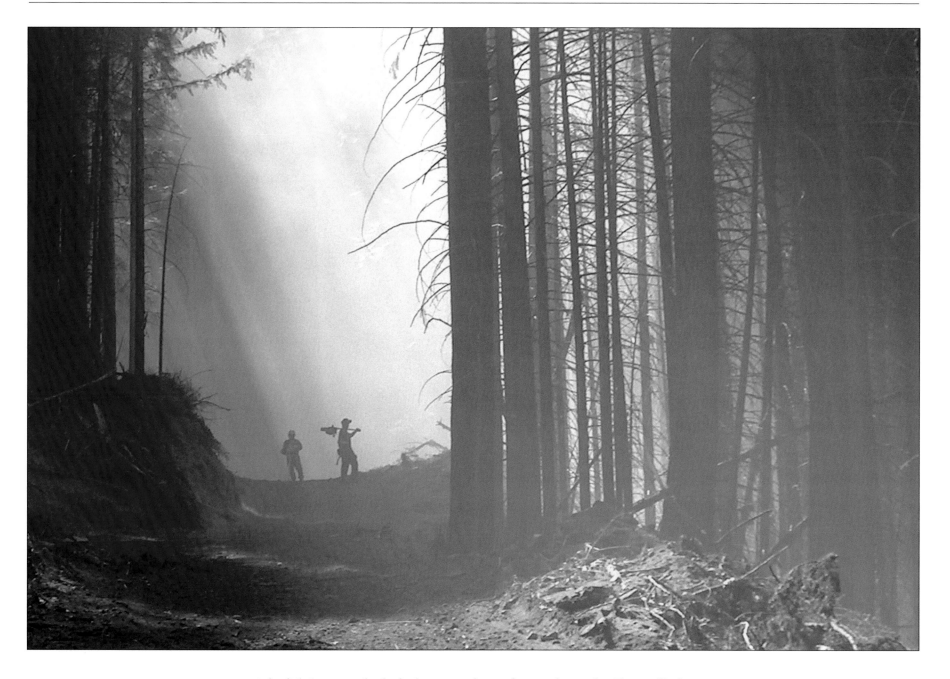

A firefighting crew checks for hot spots along a fireguard near the Cherryville fire.

(Warren Lee)

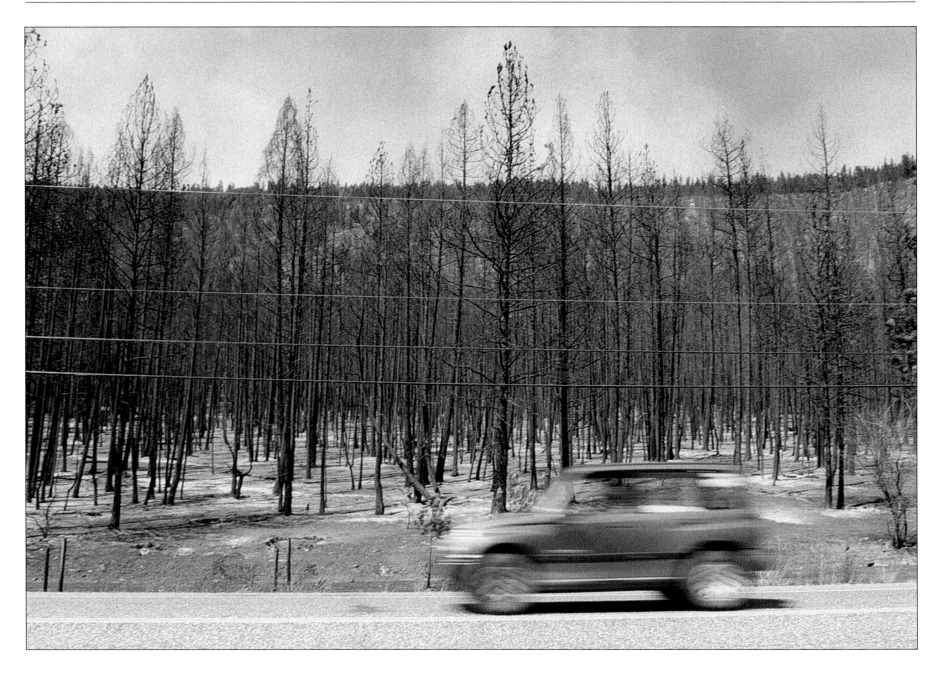

The Cedar Hills fire near Falkland forced the closure of Highway 97 for several days. The fire started at the side of the road near the Whispering Pines Cafe. (Darren Handschuh/*The Daily Courier*)

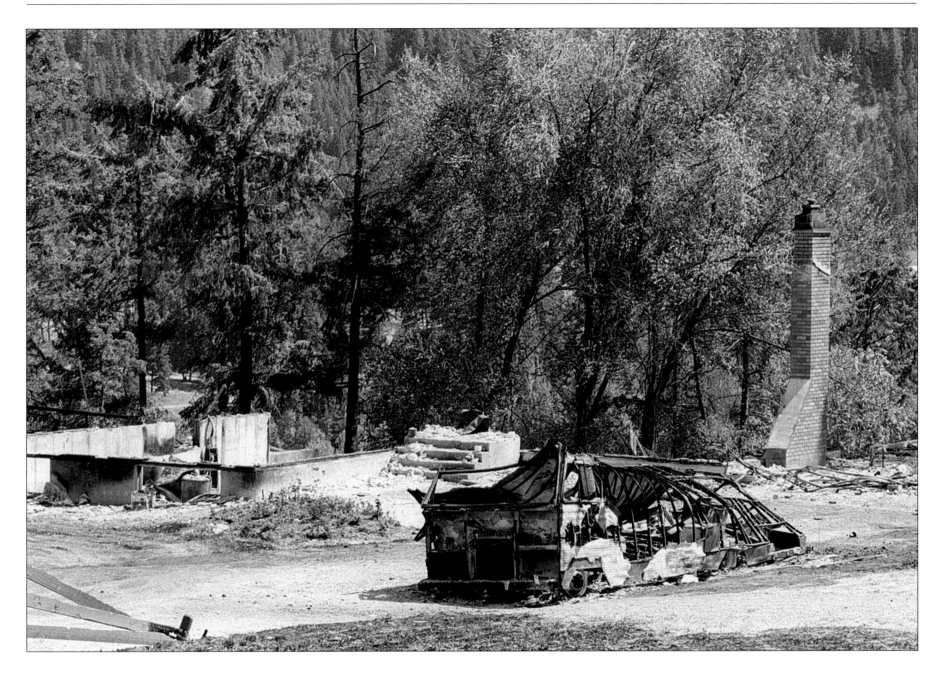

Although almost 1,000 people were evacuated, the Cedar Hills fire near Falkland claimed only one home.

(Darren Handschuh/*The Daily Courier*)

Lieutenant-Governor Iona Campagnolo writes a note of thanks to firefighters on a blackboard at Vernon's Clarence Fulton Secondary School, site of a fire camp for those battling the Cedar Hills fire. Campagnolo met with fire officials and toured the area.

(Darren Handschuh/*The Daily Courier*)

Heavy-equipment crews get ready to tackle the Cedar Hills fire near Falkland.

(Darren Handschuh/*The Daily Courier*)

The remains of the Kutetl Creek fire paint
a dramatic picture of what's left after flames
tore through the forest near Nelson.

(Darren Davidson/*Nelson Daily News*)

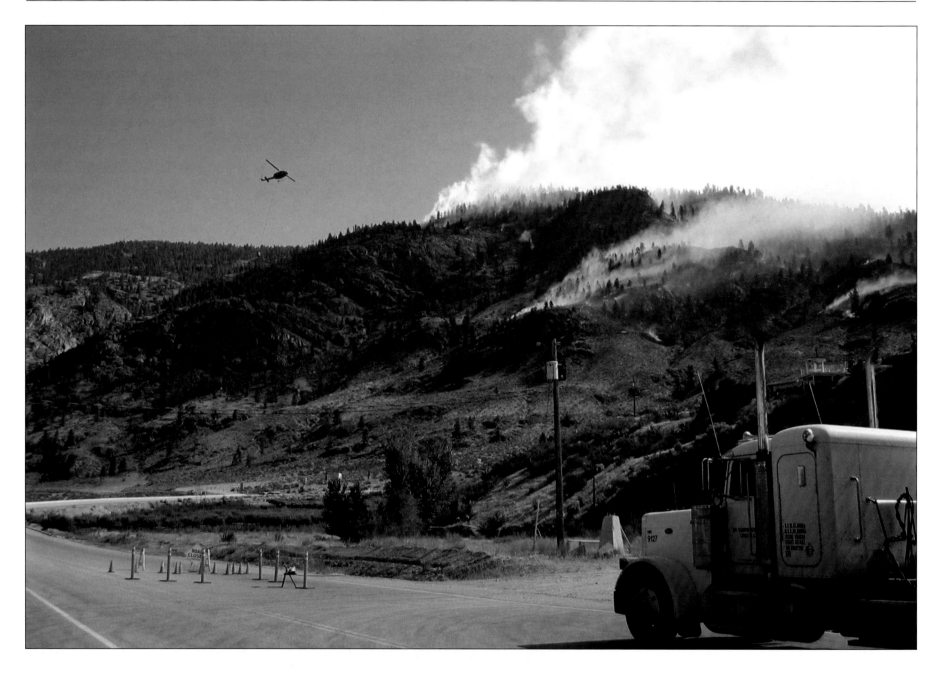

A tractor-trailer waits at a roadblock on Highway 3 while a helicopter fights the Anarchist Mountain fire.
(Laurena Typusiak)

Ten days after the Kutetl Creek fire started 10 kilometres southwest of Nelson, a massive smoke plume crawled over the mountainside the city is built on. The next day, heavy smoke settled into the valley, where it stayed for close to a month. (Kathy Kiel)

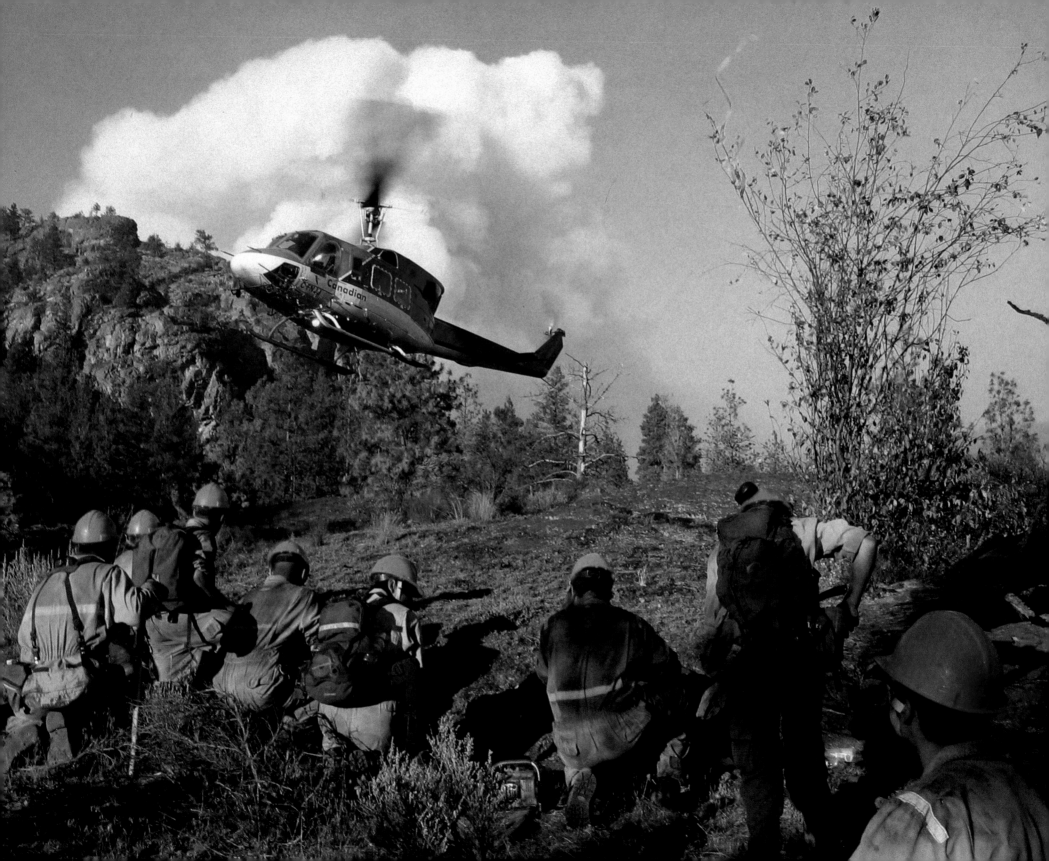

THE FRONT LINES

Sweat carved rivers in their soot-blackened faces. Fatigue showed in their red-rimmed eyes. They choked on the smoke and felt the fire sear their skin. Around them, trees candled and popped. Flames leapt and roared and raced along the ground, chased by crown fire that skipped across the tops of trees. They worked 12 to 18 hours a day and perspired as much as a litre of water an hour. Unless you've worked in the asphyxiating fog of a forest fire, it is impossible to appreciate what they endured on the front lines in 2003. The work was dirty, hot, and exhausting. They used pickaxes, power saws, and packed in hoses to clear fireguards. They gulped water. Unless they were in immediate danger, they worked unceasingly, chopping at tree stumps and spraying hot spots while breathing bad air.

The rash of fires raging through B.C.'s interior was unparalleled. Firefighters faced an enemy like none they had ever seen. High temperatures and dry conditions were the worst in a hundred years. Strong winds made the job especially treacherous. A Naramata firefighter described the Okanagan Mountain Park blaze as a front of flame a mile wide. Spot fires broke out at random. The roar of the fire sounded like a jet screaming above treetops.

◀ *Firefighters wait for a helicopter to take them into the fire.* (Kyle Sanguin)

In addition to all the other dangers, the firefighters had to contend with embers, 20 to 25 centimetres of matted needles that could blow for kilometres, and new fires ignited by the fierce heat up to 50 metres in front of advancing flames. The updraft of hot air sucked in cooler air, creating a windstorm that ripped the needles off pine trees. Deadfall, snags, and pits of hot ash were constant hazards. Firefighters inhaled ash when water hit smouldering areas. One man near Barriere was badly burned when he fell into an ash pit, which had hot coals at the bottom.

On the worst day of the McLure-Barriere fire, a wall of smoke and tower of flame roared up the North Thompson River valley, destroying houses and the mill in Louis Creek. The roar of the flames echoed through the valley as propane tanks at the mill exploded.

The August 22 firestorm in Kelowna burned firefighters' morale as well as hundreds of houses. Fire Chief Gerry Zimmermann choked back tears as he announced that three of his men had lost their homes. "They were in there fighting to save other people's houses and they lost theirs. That's tough," he said. "And probably there's hundreds of houses standing today because of their guts."

John Kelly, 39, found out the house he had built for his family in Kelowna was destroyed after he drove back from Idaho with his wife and three kids. The 13-year veteran firefighter joined his colleagues on the fire

line four hours later. "I was trying to focus but I had a real hard time," he said the next day. "I want everyone to know that they did their best. I think a lot of guys are feeling guilty that it burned."

Zimmermann, 54, became the face of the city's determination and resolve. He was lauded as the city's own Rudy Giuliani, reassuring residents that all would be well again. He came across as a leader with compassion and good sense. People appreciated his upfront manner and dedication. When he told residents their houses were gone, some hugged him.

Most people on the front lines did their jobs without recognition. Heavy-equipment operators put their lives on the line just as firefighters did. They cut down trees, and built fireguards and supply lines. Changing winds pushed flames in new directions, forcing some to leave their bulldozers and skidders and flee on foot.

Firefighting mop-up crews worked in grids, looking for grey ground that indicated it was still hot and had the potential to flare up as fire. They turned over dirt and hosed it down. They sprayed water on logs and stumps. Electricians kept power running when lines were down. Utility crews made sure water was flowing through firefighters' hoses. Medical staff treated the injured or exhausted near the front lines. Police and other emergency staff kept people moving during evacuations. Air tankers were called in to slow the larger fires, buying time for firefighters on the ground to battle the flames, and for back-up crews to bring in bulldozers, skidders, and backhoes.

During the McGillivray fire, pilots saw orbiting fire a hundred metres above the trees. They could hear branches bouncing off the belly of the aircraft. By the end of August, air-tanker pilots had flown 1,080 missions and dropped 22 million litres of retardant. They averaged 250 to 300 hours in the air over the course of the summer compared to the average 150 hours. Helicopter pilots worked flat out, logging eight-hour shifts every day for weeks at a time. Their biggest challenge was to dump their water-filled buckets on target in areas where smoke obscured visibility.

Three pilots were killed during bombing missions. A four-engine air tanker crashed during a retardant run over a small forest fire near Cranbrook July 16, killing 41-year-old pilot Ian MacKay of Rossland and 36-year-old co-pilot Eric Ebert of Toronto. A month later, helicopter pilot Berhard George von Hardenberg died when his chopper crashed while he was fighting a fire north of Barriere. Others made sacrifices on the province's behalf. The effort to save the Interior from burning up became the largest Canadian Forces operation outside Afghanistan. Reservists and regular soldiers worked shoulder to shoulder with city and Forestry firefighters. The troops received only a day of training. The work was more labour-intensive than most peacekeeping missions. At the peak of the fire season in late August, 1,500 soldiers were fighting fires in B.C. Soldiers likened the firefight to a battle zone. Air operations and heavy tractors that sounded like tanks reminded many of battlefields they had fought on. For weeks, it was hard to say who was winning.

A sense of purpose against a common foe helped prevent more fatalities and bolstered the offensive. Soldiers say the crucible of war forges a bond among strangers. One of the first firefighters on the McLure-Barriere fire described his cohorts as a "band of brothers." The camaradarie kept them strong, and they won.

An injured firefighter is taken from a helicopter to a waiting ambulance at the Kelowna fire hall. Ambulance crews were waiting in the parking lot when the helicopter landed. (Darren Handschuh/*The Daily Courier*)

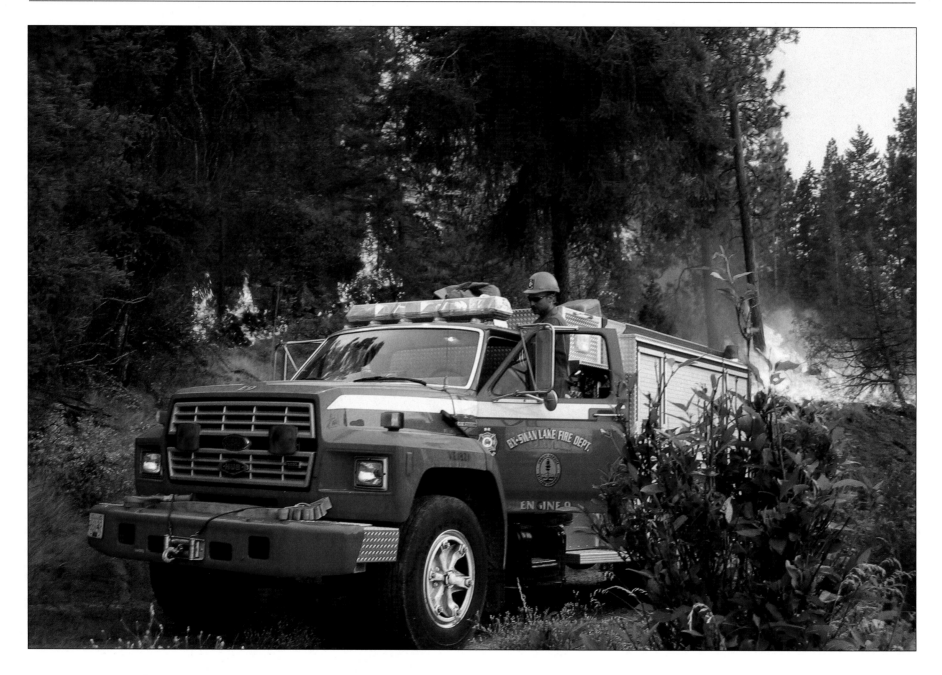

Firefighters from all over British Columbia, including this crew from Vernon, came with their trucks and equipment to help fight the many forest fires. (Kyle Sanguin)

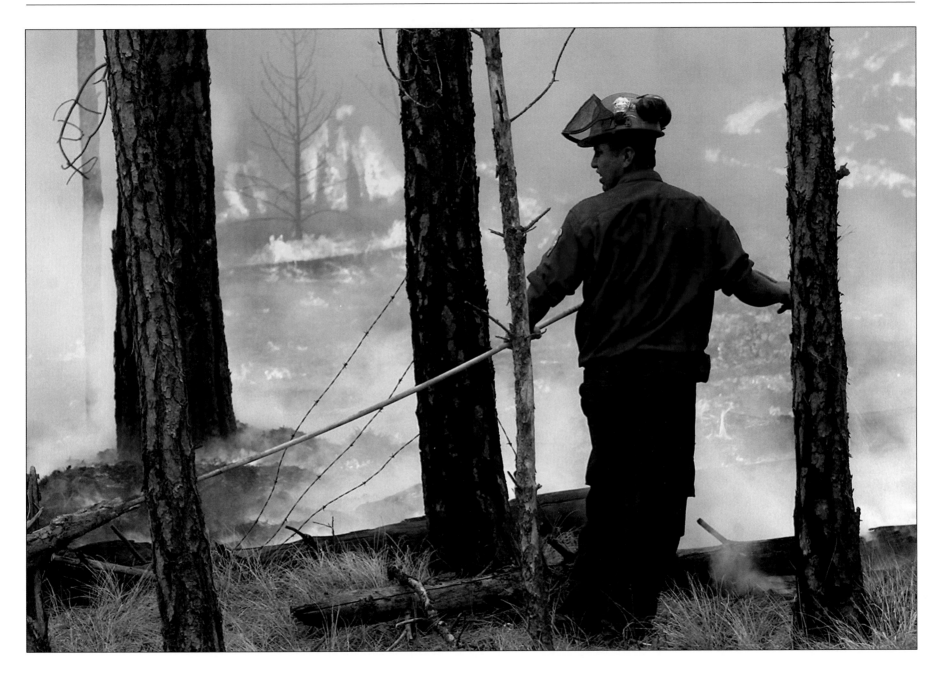

A firefighter battles a flare-up of the Okanagan Mountain Park fire along Lakeshore Road in Kelowna.

(Gary Nylander/*The Daily Courier*)

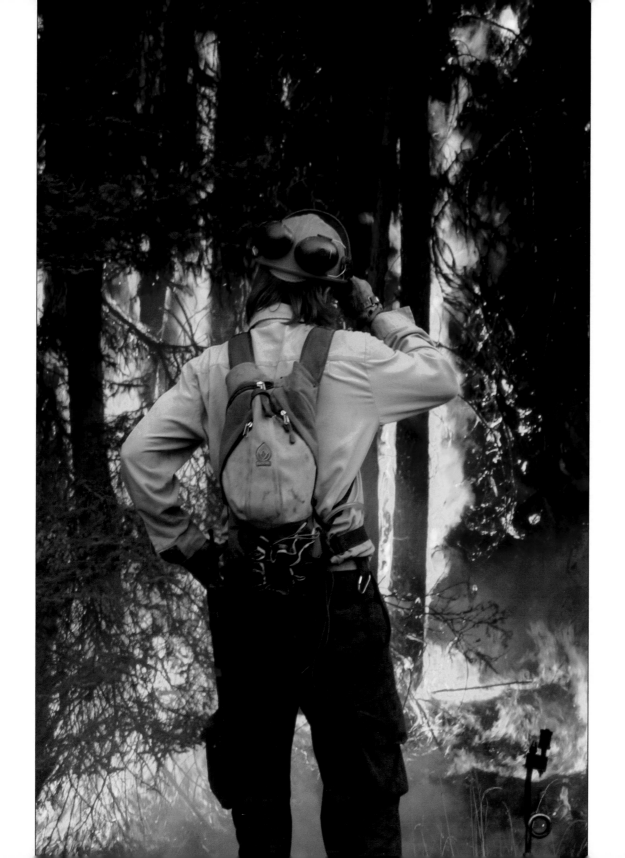

For a brief moment, firefighter and fire confront each other before engaging in battle during the Okanagan Mountain Park fire. (Kyle Sanguin)

Opposite left: *Danger tree assessor Warren Lee cuts down a still-burning tree at the Vaseux Lake fire, making the area safer for the firefighting crews that would follow.* (Sean Ardis)

Opposite right: *Private Shane Ritchie of the B.C. Dragoons in Penticton puts out hot spots on the fire line of the Okanagan Mountain Park fire in East Kelowna.* (Gary Nylander/*The Daily Courier*)

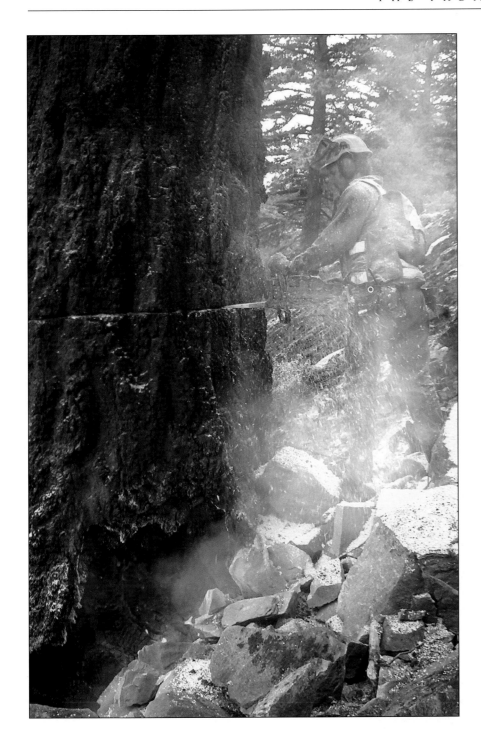

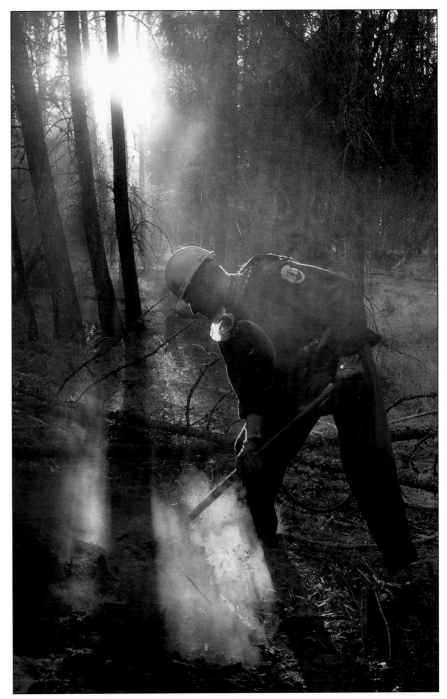

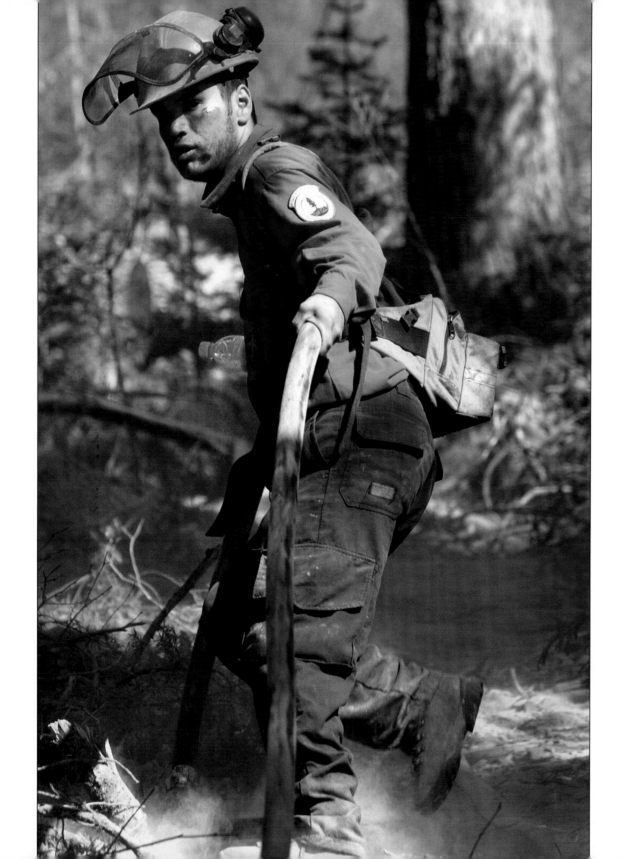

Gregory Peters pulls a hose through the trees above Niskonlith Lake while fighting hot spots on the McGillivray fire near Chase.

(Keith Anderson/*Kamloops Daily News*)

Firefighter Yukon Ellsworth takes a break at the Chute Lake staging area near Kelowna.

(Gary Nylander/*The Daily Courier*)

Bulldozer operator Ken Longstaff a takes break from fighting the Okanagan Mountain Park fire. (Gary Nylander/*The Daily Courier*)

Anna Chayba, a Kelowna volunteer firefighter, was one of several women volunteers who fought the Okanagan Mountain Park fire.
(Gary Nylander/*The Daily Courier*)

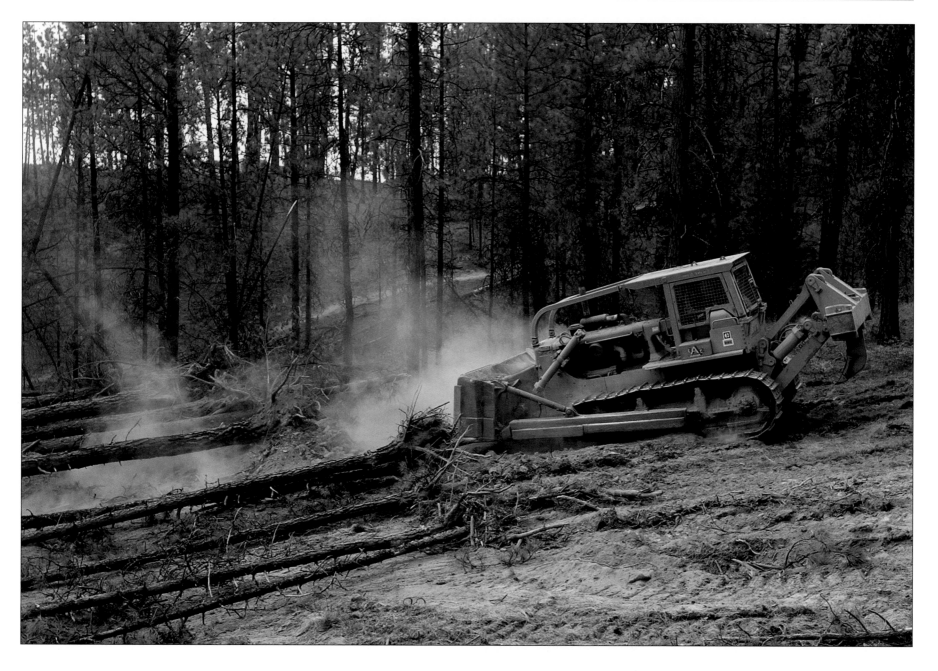

Ken Longstaff's big D8 Cat knocks down trees to create a fire break ahead of the advancing flames outside Kelowna.

(Gary Nylander/*The Daily Courier*)

Dust billows behind a tanker skidder coming from the fire line above June Springs Road in Kelowna. The dry conditions turned the mountains into dust bowls.

(Darren Handschuh/*The Daily Courier*)

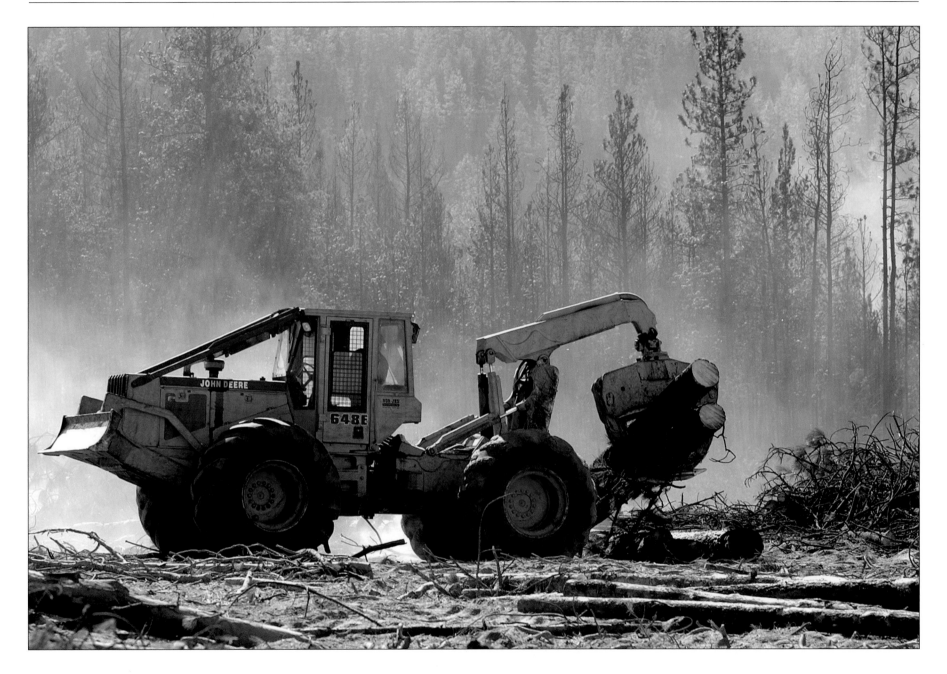

A machine works along Chute Lake Road where logs are being salvaged from the Okanagan Mountain Park fire.

(Gary Nylander/*The Daily Courier*)

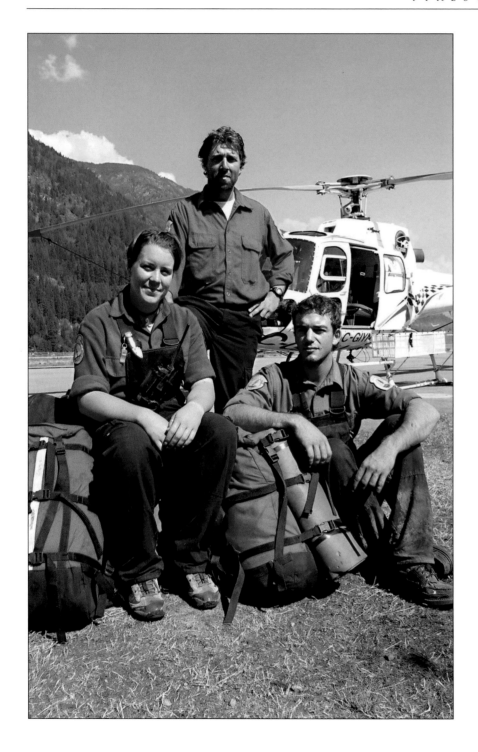

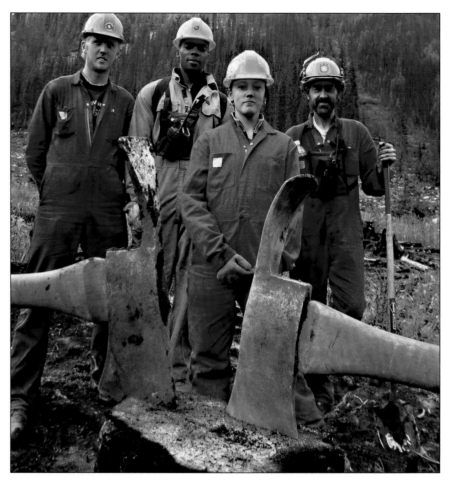

By mid-September, the Kutetl Creek fire near Nelson was contained and fire crews were putting out hot spots. This crew was called Timberland India and was one of the last to work on the 7,800-hectare fire.
(Darren Davidson/*Nelson Daily News*)

The Southeast Romeo initial attack crew prepare for one of their final helicopter flights of the summer. Shannon Mallory, left, Derek Sommerville, centre, and Josh Cinnamon spent the summer on the front lines.
(Bob Hall/*Nelson Daily News*)

Private Bree Healey of the Seascott Canadian Scottish Regiment on Vancouver Island takes a break from battling the Okanagan Mountain Park fire. (Gary Nylander/*The Daily Courier*)

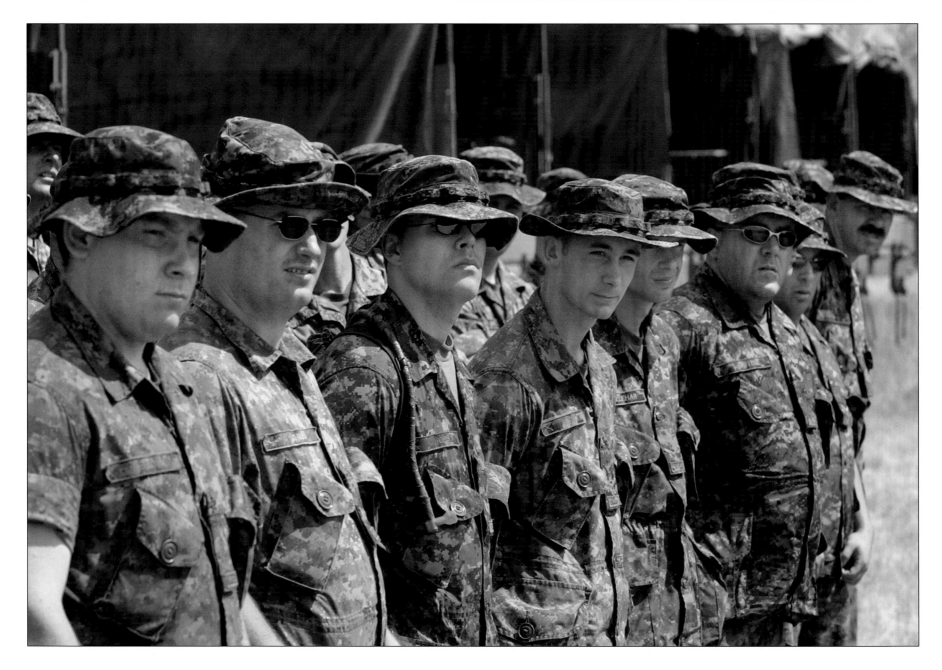

Members of B Company, First Battalion Princess Patricia's Canadian Light Infantry from Edmonton are briefed on the fire at the Rayleigh fire camp in Kamloops before moving onto the fire line. (Keith Anderson/*Kamloops Daily News*)

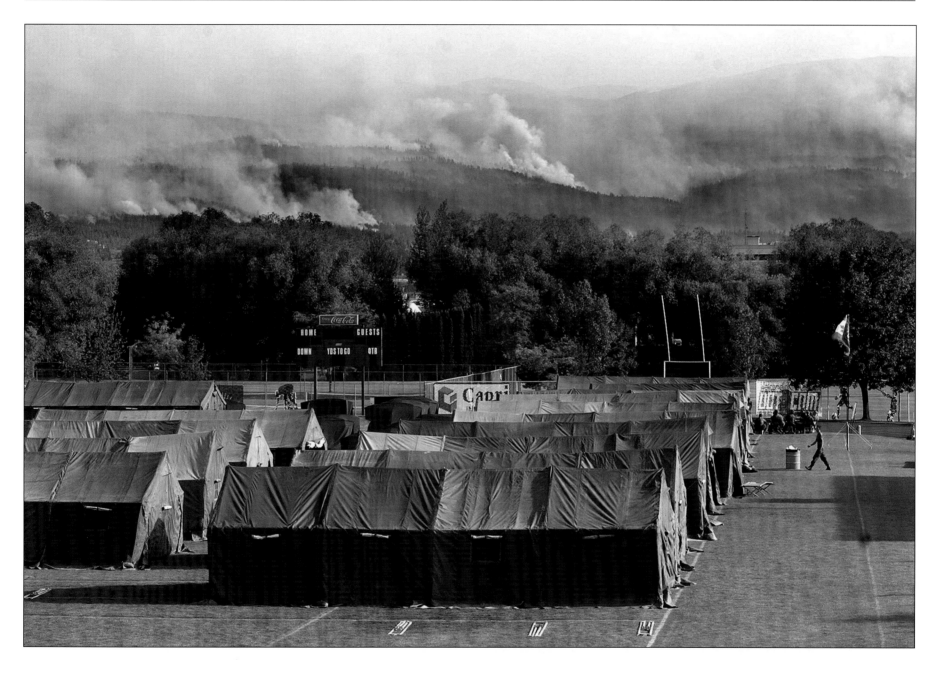

Kelowna's Apple Bowl is transformed into a Canadian Forces camp for the duration of the Okanagan Mountain Park fire.

(Gary Nylander/*The Daily Courier*)

Firefighters Jeff Duncan and Derek Taylor prepare loads of equipment for the Kutetl Creek fire near Nelson. (Darren Davidson/*Nelson Daily News*)

A Forestry firefighter stands nonchalantly atop a burning stump above Squally Point in the early days of the Okanagan Mountain Park fire. (Jeremy Wageman)

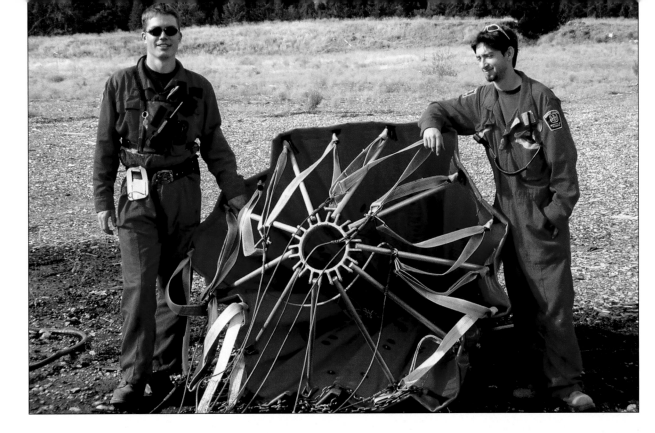

The Bambi bucket, suspended from a helicopter and filled with water, was an integral part of the fight against the B.C. forest fires. Yukon Ellsworth (left), and Jeremy Wageman get a close look while the helicopter fuels up near Peachland.
(Jeremy Wageman)

Firefighter Jamie McLean was one of the last to work on the Kutetl Creek fire near Nelson, which had all but burned out by mid-September.
(Darren Davidson/The Daily News)

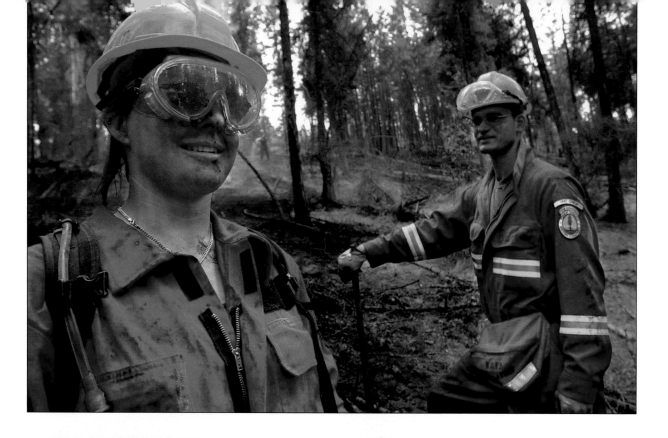

Private Tatyana Danylyshyn, left, and Corporal George Scott of the Canadian Scottish Regiment were part of the military contribution to the firefighting effort.
(Gary Nylander/*The Daily Courier*)

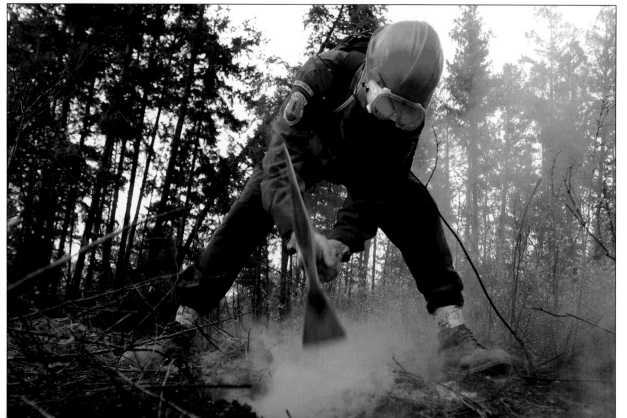

Private Gagandeep Nahal attacks a hot spot in the Okanagan Mountain Park fire near East Kelowna.
(Gary Nylander/*The Daily Courier*)

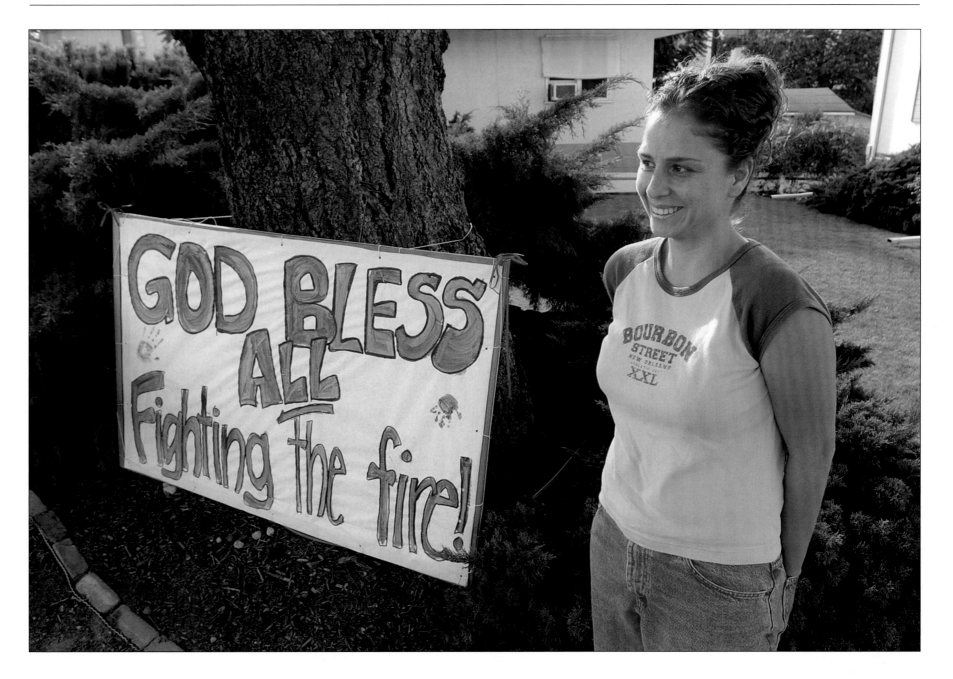

Ingrid Ulrich of Kelowna stands beside the sign she put up in front of her Bernard Avenue home in Kelowna.

(Gary Nylander/*The Daily Courier*)

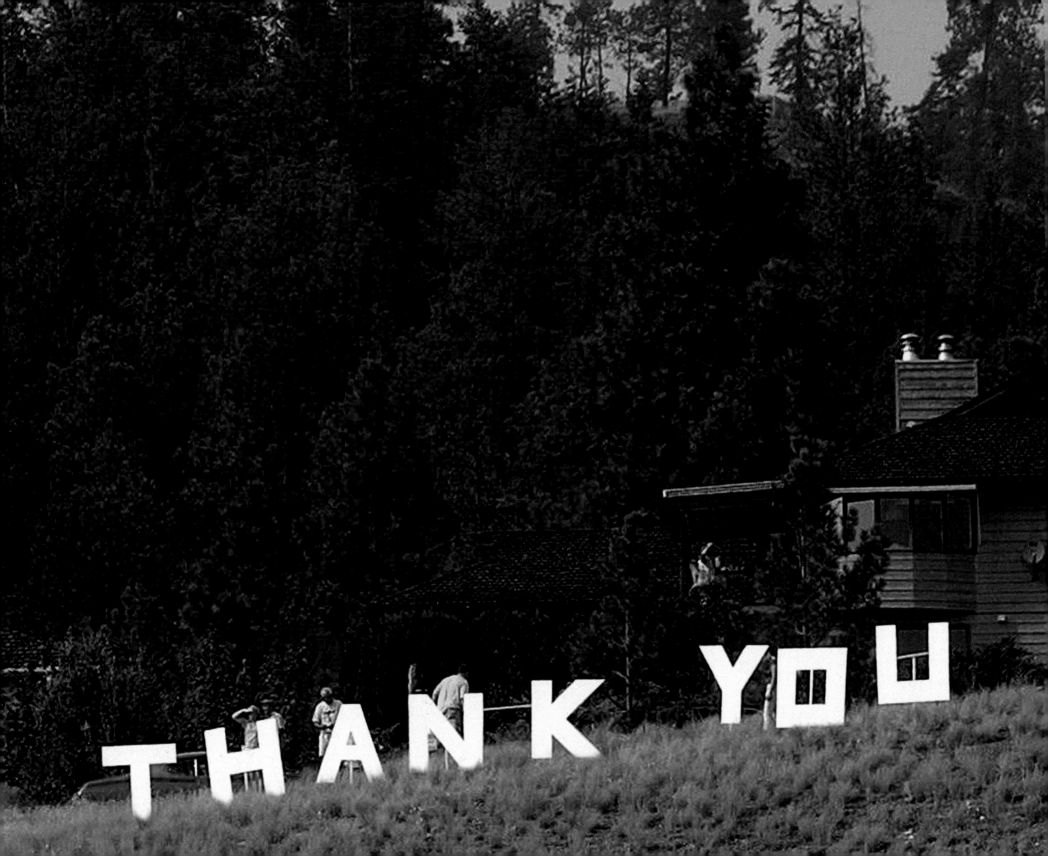

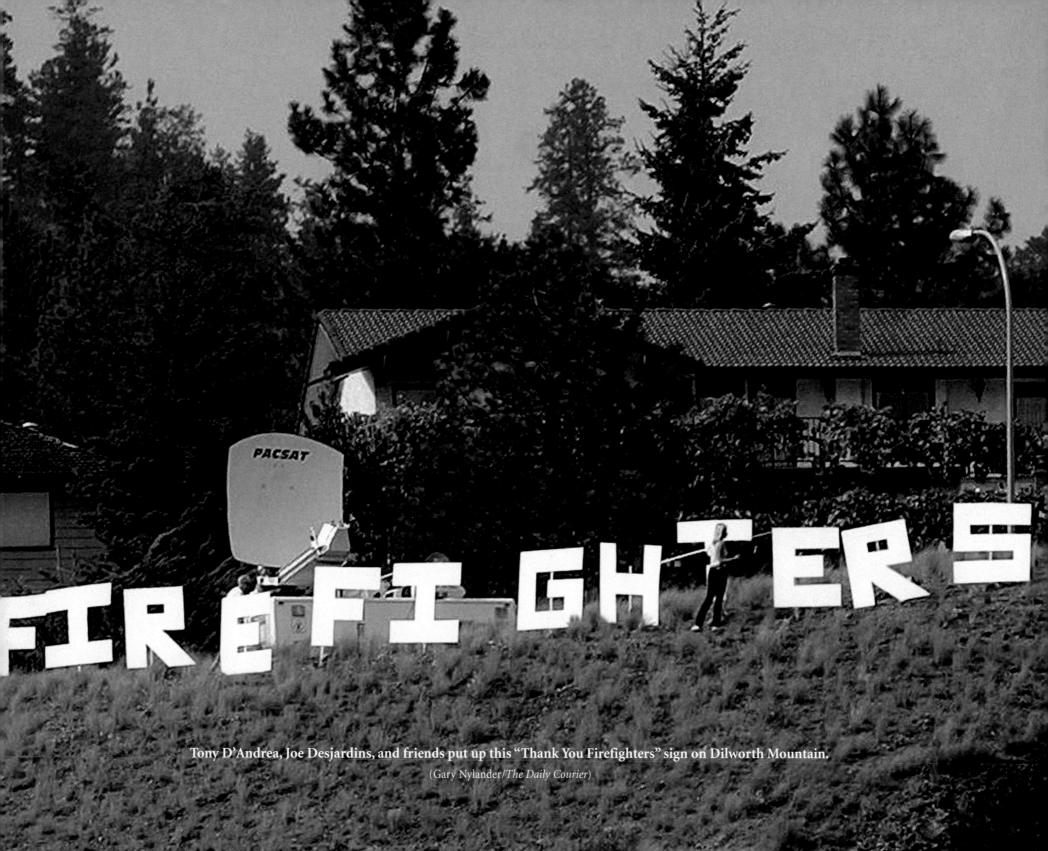

Tony D'Andrea, Joe Desjardins, and friends put up this "Thank You Firefighters" sign on Dilworth Mountain.

(Gary Nylander/*The Daily Courier*)

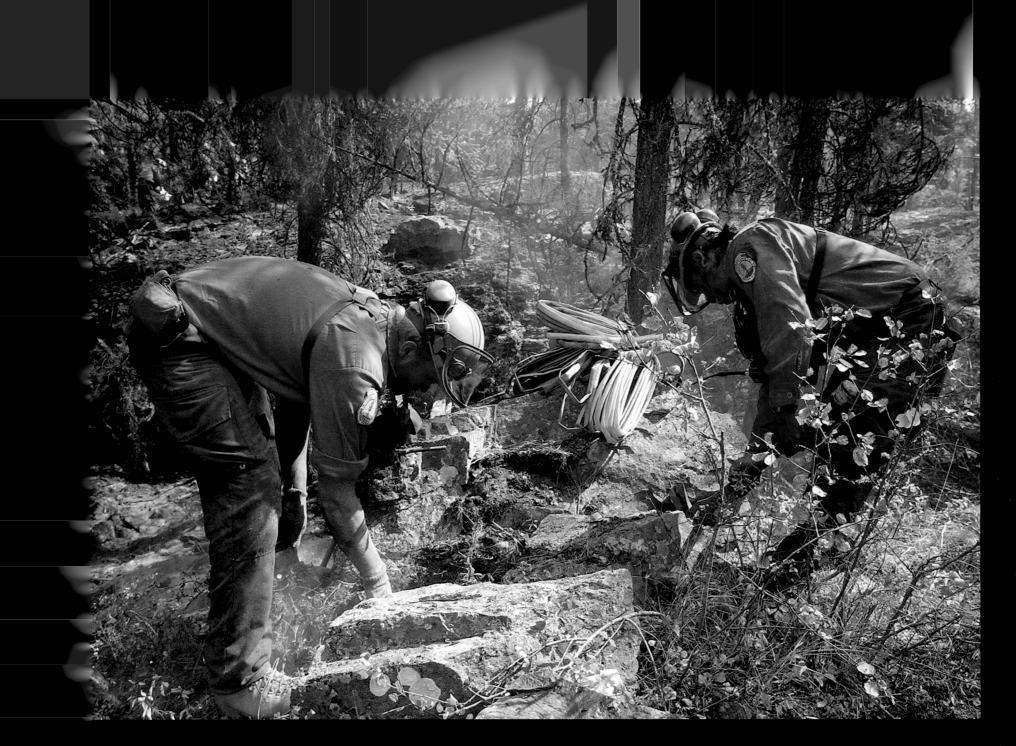

Forestry firefighters work on a hot spot in the hills above June Springs Road in Kelowna.

AFTERMATH

Forest fires are an integral part of earth's natural cycle. Experts had predicted they would scorch B.C.'s steep terrain during a hot summer, but no one could have guessed the scale of the devastation. Now, British Columbians know a similar catastrophe can happen any time. The long-range forecast for the province is for continued dry conditions through June 2004. Meanwhile, scientists say climate change around the world is becoming more pronounced. Summers and winters are warmer and drier than they were a decade ago. B.C. has had three successive summers of below-normal moisture. Who is to say there won't be a fourth or fifth?

Once the fires were contained, the B.C. Forestry Service began rehabilitating the soil with late-season grasses to redeem the fireguards. The effort was undertaken too late in the year to get a deep root system started, but it was a start just the same. Firefighters were still burning off timber and repairing access routes as winter approached. They fixed fences and dug trenches on steep hills so runoff would be dispersed more efficiently, without eroding fireguards.

The region needs major winter rains and heavy snow to put the embers out, said Judi Beck, a fire-behaviour specialist from Victoria. The perimeter of many of the summer's fires exceeded 100 kilometres.

Every hidden ember still alight within those perimeters must be completely extinguished so hot spots won't re-ignite in spring when temperatures rise again. "The fire must not be able to travel through trees and there must not be any smouldering on the forest floor," Beck said. "Crews will literally have to crawl on their hands and knees and make sure nothing is burning."

Residents are still counting the cost and assessing the consequences of the fires. Experts are questioning the wisdom of building homes in interface zones, where houses are built either on the edge or within the forest. Critics blame strict zoning regulations in the province for forcing people to build outside of agricultural land and up against the forest fringe. Now the risk of mudslides hangs over people living next to fire-ravaged stands of trees. With the loss of evergreens and vegetation, no root system holds the soil on previously forested slopes. Heavy rain or snowmelt can transform the soil into a thick soup which, in turn, may carry debris down creeks where it can form dams and cause flooding.

Then there's the immediate human cost of the fires. Uprooted families resigned themselves to spending six months or longer living in motels, with relatives, or in rented accommodation if they could find it. Many had their losses covered, but some were without property

insurance. Others who have lost their businesses or houses were preparing for a long fight over reimbursement. More than 180 families had to find a new source of income after the Tolko mill burned down.

Fire-incident commanders were commended, and in some cases criticized, for the tactics they used to fight the fires. The effort was expensive. The bill for fighting British Columbia's fires is expected to top $500 million. Still, the property losses could have been far greater if not for the resources thrown into fighting the infernos. As winter approached, the strategies and decisions made during the crisis were examined closely. Former Manitoba premier Gary Filmon led a review of the fires with public input. His report promised an improved level of preparedness as the province braced itself for new challenges in coming years. But the challenges British Columbians faced, suffered through, and finally surmounted in the summer of 2003 can only give us strength and hope for the future.

THE FINAL TALLY

Chilko Lake

29,202 hectares

17 people evacuated

Resources used: 200 personnel, helicopters, air tankers, and a Martin Mars bomber

Communities affected: Chilko Lake, Anaham Reserve, Alexis Creek, Nemiah Valley, Scum Lake

McLure-Barriere

26,420 hectares

72 homes lost or damaged

9 businesses, including a mill that employed 180 people, lost or damaged

3,800 people evacuated (plus 880 re-evacuated)

Maximum resources used at any one point: 1,100 personnel, 160 pieces of heavy equipment, and 12 helicopters

Communities affected: Barriere, Louis Creek

Okanagan Mountain Park

25,600 hectares

238 homes lost or damaged

12 wooden trestles in Myra Canyon lost, decks on two steel trestles burned

27,050 people evacuated (plus 4,050 re-evacuated)

Maximum resources used at any one point: 700 personnel, 250 pieces of heavy equipment, and 20 helicopters

Communities affected: Kelowna, Naramata

McGillivray

11,400 hectares

20 homes lost or damaged

2,450 people evacuated (plus 805 re-evacuated)

Maximum resources used at any one point: 850 personnel, 125 pieces of heavy equipment, and 11 helicopters

Communities affected: Chase, Niskonlith Lake area, Pritchard, Sun Peaks Ski Resort

Lamb Creek

10,979 hectares

195 people evacuated

Maximum resources used at any one point: 520 personnel, 70 pieces of heavy equipment, 17 helicopters, and 2 boats

Community affected: southeast section of Cranbrook

Kutetl

7,808 hectares

Maximum resources used at any one point: 100 personnel, 3 pieces of heavy equipment, and 2 helicopters

Communities affected: Harrop, Procter, Nelson, Kokanee Provincial Park, West Arm Provincial Park

Venables Valley

7,635 hectares

210 people evacuated

Maximum resources used at any one point:
 340 personnel, 50 pieces of heavy equipment,
 and 10 helicopters

Community affected: Ashcroft

Ingersol

6,700 hectares

30 people evacuated

Maximum resources used at any one point:
 150 personnel, 20 pieces of heavy equipment,
 and 3 helicopters

Community affected: Nakusp

Strawberry Hill

5,731 hectares

4,000 people evacuated (plus 300 re-evacuated)

Maximum resources used at any one point:
 285 personnel, 20 pieces of heavy equipment,
 and 5 helicopters

Communities affected: northeast section
 of Kamloops

Kuskanook

4,832 hectares

Maximum resources used at any one point:
 220 personnel, 10 pieces of heavy equipment,
 and 7 helicopters

Community affected: Kuskanook,
 25 kilometres north of Creston

Vaseux Lake

3,300 hectares

120 people evacuated

Maximum resources used at any one point:
 655 personnel, 85 pieces of heavy equipment,
 and 5 helicopters

Community affected: Okanagan Falls

Plumbob Mountain

2,870 hectares

16 people evacuated

Maximum resources used at any one point:
 170 personnel, 35 pieces of heavy equipment,
 and 7 helicopters

Community affected: Baynes Lake,
 35 kilometres southeast of Cranbrook

Cedar Hills

1,620 hectares

1 home lost

1,000 people evacuated

Maximum resources used at any one point:
 430 personnel, 110 pieces of heavy equipment,
 and 7 helicopters

Community affected: Falkland

Tatla Lake

1,867 hectares

15 people evacuated

Community affected: northeast end of
 Tatla Lake

Bonaparte Lake

1,500 hectares

100 people evacuated

Maximum resources used at any one point:
 60 personnel and 6 pieces of
 heavy equipment

Community affected: Bonaparte Lake

Anarchist Mountain

1,230 hectares

3 homes lost or damaged

6 people evacuated

Maximum resources used at any one point:
 200 personnel, 12 pieces of heavy
 equipment, and 10 helicopters

Community affected: Osoyoos

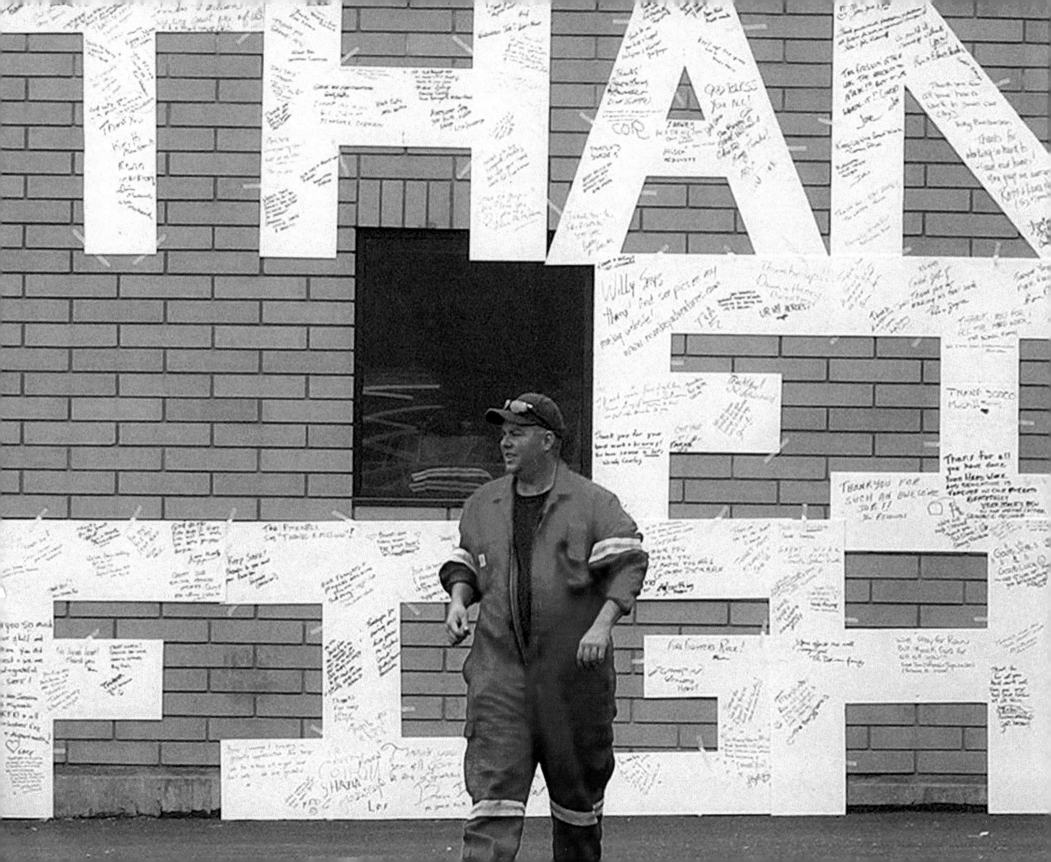